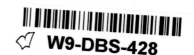

SIGNS AND SYMBOLS

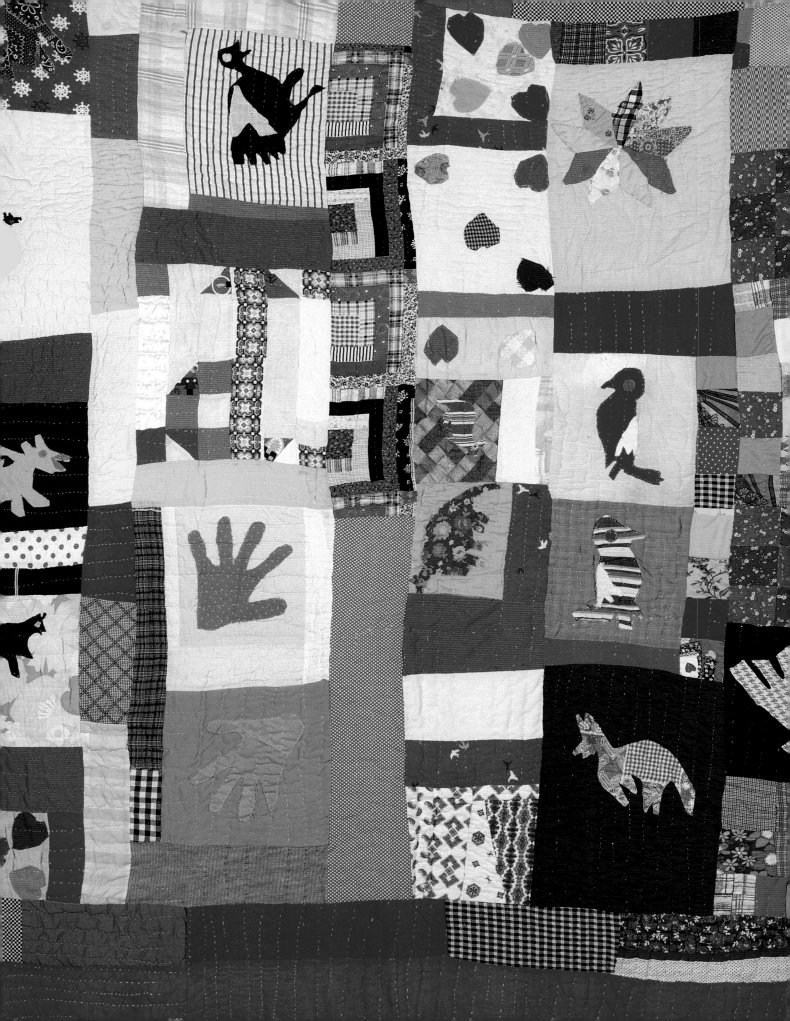

SIGNS AND SYMBOLS
African Images
in African-American Quilts

Maude Southwell Wahlman

STUDIO BOOKS
in association with
MUSEUM OF AMERICAN FOLK ART
New York

STUDIO BOOKS
Published by the Penguin Group
Penguin Books USA Inc., 375 Hudson Street,
New York, New York, 10014, U.S.A.

Penguin Books Ltd, 27 Wrights Lane,
London W8 5TZ, England

Penguin Books Australia Ltd, Ringwood,
Victoria, Australia

Penguin Books Canada Ltd, 2801 John Street,
Markham, Ontario, Canada L3R 1B4

Penguin Books (N.Z.) Ltd, 182-190 Wairau Road,
Auckland 10, New Zealand

Penguin Books Ltd, Registered Offices:
Harmondsworth, Middlesex, England

First published by Studio Books, an imprint of Penguin Books USA Inc.

First printing, July, 1993
10 9 8 7 6 5 4 3 2 1

Copyright © Museum of American Folk Art, 1993
All rights reserved

Library of Congress
Catalog Card Number: 93-84220

Printed and bound by Dai Nippon Printing Co., Ltd., Tokyo, Japan
Book designed by Marilyn Rey

ISBN: 0-525-93688-2 (cloth); ISBN: 0-525-48614-3 (paperback)

Contents

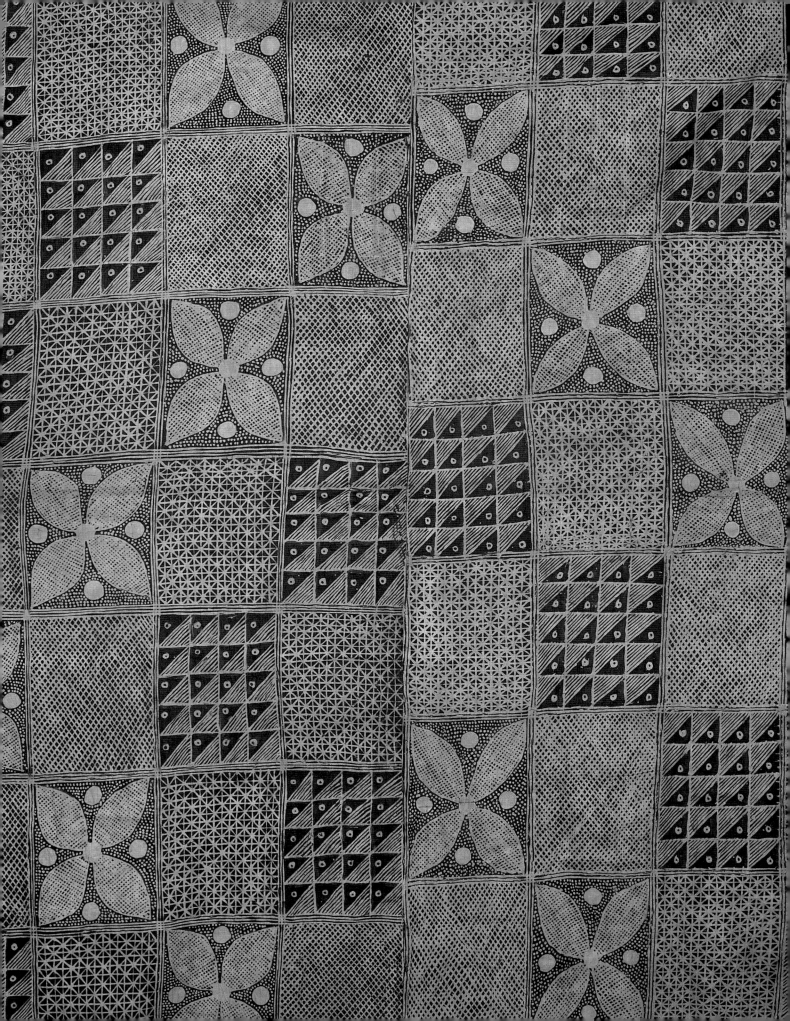

Preface

The goal of this book is to introduce the art of African-American quiltmaking to the general public. My thesis is that most African-American quiltmaking derives its aesthetic from various African traditions, both technological and ideological. Thus I deliberately study African-American quilts that exhibit similar aesthetic tendencies with African textiles.

This book is an extension of two articles requested by Didi Barrett, editor of *The Clarion*, the magazine on folk art published by the Museum of American Folk Art, New York City. By the time these two articles were published in conjunction with the opening of Gladys-Marie Fry's exhibit of slave quilts at the Museum of American Folk Art, I had been approached by Robert Bishop, the late director, to act as curator for a traveling exhibition of contemporary African-American quilts for the museum.

However, *Signs and Symbols* is not the definitive book on the subject; the definitive book has yet to be written, and I hope it will be my forthcoming book to be published by Indiana University Press. For those readers who fall in love with this subject, as I did, that book will provide an abundance of detailed information on African textiles, the history of quiltmaking in India, Europe, and the Americas, and extensive interviews with quilters.

My research on this topic began in 1977 while I was a graduate student at Yale University. Two advisors, Robert Farris Thompson and William Ferris, knowing that I had done research in Africa on textiles for my 1973 book, *Contemporary African Art*,[1] asked me to examine the possible connections between African textiles and African-American quilts. I began by interviewing quilters in New Haven. They had come from the South, so my research, which evolved from a term paper into a dissertation, eventually took me throughout the South on numerous trips. By now I have five thousand slides of African-American quilters, their quilts, and their environments, and I know or have interviewed at least five hundred quilters. Thus my conclusions are based on ongoing comparisons of thousands of quilts, with collaborating material from interviews with quilters and their families, plus research on African textiles and the history of European and American quiltmaking.

For my 1979 dissertation, with the help of John Scully, I struggled to identify some aesthetic characteristics that might explain those African-American quilts that were similar to African textiles. These ideas were promoted in the first exhibit of African-American quilts for which John Scully and I served as curators at the Yale School of Art

Gallery in January 1980 (fig. 1). We noticed seven traits that seemed to distinguish African-American quilts from the Anglo-American tradition: 1) an emphasis on vertical strips; 2) bright colors; 3) large designs; 4) asymmetry; 5) improvisation; 6) multiple-patterning; and 7) symbolic forms (fig. 2). These aesthetic criteria were simply a starting point, and in no way was I trying to pigeonhole this innovative art. Yet others picked up on these criteria and used them as rules to determine which quilts were "real" African-American quilts. Cuesta Benberry has recently clarified this situation by correctly pointing out the great diversity of quilting made over the last two centuries by African-Americans.[2]

Gradually, I began to perceive an additional layer of similarity between African textiles and African-American quilts. Many quilt-top designs were similar to designs found in African religious textiles, designs that could be decoded because contemporary Africans knew what the symbolic designs meant. As an art historian, I had to postulate possible continuities of meaning, especially since so many African-American quilts seemed to incorporate symbolic patterns.

For social and political reasons, quilters and other African-American artists do not always acknowledge or even recognize the religious ideas that may underlie their art. I have chosen to protect their confidential statements, for indigenous African-American religious ideas are not always readily acceptable to all members of a society. Therefore, my identification of religious symbols in African-American quilts is based on two sets of information: knowledge of African religious textiles and conversations with many African-American women.[3] Information about symbols used in African textiles is passed from one generation to the next in Africa, and one must assume that this is no less true for African-American women. In spite of forced migrations to the new world, "models in the mind," as Eli Leon has noted after a quote from Moni Adams, continue in new environments.[4]

Some of my conclusions may be controversial. Mary Twining and John Vlach first noticed that two African textile techniques seem to be retained in the New World; the sewing together of narrow strips to make a larger textile, and the use of appliquéd forms.[5] My research confirms these observations. In my dissertation, I also documented the evidence for patchwork in Africa and the United States. Eli Leon has carried on this research in greater detail.[6]

Research would not have been possible without the

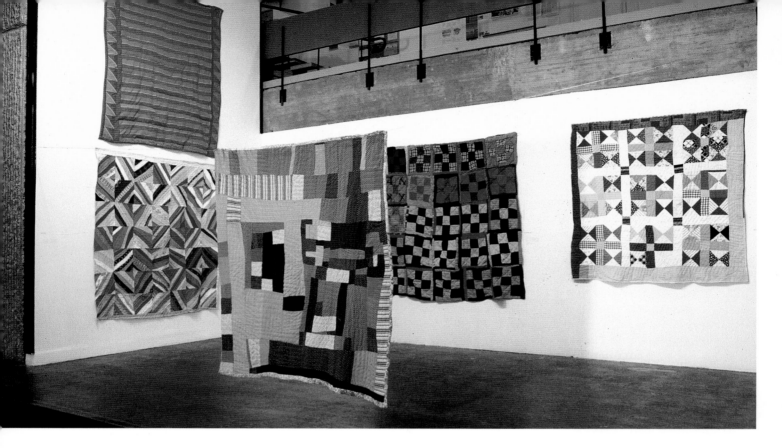

1. "Black Quilters." This first exhibition of African-American quilts was curated in 1980 by Maude Southwell Wahlman and John Scully for the Yale School of Art and Architecture Gallery, New Haven, Connecticut. Photograph by Maude Wahlman.

financial support of the Yale Center for American Art, The National Endowments for the Arts and Humanities, The Southern Arts Federation, and the University of Mississippi, which made field work possible, and supported the still-traveling exhibition, *Ten African-American Quilters*.[7] Recent support from the Museum of American Folk Art made possible this book and a new exhibition, "Signs and Symbols: African Images in Quilts from the Rural South."

Numerous people have aided in this detective story. Foremost is Robert Farris Thompson, my advisor at Yale and the person who first suggested the topic for my research, and guided it into a dissertation. George Kubler was equally instrumental in the development of my thoughts regarding symbols used over time. I thank George Kubler, Zdenka Pospisil, and William Ferris for their numerous helpful comments on the dissertation.

Many quilters have generously shared their knowledge with me, and I am forever indebted to these women who paint with cloth for indoctrinating me into their cultural heritage. In particular I want to thank Mozell Benson; Arester Earl; Martha Jane Pettway and her daughters, Plummer T and Joanna; sisters Pecolia Warner and Pearlie Posey, and Pearlie's daughter, Sarah Mary Taylor; as well as Nora Ezell; Lucinda Toomer; and Yvonne Wells. Con-temporary artists who draw on folk quiltmaking traditions have been equally generous with their perspectives, and I especially thank Jesse Lane, Wini McQueen, Joyce Scott, and Faith Ringgold.

I especially want to thank those people who were an immense help with field work: John Scully, Ella King Torrey, and Frances Dorsey. Quilt scholar Eli Leon generously read this manuscript and shared ideas about quiltmaking and slides of quilts in his collection. I thank Robert Cargo for reading the manuscript, lending slides, quilts, and information on quilters, and his southern hospitality. Frances Dorsey, Letitia Langord, and James Olander also generously offered helpful comments on the manuscript.

I am in great debt to Maggi Honda for keeping my computer functioning, and to Mabel Mathis for mending quilts when I needed time to write. Others who were most helpful include my sister Victoria Southwell, Katherine MacDiarmid, David Garcia, Dorothy Lallement, Judy McWillie, Mary Twining, Dan Crowley, Janet Berlo, April Campbell, Phillips Stevens, Jr., Justine Cordwell, Mary Hart, Frances Drummond, Margaret Gorove, Becky Moreton, Gladys-Marie Fry, Bill Gilcher, Wyatt MacGaffey, Fred Lamp, William Fagaly, Stuart Schwartz, Mary Jo Arnoldi, Enid Schildkrout, Julie Silber,

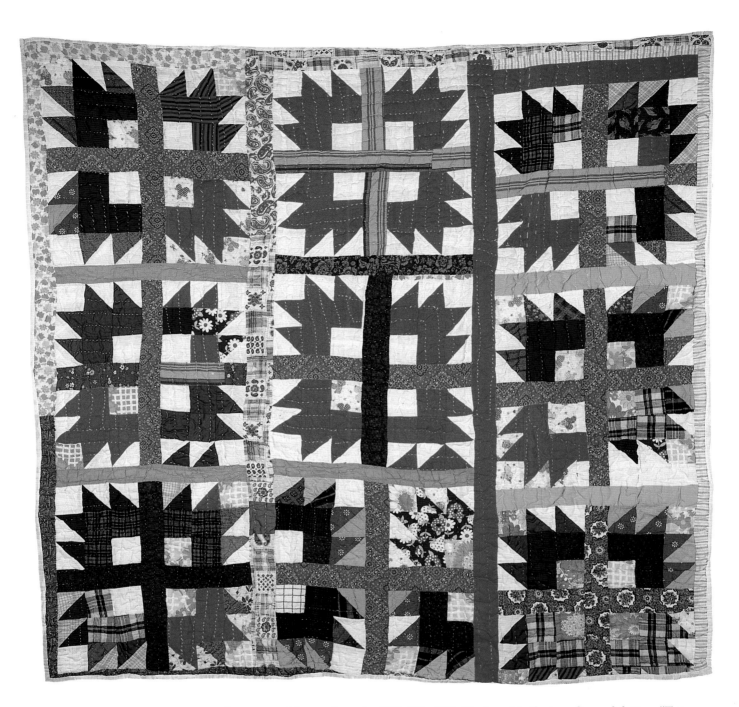

2. Cotton Leaf quilt by Lucinda Toomer, Macon, Georgia, 1979. 76″ x 71″. Displayed in the traveling exhibition, "Ten Afro-American Quilters." Here we see strips, bright colors, large designs, asymmetry, multiple patterns, improvisations, and symbolic forms. It is easy to see how Lucinda Toomer has adapted the Anglo Cotton Leaf or Bear's Paw pattern and Africanized it by creating eight more variations on this theme, as is done in African-American jazz, blues, dance, dress, and speech. Collected by Maude Wahlman. (Private collection)

Ellen Elsas, Ralph Sessions, Sterling Stuckey, John Vlach, Richard Hulan, Jeannette Henney, Bruce Whisler, and Peter Wood.

I wish to thank Jean Herskovits for the gift of a Brazilian doll dressed as a Yoruba priestess, Victor D. DuBois for a Kuba hat (my first *Nkisi*), Chris Healy for the gift of two Surinam textiles, Charles Counts for the gift of a Yoruba men's weave, Fay Leary for my first *Pacquet Kongo*, Deborah Garner and Jay Bommer for various charms, Judith Alexander for several *Pacquets Kongo*, Charles Jones for numerous charms, and Scott Rodolitz for a Kongo priest's hat and for explaining Masonic symbols. I am so very grateful to Marjorie Greathouse, Frances Dorsey, and John Burrows for their beautiful photographs of quilts and African textiles.

I am especially in debt to my husband, James Philip Wahlman, for his enthusiasm toward the quilters and their quilts, his editing skills, and his strength in carrying, photographing, and shipping quilts. My daughters, Christina and Victoria, are to be thanked for their love for the quilters and the quilts, and their patience. Finally, I thank my mother, Priscilla Lewis Cox Richardson, for financial support, for teaching me to value all cultures, and to appreciate creativity and beautiful things.

The Artists

MOZELL BENSON
Waverly, Alabama
Born January 26, 1934, Lee County, Alabama

Born and raised on a farm with nine brothers and sisters, Mozell Benson grew up independent and self-sufficient. Although she lived briefly in southern Alabama and in Chicago, she has spent most of her life supporting her family in rural central Alabama. Mozell married in 1952, and again in 1955, and was widowed in 1968. Since 1969 she has driven the local school bus, but her principal energies have been directed toward rearing, feeding, and clothing ten children and numerous visiting grandchildren. Mozell was taught to quilt by her mother, but was not interested in sewing until later in her life. Her attitude toward quilting is a reminder that African-American quilting is inextricably linked to the thrift and industry that characterize rural black Southern life.

"After I got married and had my own family, then I got into quilting because we had to have covers. So quilting was a way of doing it, and it was inexpensive because people gave me pieces of material that they weren't going to use, and I could always find use for it because we had to have covers. And then a lot of times pieces would be large enough that I could make the girls a dress, the boys a shirt, something like that, and take the scraps and put them in the quilts."

Mozell produces approximately twenty quilts a year—piecing them during the spring, summer, and fall, and then quilting the year's tops and linings together in the winter. Mozell makes quilts exclusively for her family's use, although she will sometimes give them away. She makes fewer quilts now than previously because her grown children do not wear out the quilts as rapidly as they did when they were younger.

Mozell's profound individuality is expressed in her quilting style. She does not use patterns but, instead, allows a quilt-top design to evolve while she is piecing. Mozell is consciously creative in her piecing—she selects, cuts, and sews her scraps with a concern for originality, but never permits artistic impulses to interfere with her basic frugality. All of the scraps Mozell uses are given to her. She values cotton most because of its durability, but will occasionally make a heavier quilt with wool. Mozell pieces broad, multicolored centrifugal patterns to create focal points that arrest the eye and contribute to her quilt's appearance of depth and optical movement. She uses broad bands, somewhat wider than typical African-American quilt strips, as the organizing design elements in her quilts. She explains the difference as a timesaving device because the larger the pieces, the less time needed for sewing. In addition to saving time, the wide strips delineate colors and designs particularly well.

For batting Mozell uses old blankets and spreads or old quilts that cannot be repaired. She does not quilt her tops and backings together but tacks them with evenly spaced single stitches of yarn or heavy thread. The tacking technique reduces the time Mozell spends producing a single quilt. The spacing of the tacking gives Mozell's quilts a feeling of openness and accessibility, while its consistent color helps to unify the final quilt-top design. The use of the strip and the powerful optical movement of her quilts place them within the African-American quilting tradition, clearly associated with African textile design. Mozell

is aware of the probable African origins of her quilt making. She comments, "Black families inherited this tradition. We forget where it came from because nobody continues to teach us. I think we hold to that even though we're not aware of it."

Even though she is conscious of this African-American tradition, Mozell's approach to quiltmaking is quite unsentimental and emphasizes the art's utilitarian purpose. At the same time, quilting contributes to Mozell's sense of self-worth by providing an outlet for both her creativity and her industriousness. When discussing her future, Mozell reveals the significance quilting has come to have in her life: "I always felt that if I got so I couldn't use part of my body, as long as I had eyes to see and hands I could still find something to do.... When I can't do anything else but just sit around, I'll get back to all those little bitty pieces."

See figures 35, 36, 69, 147.

ARESTER EARL
Born February 19, 1892, Covington, Georgia; died in 1988

Arester Earl grew up with six brothers and five sisters in Covington in the house of their father, John Wesley Wyatt, a preacher and farmer. As the son of a plantation owner and the plantation's cook, Wyatt had acquired over one thousand acres of farmland by the time Arester was born. As a child, Arester had private schooling, her own horse and buggy, and the liberty to pursue her interest in sewing. She began quilting when she was eight years old, instructed by a stepmother and older sisters. Arester remembers:

"I was quilting on a frame then. There were about four or five of us girls at home that made quilts. I was too small to do it, but I was just determined I was going to sew so I just learned to quilt on the quilt like they did."

In 1914 Arester married James Monroe Earl, a house painter, and they had five children. Because of the time required for her family, Arester discontinued quilting. She returned to quilting in the late 1970s, when she suggested making a quilt as a project for her local Equal Opportunity Agency. She helped make several quilts at the EOA Center, and began making quilts again at her home. Quilting became Arester's passion. In each of the next few years she produced over one hundred quilts, often working through entire days and nights.

Arester's unique quilting style—individually stuffed and quilted blocks sewn together with large loose stitches—is an innovation Arester developed in order to continue quilting despite a partially paralyzed side and weakening eyesight. When she could no longer sit or stand at a quilting frame, Arester would piece, stuff, and quilt separate blocks while lying in bed or sitting in a chair. The idea of quilting block by block occurred to Arester when she saw similarly made quilts at craft fairs, but Arester developed her own style and technique. Significantly, stuffed and padded forms are symbolic, religious artifacts among the Kongo peoples of Zaire. Similar forms have remained important in African-American culture as a good-luck charm, sometimes called "mojo" or "hand."

The sculptural quality of Arester's quilts is enhanced by their strong colors and bold designs. Arester's manual and ocular frailty contributed to the large stitches and loosely tacked blocks of her quilts, but so does the powerful African-based aesthetic that emphasizes how a textile is perceived from a distance, not how it appears on close inspection. Arester preferred bright colors because "they show up better" and used a botanical analogy to explain her choice of color juxtaposition:

"You know a green leaf on a flower? If it's got the flower on it without the green leaf it won't show up as well as it will with green leaves. You take a dogwood tree, the flower comes out before the leaves do. It won't look good until the leaves come out."

Simple patterns augment the visual power of Arester's quilts. Arester mainly used quilt patterns she learned as a child, or similar patterns that she invented, sometimes inspired by dreams. She saw many "fancy" patterns at craft fairs and in magazines, but chose to work with what

she called "common, ordinary patterns." These standard patterns were transformed into sophisticated designs by Arester's use of contrasting colors.

So small and frail that she was unable to lift most of her quilts, Arester considered her quiltmaking a rejuvenating activity. Her quilts have a palpable vitality. Arester spoke of how quilting affected her life:

"The more you have to do when you get older the better you feel. You know, it keeps me from sitting up holding my hands together....It means life to me."

See figures 124, 151, 152, 153.

NORA EZELL
Eutaw, Alabama

"I was born in 1917, in Brooksfield, Mississippi. My father's mother was a mulatto. She was light and had long hair. My father died in 1962. Before he died, he told me about his fair mother. She never worked in the fields like he did. My father was French. His father was freed in North Carolina after the Civil War. My father's father was half Black Creek Indian. He worked his way to Louisiana to find a brother who had been sold there. He met my grandmother in Louisiana.

"My mother was a nurse and taught school. She put herself through school in Holly Springs, Mississippi, and took a course in practical nursing through the mail. My mama used to wear a "nition bag" under her clothes. If someone got a silver dollar, they would keep it in that bag and stay lucky. They were made of red or black cloth. Vodou is just common sense. If you kept a silver dollar in a bag, you wouldn't be broke. It's not luck. I've never made a charm. I've heard of conjurers all my life. The only one I know is the one up above. Hoodoo is really Vodou. I've heard many people say they believe in conjurers. I have strong ESP powers, but I don't work to control them. My dreams tell me things that might happen. I don't push it.

"My father got a job at the Old Tennessee Iron and Railroad company in Birmingham, so my family moved there when I was five or six. We lived in the company town and I went to school there. We had white teachers; my favorite was my Home Economics teacher, Miss Hardins, who taught me to sew by hand and to use a treadle machine to make my own clothes and baby clothes.

"I loved to play in my playhouse as a child. I loved school when I was going. I'm one year short of finishing school. I got married in 1936. My husband promised me I could go back to school in the fall, but I got pregnant, and then I was too busy. I may go this fall and get my GED. It would be a good example for the young folks. But school is like quilts, you have to put time into it. You have to excel at whatever you do. If you have no education, but you have it in you to do something, you will do it anyway.

"We lived in Aliceville, Alabama, till 1956. I had one daughter who died in 1984 of cancer. We moved to New Jersey in 1956 to be with our daughter, and moved back to Alabama in 1974, to Eutaw in Greene County. I have four grandchildren and six great-grandchildren.[1] They're sweet. They work hard. My ability to do hand work comes from the Indian side of my family. In 1984 my grandson was fifteen when his mother died. He took it hard. We drove to San Francisco, Detroit, Canada, and then home. We stopped on the Navajo Reservation. They do beautiful work.

"I learned how to quilt by watching my mother and my aunt, Ethel Mack (we called her Aunt Tony). My mother would ask me to fan her while she quilted. Sometimes I would just sit down with a few pieces and sew them together. It amazes me that all black women don't know how to sew and quilt because sewing was such an important skill. We used to save feed and fertilizer sacks and boil them in lye for linings, or unravel them for thread. One ball was as big as my head. We would scrape up late bolls of cotton. The gin would keep the seeds as payment for ginning the cotton.

"There is one quilt I will never sell because I will never finish it. Its lining is made from printed cow and mule

feed sacks, and it has brown cotton inside. I don't know if the cotton was rare or inferior. The feed sacks were printed with pretty patterns; we used to make dresses from them. They had about a yard and a half each. Sugar used to come in cloth bags too. There used to be a rolling store, a station wagon. The man would sell boxes of candy for a dollar fifty. If you sold the candy, you got to keep fifty cents or get muslin material. You could get five or six yards of material for selling a box of candy.

"I went to school in Birmingham. When I started to make quilts, it was easy. I taught myself how to make quilts. I have made and sold so many quilts. I do them my way. There is nothing that says you got to do it this way or that. I try to stay with traditional ways because I worked with the Alabama Council for the Arts and they encouraged me to continue the traditional ways. I have tried machine quilting, but quilting by hand gives me better luck. I have more control that way. A lot of people have asked me about my colors. I don't care about color combinations. I do what looks good, but I keep the pattern in mind. I never saw a black flower so I won't put one in a quilt. I don't know which colors blend or fight. As long as it suits me, it's okay.

"My patterns come off the top of my head. My favorite traditional pattern is Grandmother's Flower Garden. It is the first pattern I remember making. I started one last year and finished it this year. I pieced it every morning as I woke up. I also made one for a lady in Jacksonville, Florida, this year. I met her at the festival in Montgomery last year. The Star Puzzle was one of my original patterns. It was made in 1974, before we left New Jersey. My husband could rip good, so I would get him to rip out my mistakes. I made him rip that quilt out so many times that he complained. So I got it right, the way I wanted it.

"I have stacks of patterns. Everyone who makes pattern books sent me one this year! Some cost thirty dollars, and you might get one new pattern. The rest are patterns I've seen and heard about all my life. I always make my own. Sometimes I want larger pieces. I make a block to see how it works. Then I set that block aside for a sampler quilt. We used to call them Friendship quilts. We would go from one house to another piecing blocks till everyone had enough for a quilt top. Then we went from one house to another to quilt.

"I have one now that's ready to quilt. I finished a quilt of strings and patches this evening. I like to do them because I can use all the little and big pieces. I hardly ever buy material. I have a dear friend who may buy one hundred dollars worth of material to make a quilt. That's not what quilting is all about. Scrap quilts are the prettiest quilts, more so than the ones where people try to match all the pieces up.

"The first quilt I sold, sold for seven dollars. It was when I worked at the hospital in Birmingham. They pulled names at Christmastime for presents. I made a quilt. A nurse saw it and wanted one. I made one for her for seven dollars. I have this new thing I make—towels. When I was in Mississippi last, I saw a lady doing towels with lace and ribbons. I sell three-piece sets for thirty-five to forty dollars. I do all kinds of handicrafts: tatting, lace work, and embroidery.

"I do pictorial quilts lately. My daughter, Annie Ruth, and I came up with the idea. We saw a quilt in Greensboro—a University of Alabama quilt. My daughter asked me what I thought of that quilt with a brown hat and a football. I said, 'Not much.' A few weeks later we were on our way to the Birmingham hospital and she said, 'Mother, I think we could make a better quilt with things from the history of the University of Alabama.' We thought of different things to put on it. Then someone gave me a bunch of scraps. Many were red and white, the colors of the university. So I made the school doors, Bryant's hat, footballs, a map of Alabama with stars falling on it, and on the bottom strip, books for the different subjects one can take. At the end I put a cap and gown and a certificate. My daughter died in 1984 before I finished it. I had to lay it aside for several years. I got a lot of compliments on it. I had it on consignment once. A lot of students had photos taken in front of it. Bob Cargo bought it.

"My Martin Luther King quilt was next. It's on a 1992 Alabama calendar.[2] Ask Bob Cargo for one. He had a lot. The Stillman College quilt showed one hundred years of history. I had to finish it quickly. My husband, Joseph Ezell, died on October 18 in 1986. My first show was scheduled at Stillman. The show opened on a Sunday. He died on Saturday; it was hard. The quilt was not finished; the blocks were all done. It was a big disappointment that the school did not buy it. Bob Cargo bought it.

"Then there was a beautiful Birmingham quilt made for a couple. It had the zoo, the library, their house, their dog, the iron man, the old steel plant turned into a museum. The architects' drawing for the museum was in one block. She sent me photographs of their Model T Ford and their tractor.

"Then I made a Bible Story quilt. I hadn't planned it for anyone.[3] I was working on it in Birmingham. Jim Hedges, from Chattanooga, was there. He had seen the 'Stitching Memories' exhibit in Memphis and wanted one of my quilts. He put a down payment on the Bible quilt and bought a Donkey quilt. The quilt had squares with Christ on the Cross, Mary and her Baby, Samson, Christ with the Lambs, the Flight to Egypt, and Moses. There are nine blocks. It took a thousand hours to complete. I keep a log of my hours on story quilts; I allow myself three dollars an hour. I never do more than one of a story quilt because I don't have any patterns. I'm going to do a different Bible Story quilt for a woman in Louisville. She's worried because I have rheumatoid arthritis. I have trouble with my hand. I couldn't walk this year.

"I finished the Kentucky Derby quilt three weeks

before the Derby race. I started it in November. Now I'm working on my tenth pictorial quilt for a group in Birmingham, to commemorate a lady who was interested in music. She helped musicians. The Birmingham Jazz Combo is commissioning this quilt and will dedicate it to her. She crocheted and knitted all the time. They brought me six bags of knitting yarn to use in the quilt. I plan to show all kinds of musical instruments in the quilt. It's all laid out. I live alone. If something is on my mind, and I can't get it together I go to sleep, and if a solution comes to me in my sleep, I get up and do it.

"I do traditional quilts all along. I can do one in eighteen to twenty hours. It's like making a dress. No trouble at all. It's hard to get a Star pattern to lay flat. You can make a bowl or a hat if it doesn't work out. It's all in the cutting—seventy-five percent of the job. If it's cut right, I won't have any trouble putting it together. I only mix fabrics in a Crazy quilt. Otherwise, I put cotton with cotton, and knit with knit.

"I won the NEA award this year. I'll be in next year's book. I'm going to Washington, D.C., in September, and taking quilts for an exhibit. My grandson is going with me. I need to make my own clothes to take. I had cancer twenty-two years ago. Nine members of my father's side of my family have died from cancer. I had a mastectomy twenty-two years ago. My daughter also had breast cancer, but they gave her treatments. I don't dwell on it. I still do my own house repairs. I have a beautiful garden in one acre. It's all clean; I keep chickens.

"I can't sit still without doing something. When I go to church, I'm on pins and needles. You can't sew in church. I tried to get my two granddaughters interested in quilting, but it didn't turn them on. It's the hardest thing in the world for me to put my quilting down. I may work on three or four quilts at the same time. I always do traditional quilts while I'm doing story quilts. I am never bored. I have an old car and an old truck and I go look for some junk, or material, or thread.

"I have two videos. One was made by the University of Alabama at Birmingham. I went there for a show. The art teacher had me speak to her class and had it videotaped. Another video was made by a school in Decatur. It's six hours long. There was a good writeup and photos of her in the *Montgomery Advertiser* on June seventh. Mike Land wrote the article; a lady did beautiful photos.

"I still enjoy doing what I'm doing. My book is coming out next year. It's called *My Quilts and Me*. I wrote it. It's finished and waiting to go to a publisher in Tennessee. Mr. Hedges is helping me. Anything you set your mind to do, you can do. You can find joy in anything you do. It makes me feel so good to make a pretty quilt and have someone enjoy it."

Nora Ezell won an Alabama Folk Heritage Award in 1990, and a National Heritage Fellowship in 1992.

See figures 42, 85.

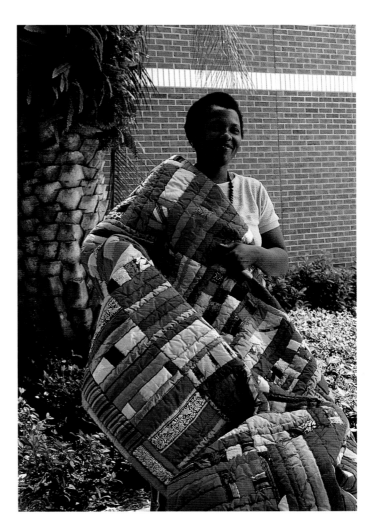

JESSE LANE
Gainesville, Florida
Born January 6, 1948, Autagaville, Alabama

Jesse Lane has lived in Alabama, California, Washington, New Mexico, and Oklahoma, and she now lives in Gainesville, Florida. She attended Santa Barbara City College and the University of California at Santa Barbara, and has a B.A. in art with a concentration in painting. Her painting started to look like quilts, so she began to make quilts in 1975. A good friend and neighbor, Elizabeth Hardy, first inspired her to make quilts. Their children played together, and eventually Jesse and Elizabeth discovered each other's arts. Jesse was making pottery and painting huge pictures of people in bright colors at that time. Jesse's first quilt was made from a painting. She knew nothing about making a quilt.

"I ran out and bought material, velvets, and upholstery batting. My first quilt was of two people touching hands. There was a yellow moon at the top with a crescent below.

I used embroidery thread to quilt it. My mother thought it was crazy. I made a quilt for each of my children, and one for my sister. I was hooked after that."

Jesse's mother, Verda Hunter Lane, moved away from Santa Barbara one year after Jesse graduated. Jesse didn't remember that her mother quilted until she mentioned that her quilts were in a show in California. Then her mother said, "My sisters and I made quilts." Verda was the youngest of nine children. Verda's mother had always made quilts, but she died when Verda was seven or eight; her sisters raised her and taught her to sew. They sewed together, always trying to outdo each other in making small stitches and fancy patterns. Verda remembered making quilts as a child, but not after she had children.

Verda Hunter made all her children's clothes and taught all her seven children, including one boy, to sew. Once he made his own suit. Jesse remembers that her uncle sewed also. She says, "You tend to do what people around you do." Jesse learned to sew by watching her mother; she learned to cook the same way. "You learned by watching," she says. At first she made doll clothes. When she was a teenager, she laid out a dress she really liked by using patterns made from brown paper.

A Strip quilt was one of Verda Hunter's favorite patterns. Jesse vaguely remembers her mother working on a patchwork quilt before her younger sister, Marie Lane, got married. Verda saved scraps from the younger sister's dresses for the quilt. Verda Hunter now lives in Kokomo, Indiana, with Jesse's older sister, Evelyn Tyler. They both left California because it was changing so fast in the seventies.

Jesse Lane likes a Triangle/Diamond pattern that she first saw on a basket her mother treasured. Later she saw the pattern in Indian and Tibetan arts. Now the pattern is in a small rug she keeps on the wall at home. She sent her mother a quilt made with this pattern, which was made from dresses they had worn. She also prefers Strip quilts because she likes randomness in art.

Jesse Lane was married to Harry Kennedy on September 15, 1963, in Santa Barbara, California, when she was fifteen. They had three boys, who are now twenty-six, twenty-eight, and thirty. Later she married Raymond Moore, and had twins, Magela and Bishara, now twenty-three. Magela is studying to be a computer engineer in Santa Fe, New Mexico. Bishara has his own landscaping business near Gainesville, Florida. She has three more children living with her: Onawa, a girl, eleven; Galena, a girl, nine, and Iam Tha Tiam, a boy, seven.

Since 1980, many of Jesse's quilts have been on exhibit in Florida at Ormond Beach, Gainesville, and at the Zora Neale Hurston festival in Eatonville; in Spokane, Washington, and Tucson, Arizona. She constantly submits textiles for exhibits. Some quilts feature appliquéd shapes, stitchery in contrasting colors, as well as patchwork. Cur-

rently she is designing hand-embroidered capes and hats. See figure 154.

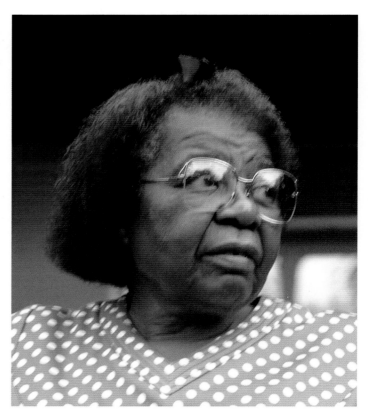

MARY MAXTION
Boligee, Alabama

Mary Maxtion learned to quilt from her mother, who died when Mary was a girl. She is thinking of retiring from quilting even though she has made quilts all her life and loves it.

Mary Maxtion makes traditional African-American String quilts, as well as Album quilts made from patterns she has acquired from magazines or from friends. As Fran Dorsey notes, "Vivid colors in surprising juxtaposition characterize her quilts. A prolific quilter, she makes quilts distinguished by fine craftsmanship as well as exuberant color and rhythm."[1]

Her Snail Trail quilt is an impressive creation, made by blowing up a pieced pattern into large units with subtle variations.

See figures 30, 41, 130.

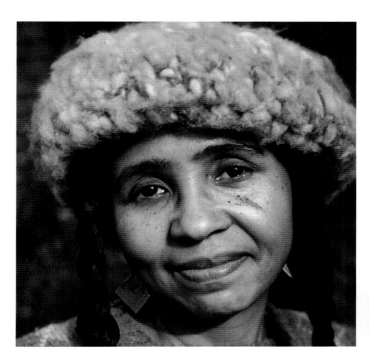

WINI McQUEEN
Born 1943, Neptune, New Jersey

Wini McQueen thinks of herself as a fabric designer and a fiber artist, even though her Howard University B.A. was in English. She made her first quilt at the age of seven, and a block from that quilt is now incorporated into *Little Oba's Heritage*. Inspired by family and cultural traditions, she creates literary quilts with transatlantic images and symbols as well as photographic documents. A 1987 Georgia Council for the Arts grant enabled Wini McQueen to develop innovative fabrics that combine African textile traditions, African-American quilting ideas, and contemporary art techniques such as appliqué, bead-work, batik, hand-block printing, photo blue-print, resist-dye, and Xerox transfers.

Her *Family Tree* quilt featured photos of McQueen's mother, grandmother, uncle, aunt, grandfather, etc., all of which were laid out in the shape of a tree. McQueen said of this quilt, "I just feel that there's such a need to preserve our history as black people. I wanted to use this as an opportunity to record something about myself and my family and people who live in these times. I used it to tell my story, and in this instance the whole experience was like being an artist and being a storyteller. All of the photos belong either to me or my family. I've even made some of the photos—taken, developed, and transferred them." The leaves falling from the tree "represent people who have fallen; people who have died, my mother, for example."

Little Oba's Heritage was designed as a crib quilt in

1987 for Ryan Darrell Kelly, the year-old son of Wini McQueen's cousin. A parchment letter accompanied the quilt to explain the African references in the quilt. Using the narrow strip motif of West Africa, McQueen inter-spersed family photos with images of Egyptian gods, Adinkra symbols, and even pieced together satin hair ribbons to simulate royal Asante robes. Cowrie shells are added as a symbol of money, with the advice that knowl-edge is more valuable than money.

Wini McQueen lives in Macon, Georgia, with her hus-band, Milton Dimmons, a lawyer who does the photo transfers and deals with copyright questions. McQueen often sends her designs to Dorothy Dickerson and Bar-bara Rogers to be quilted.

See figure 155.

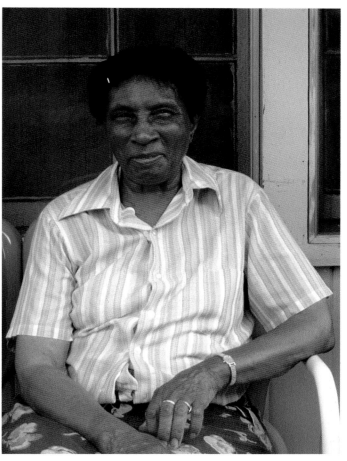

LURECA OUTLAND
Born March 15, 1904, Green County, Alabama

"My father died when I was one year old, and my sisters were three months old and five years old. He took sick in the field, came to the house, and died soon afterwards.

My grandmother helped to raise us. As a child, I quilted the tops my mother pieced. Some were filled with cotton left from ginning; others were filled with worn-out clothing. My mother taught me to quilt when I was in my teens. We would piece up pants and dress pieces. Those quilts were not fancy like they are now. We used to piece up strip quilts. My mother knew some pattern quilts.

"When I was nineteen I got married to Alfred Outland. He died thirteen years ago of leukemia. He was smart, a carpenter. He built houses and churches. When I got married, we had our own farm. I worked in the fields and washed on a washboard. We didn't have a washer. I ironed by the fireplace with solid smoothing irons. When they got hot, you rubbed them with cloth to get the ashes off; then they ironed good. We had four boys, one girl, and two children who died. Now I have fourteen grandchildren.

"Since my children have grown up, I do more quilting. I sold a P quilt to Bob Cargo two months ago. He also bought a Leaf quilt. My sister's daughter calls it a Carolina Leaf. I'm piecing a Flag quilt now on the machine. Stars are my favorite pattern. I also like the Pig Pen quilt. You go around from the center and use three colors. Cotton is all I put in my quilts. I have four pieced and quilted now. I quilt by myself. I did not make fancy quilts until after I joined a senior-citizens quilting group with Mary Maxtion. Sometimes she quilts with me. The members usually piece their own blocks.[1] I like red. My flag quilt has red, black, and white. I made a P quilt in black and white. I'm thinking about piecing a Cross quilt in brown and yellow. I will take my quilts to the festival in August on the courthouse square. I enjoys stars and other tricky patterns.[2]

"We don't work the land now; there is no one to work it. Only the cows are on it. We don't plant anything. My son, Alfred J. Outland, Jr., taught school. He retired the year before last. His son, Alfred J. Outland, III, went to Princeton. He got married last year while he was living in Atlanta, then he moved to Virginia. My other son, Clarence Edward Outland, had been overseas, but he came back last May. He works for Goodyear Tire in Tuscaloosa. His son has a scholarship to Xavier College in New Orleans. My son, George, lives in Chicago. My son, Charlie, died five years ago; he smoked too long. Almamarine Hawkins is my daughter."[3]

See figures 63, 64.

ROSE PERRY DAVIS and ATLENTO PERRY WARNER
Orlando, Florida

Born in Orlando, Florida, these sisters lost their mother, Edna Mae Cookley Perry, in 1989, when she was seventy-nine. They decided to make quilts and other artifacts from her closetful of clothes. They didn't want to part with her clothes, but thought they should not just hang in the closet unused. One night their father got tangled up in the bedsheets and fell out of bed. Rose Davis told him, "Daddy, Mama's still fighting you from the grave."[1] Now they find it comforting to know that during the chilly months, their eighty-six-year-old father, Pam Perry, can keep warm under a quilt made by his daughters, from clothes his wife wore.

"I think that the beautiful thing is that even though Mama is no longer with him, every winter he can sleep under something that she wore during their marriage," said Rose Perry Davis.[2]

Rose and Atlento also made pillows, wall hangings, bookcovers, and decorated sweatshirts from their mother's dresses and blouses, and decorated her shoes and handbags with flower arrangements. When relatives saw their handiwork, they also wanted mementos. Rose and Atlento learned to sew from their mother and made dresses and skirts from flour and feed sacks while the family of fourteen brothers and sisters grew up on a farm in Gifford, Florida. The girls got the feed sacks that were big enough for dresses. "I got in big trouble once for emptying a flour sack to make a skirt. My sisters had new skirts for church, and I wanted one too,"[3] said Atlento, who now works as a tailor at the Orlando Naval Training Center.

Since 1979, Rose and Atlento have been asked by four other families that have lost a loved one to make gifts for relatives from the deceased's clothing. In two years, the sisters have made more than three hundred pillows, sixteen quilts, and dozens of other pieces, including wall

hangings made from hats. "You might get tired of old clothes and give them away," said Christine Reagan Barriner, "but this is something you can pass on from generation to generation."[4] She had three quilts made from her mother's dresses. Rose and Atlento now maintain picture books showing the original dresses as well as the objects made from them.

When I mentioned to them that in Central Africa the Kongo people believe that success in life comes from honoring one's ancestors, they were very excited. Rose said, "You must be right because my father said our ancestors came from Ethiopia and the Congo."[5] They were also very interested to know about the Kongo belief in Birth, Life, Death, and Rebirth, often depicted as a cross or a diamond, as one of their favorite quilt patterns creates diamond shapes from small strings of cloth. A photograph of the sisters with their Diamond quilt was featured in the *Orlando Sentinel* in 1992. Rose said, "Ever since we made quilts from our mother's clothes, all sorts of good things have happened to us."[6]

died in 1972, when he was one hundred years old. He was a wood carver like his son, Sultan, now sixty-nine, a retired factory worker who lives in Syracuse, New York.[1]

Alean has a twin sister, Evelyn. Another sister, Collie, is also a quilter, but is also famous for her hand-built white twig fence, featured in the June 1981 issue of *Life* magazine. Alean and her sister, Collie, are the only remaining quilters left in the family. Now she often quilts alone, while watching television. While Alean sells many of her quilts, Collie only gives hers to her son, Marion.

Alean Pearson was baptized at thirteen, and married Steve Pearson in 1935. They had fifteen children (twelve are living), twenty-three grandchildren, and four great-grandchildren. When she married, she "had to piece up six [quilts] of my own." The Pearson family built their house in 1969, down the hill from the original family home near the University of Mississippi campus.

See figures 40, 56, 117.

ALEAN PEARSON
Oxford, Mississippi
Born March 6, 1918

JOANNA PETTWAY
Boykin, Alabama
Born November 13, 1924, Boykin, Alabama

Alean Pearson moved to Oxford, Mississippi, at age one: her father was a farmer. She started quilting at age six; she was taught by her mother who lived until 1978. Instruction was by example. She started sewing doll quilts first, using thread from unraveled flour sacks. She copied the quilt patterns made by her mother. Her father, Will Rogers,

"We were kind of a big family—seven sisters and five brothers. Back then we cut the dresses to make the quilts. Go to the field, pick cotton. Go to the gin, wrap it up, put the padding on the quilt. We just enjoyed it."

Joanna Pettway fondly remembers her childhood in rural Boykin, Alabama. She has traveled throughout the

South and Midwest, but prefers to stay at home in the small community where she was born.

While she raised twelve children of her own, Joanna has always lived with her mother, Martha Jane. Today the two have a house and a large garden not far from the farm where Joanna grew up and within walking distance of the house owned by her sister, Plummer T Pettway. The women visit daily, exchanging stories, information, flowers, vegetables, and quilting scraps. Making quilts is a family activity for the Pettways—each woman pieces her own quilts separately, but they quilt together every few months.

Joanna, Plummer T, and Martha Jane can complete two or three quilts a day. Joanna recalls finishing many more when she was younger and attended local quilting parties:

"It isn't like it used to be. Used to have fun taking quilts from one house to the other one. Get out quilts down here, go up there, get it out there, then go up to that one. Quilt so many in a day."

The quilts she and her neighbors quilted were usually made from old dress skirts and pants legs, backed with flour or meal sacks, and then padded with field cotton. The patterns they used were almost all modifications of the basic African-American strip.

The quilts Joanna makes today bear little resemblance to those she made in her youth. Unusual designs and patterns coupled with sparkling colors distinguish Joanna's contemporary quilts. An employee of the Freedom Quilting Bee sewing cooperative in Rehobeth, Alabama, Joanna saves multi-colored scraps from the Quilting Bee to use in her own quilts. While Martha Jane likes to piece with scraps precut at the Quilting Bee, and Plummer T often combines the precut scraps with her own, Joanna Pettway prefers to cut the Quilting Bee's scraps into new shapes for use in her own unique patterns.

Joanna's artistic independence is also apparent in the innovative quilt-top designs that combine several traditional patterns in new ways. She candidly admits she favors patterns that require large design elements because they demand less stitching, and whenever possible she uses a sewing machine to piece her scraps.

The resulting bold geometric images reflect her independent spirit and serve her personal aesthetic as well. While her quilts vibrate with subtle movements, Joanna places broad, solidly colored bars in her designs to act as visual anchors. The aggressive colors and patterns of her quilts dominate the overall design and focus the viewer's attention, while simultaneously inviting closer examination. These quilt-top designs suggest aesthetic values that can be traced to West Africa, where textiles are made to be seen clearly at great distances, but at the same time must be analyzed closely to be thoroughly understood.

Quiltmaking is an integral aspect of Joanna's southern rural life. She associates her quilting with the season:

"This time of the year the cotton opens up. We pick cotton and go to quilting. After you finish with the cotton, you go back to quilting. All the time—something to do all the time."

Like most African-American quilters, Joanna enjoys making quilts because it keeps her busy and productive. Quilting provides every quilter with private satisfactions, too. Joanna particularly cherishes the quilting sessions with her mother and sister, when she can pause and reflect on life. She describes an afternoon spent quilting:

"We're just sitting down thinking about old back times—how they do and what they do. And looking for days to come."

See figures 119, 125.

LEOLA PETTWAY
Boykin, Alabama
Born 1929

Leola Pettway has lived in Boykin, Alabama, all her life, where she was born in 1929. She lived with her grandfather and remembers "plastering newspaper and old magazine sheets on the walls of their house to stop up the cracks, to keep out the cold, and to dress the house up and make it look good."[1]

She is part of a large extended family of quilters, and has been quilting since she was eleven. As a child she "loved quilts more than anything in the world." She watched her aunt make quilts, but doesn't remember being taught. "If something is on your mind, you do it."

She learned to make Bear's Paw and Sawtooth patterns, and borrowed a book of quilt patterns from a neighbor. If they did not have cotton, they would use a blanket as the batting for a quilt.

Leola Pettway kept making quilts after her ten children (five boys and five girls) were born, and sold many to Mary McCarthy.[2] She used to work at the Martin Luther King Freedom Quilting Bee nearby, but doesn't now because she had a light heart attack after a daughter died in 1991. She still makes quilts, but not as fast as before. Some of her children make quilts, and some work and don't have time. Leola Pettway is also known as a singer and often sings at several churches.

On quilting, she says, "I have a mind to quilt. I just like to do it. When I'm home, I want to do something. I give a lot of quilts away, to children, to people whose houses burned up. When I sit down to quilt, I say 'Lord be with me.' When I finish a quilt, I say 'Thank you Jesus, for enabling me to get this quilt out.' It takes time to quilt. I like all colors. I sew print to plain. If I have red, I put a different color next to it. If I am scraping up a quilt, I put different materials together."

See figures 43, 60.

MARTHA JANE PETTWAY
Alabama
Born May 25, 1898, Gee's Bend, Alabama

Martha Jane Bendolph Pettway has lived all her life in remote, rural Alabama. Martha Jane grew up working on a farm with a sister, a brother, and their mother. She recalls a happy childhood, with few labors and many hours at play. In testimony to her carefree youth, Martha Jane points out that she did not learn to make quilts until a relatively late age, "when I got to be a big girl," when she was about fifteen years old. Martha Jane's mother instructed her daughters in the skills of cutting, piecing, and quilting, and taught them standard patterns such as the Bear's Paw, Grandmother's Garden, and the strip pattern. Since then Martha Jane has continued to "sew at all times."

In her teens Martha Jane married a childhood friend, Little Pettway. Little was a farmer and later the manager of a cooperative store founded in the 1930s as a part of the Rural Resettlement project that purchased plantation land and redistributed it among local blacks. The Pettways had fifteen children—five boys and eight girls were raised together; two girls died in infancy. Martha Jane believes that "everybody needs some children.... Why, if I hadn't had children, I'd have been so ornery." The Pettway children grew up working on their parents' farm. Martha Jane and her children who have stayed in the area still own well over one hundred acres, much of which is leased to other farmers.

Martha Jane appreciates the help and company of her grown children. She and her daughter Joanna live together, and another daughter, Plummer T, has a house nearby. Martha Jane says of these daughters: "Whatever I go to do, they be there helping me, whatever got to be done...cooking, cleaning, sewing, just whatever."

Quiltmaking is one of many pastimes the three women share. Martha Jane is pleased that Joanna and Plummer T carry on the skills she taught them, stating proudly, "All my daughters could quilt, every one of them. I learned them all how."

Martha Jane spends much of her time alone, and finds solace in piecing quilts. In the winter she works inside near the fire, but in the summer she likes to sit outside under a favorite tree and piece her quilt tops. Martha Jane uses precut scraps from the Freedom Quilting Bee in Rehobeth, Alabama. The Quilting Bee is a sewing cooperative that employs many local women, including Joanna and Plummer T. The discarded scraps that the Pettways bring to their mother are all of new material, originally cut to make traditional Euro-American patterns for quilts or pillows. Martha Jane uses these materials in ways classically African-American and simultaneously very personal.

Vertical strips dominate Martha Jane's quilts. The piecing of small scraps, often called strings, to make the larger strips is the oldest-known African-American textile construction technique, and is employed regularly by Martha Jane. Within the vertical design structure she uses color and placement to express a very lyrical personal aesthetic. Martha Jane's quilts have a graceful, ethereal

quality. The visual rhythms of her quilts are light, quiet, and constant—mirroring Martha Jane's personality and her vitality. The satisfaction she receives from quilting is evident: "I sit down and hold my hands—I feel bad. I do my quilt pieces and go to sewing, and I feel all right... keeps me young."

Martha Jane stores dozens of quilts throughout her house, and is constantly at work on more. She muses on her passion: "Back when, we made us quilts to put on top of the bed; now we got spreads for the bed, but we make quilts anyway....I don't make them to sell, I just make them and love to sew...just love to quilt."

See figures 27, 28, 29, 52.

PLUMMER T PETTWAY
Alabama
Born February 13, 1918, Boykin, Alabama

Plummer T Pettway is Martha Jane Pettway's third child and eldest daughter. She lives with her husband, Famous Pettway—the father of her seven children—near the house shared by her mother and sister Joanna. Plummer T does not recall when she began quilting:

"I been quilting ever since a long time and quilted a lot of quilts before I married, at Mama's house. I quilted a lot of quilts there. I been making them ever since."

Plummer T, Martha Jane, and Joanna piece quilts separately but quilt together using Martha Jane's old family quilting frames. A special bond has developed between the three women, fostered by such joint activities. While quilting, the women maintain a lively verbal interchange. Plummer T describes their quilting parties: "Talk about talk! I don't know what all we don't talk about....Oh, that's fun."

Plummer T works at the Rehobeth, Alabama, sewing cooperative, the Freedom Quilting Bee. She saves scraps from the Quilting Bee and combines them with her own scraps when piecing her quilt tops. She prefers to do the piecing with a sewing machine, although she occasionally does handwork. Plummer T's favorite patterns are the traditional Nine Patch and Lazy Gal, a horizontal strip pattern, but her well-developed personal style is better seen in more complex designs. Variety and movement characterize Plummer T's quilts. She believes that many different patterns and shapes make the best quilts. "You can't match them. No. It takes all kind of pieces to piece a quilt." She is very careful when combining her pieces, cautioning that "you have to think about the next color."

Plummer T places her colors at uneven intervals, so that her patterns appear to be constantly shifting. Her quilts have an elusive quality—the use of multiple patterns, and the manipulation of prints and hues, create an effect of constant surprise. This visual density, suggestive of giant puzzles, may have origins in West Africa, where complex messages are often encoded in multiple-patterned textiles. The unpredictable rhythms and tensions in Plummer T's quilts are similar to those found in West African textiles and other African-based black American arts, such as jazz.

Plummer T does not consider herself a "fancy" quilter. She maintains that her mother and her one daughter are better quilters. Her attitude toward quilts emphasizes their utility: "Quilting keeps you warm. I don't quilt for pretty...quilt them to cover up with."

Plummer T's children and grandchildren appreciate her skills and encourage her to continue quilting. She is pleased with her family's support and happy to repay it by making many quilts for her relatives:

"Sometimes the children send scraps. Go out with their friends, get some scraps and send them to me to make quilts out of. Then I have to make them a quilt. If they need a quilt, I'll make them a quilt."

Like many African-American quilters, though, Plummer T makes many more quilts than are necessary for her family's warmth. Quilting provides Plummer T with a means to express affection for her family, while it also

allows her to be creative and productive. Plummer T explains the degree to which quilting is a part of her life:

"If I don't quilt, I don't know what I'd be doing...sitting down, doing nothing—I have to make quilts."

See figures 38, 62, 116, 120.

PEARLIE POSEY
Born August 9, 1894, Andine, Mississippi
Died August 1, 1984, Yazoo City, Mississippi

Pearlie Jackson Posey grew up on a Mississippi plantation. Pearlie's mother died when Pearlie was five years old, and the child was raised by her grandparents from Virginia. Pearlie recalls that her grandmother taught her "how to hoe, plow, split rails, make fences, all that." She also taught her to quilt. The quilts Pearlie made with her grandmother were simple Nine Patch, Four Patch, and Strip quilts—material was scarce and thread even scarcer. To gather thread needed for piecing and quilting, women unraveled flour and meal sacks, rolling the thread into tight balls. Sacks were sewn together to make the quilt linings, or, in lighter summer quilts, for batting. Pearlie remembers quilting after returning from the fields: "When the sun went down, you could take your mule out and go on home and feed your mule, and if it was still

light, why you could sit down and quilt two or three, a few rows."

Piecing and quilting were social activities when Pearlie was young: "In my time, would be a family there and a family there and a family there and we would get together and tear up old clothes, overalls and linings and everything and piece quilt tops and linings.... If I was ready to quilt one, well, four or five women Sunday morning come to my house and put one in. That's the way we quilted, just quilt and laugh and enjoy ourselves."

Pearlie was married for the first time in 1909 to Hayes Shelby, from whom she soon separated. Then she married Wallace Johnson, the father of her son and her only daughter, Sarah Mary Taylor. When Wallace died in 1945, she married Tim Posey; they separated within a few years. During the course of her marriages, Pearlie moved from plantation to plantation in the Mississippi Delta, working in the fields by day, and attending to her family's and her personal needs in the evenings. Pearlie's life was not easy, but she appreciated certain aspects of rural life which she feels have been sacrificed to modernity: "Anything that was done in olden times wasn't going to be so hard because people did what they knew how to do."

When her daughter Sarah Mary Taylor made an appliqué quilt in 1980, Pearlie was intrigued by the new design and eager to learn the appliqué technique: "My baby there started making them and I started trying to do what she did.... I knew how to piece these Nine Patches and these other things, but I didn't know anything about how to do them; do fancy quilts." Pearlie borrowed Sarah Mary's pattern pieces and began making appliqué quilts of her own. Because of her failing eyesight, Pearlie depended upon Sarah Mary to cut out the original patterns. Pearlie Posey preferred small, intricate appliqués that she could arrange in intimate groupings: "I just like mine mixed up.... I'll have a bird sitting over yonder, something else sitting over there, something else sitting over there."

Even when repeating the same designs, Pearlie's placement would vary from block to block. Her composition creates a three-dimensional space out of each block, the figures interacting and moving within their assigned areas. Pearlie's color selection reinforces the subtleties and fineness of her designs. While her colors have the brightness and intensity found in classic African-American and African textiles, she broke up and varied the colors in a very personal manner that visually suggests a light dance. Even the traditional vertical strips, which Pearlie used in most of her quilts, are typically pieced together from many scraps in a rainbow of colors.

"From a little child on I just pieced.... Everywhere I never stopped making quilts." Quilting was an outlet for Pearlie's creative energy, but for her, quilts also had personal, emotional importance. When Pearlie's mother was dying she spent her last days piecing quilt tops for her

infant daughter—it was understood that Pearlie's grandmother would turn these tops into quilts and Pearlie would always have material reminders of her mother's love. With similar sentiments Pearlie made quilts for her own children, explaining: "Then if the Lord take me and leave you...I say you'll have some covers."

See figures 24, 89, 90, 142, 143, 150.

FAITH RINGGOLD
Born 1930, New York City

Faith Ringgold's mother, Willi Posey, moved to New York City from Florida in the 1900s. She became a successful fashion designer and dressmaker in Harlem. Ringgold's father drove a truck. Faith remembers a happy childhood, as the youngest of three children, even though frequently sick from asthma. Her mother told stories and encouraged Faith to tell stories through art. She was also very much influenced and inspired by the Harlem Renaissance.

Ringgold received a B.S. and an M.A. in art from the City College of New York. Then she married and had two children, Michelle Faith Wallace and Barbara Faith Wallace, and divorced and taught art in the New York public schools. In 1962, she married Burdette Ringgold, her current husband. In 1986 the Bernice Steinbaum Gallery began to represent Faith Ringgold's art. Now she is a professor of art at the University of California, San Diego.

Faith Ringgold's story quilts are now well known. She began them as an alternative to stretched canvases, as a soft art that could be easily transported. First she made cloth frames, inspired by Tibetan art, in collaboration with her mother.

"My mother remembers watching her grandmother, Betsy Bingham, boil and bleach flour sacks until they were white as snow, to line the quilts she made. Susie Shannon, Betsy's mother, had taught her to sew quilts. She was a slave and had made quilts for the plantation owners as part of her duties as 'house girl.' Undoubtedly many of the early American quilts with repetitive geometric designs are slave made and African influenced."

In the 1980s Faith Ringgold's interest in sewing coincided with her interest in feminism. The story quilts became a combination of traditional pieced fabrics, a narrative text, painting, stitchery, and sometimes, photoetching. Folk tales are blended with contemporary stories, representing Ringgold's interest in telling stories, not with pictures or symbols alone, but with words.[1] The story quilts are inspired by Ringgold's experiences or those of people she knows. The text and visual image do not always correspond—the text may provide a different viewpoint to the story, independent from the visual imagery. One must examine both to get the full message of these quilts. The narrators are always black women, and sometimes the texts are done in black dialect. Ringgold's well-known quilt, *Tar Beach*, was inspired by happy childhood memories of summer evenings spent on cool rooftops in New York City. *Tar Beach* is one of five works in Ringgold's "Women on a Bridge Series," in which she sets women against bridges in New York and San Francisco.

See figure 156.

ELIZABETH SCOTT
Baltimore, Maryland

Elizabeth Scott grew up in Chester, South Carolina, on the farm where her grandparents lived. She had learned to make quilts as a child in the 1920s, but, like many women, stopped quilting while raising a child and working, only to take up the art again later in life, in her case while in her seventies. Elizabeth Scott openly speaks of the good luck brought by actual rocks tied onto her quilts.[1] Some rocks are even made into bundles and embellished with seeds, beads, and button eyes to make dolls, called "monsters," which will protect the person sleeping under the quilt.[2]

"I wanted to dress it up the way my grandmother used to dress up clothes. She could do anything with a needle.

I remember how she'd take berries and seeds and make buttons of them. Sometimes I make them into monsters who are there to look after you."[3] Another term for these "monsters" might be Vodun dolls.

See figures 157, 158.

JOYCE SCOTT
Baltimore, Maryland
Born 1948

Joyce Scott comes from a long line of quilters, for her mother, Elizabeth Scott, and her grandparents also made quilts. She says, "I believe quilts were diaries for preliterate folks. There were all the family stories in the fables, memories preserved. My mother's quilts are allegorical—she paints with fabric." Joyce and her mother often are featured in joint exhibitions and occasionally teach workshops together.

Joyce Scott is a complex, multifaceted artist whose art includes altar pieces, beadwork, clothing, dolls, performance theater, paper, sculpture, and quilts. Although she has two academic degrees and an abundance of grants and exhibitions, Joyce has not lost her link to folk-art traditions, especially the African idea of protective spirits. Her 1984 *Scott-Caldwell Family Quilt* vividly documents three generations of quilters in her family.

"There are three story panels on the quilt. The top is me in utero, me as a dream. My mother really wanted me, prayed for me, for someone who'd love her unconditionally. The center panel depicts a rite of passage; my mother needling me, prodding me to accomplish something. At home we refer to it as 'jiggin with me.' It's when your mother initiates you, allows you to be an independent woman. My mother came from the fields. She was frustrated by limitations society placed on her. Consequently, in my youth, she prodded me to go further, to get an education, to make something of myself in this world. Picking cotton for her meant picking cotton balls. For me it means picking a good Gucci shirt. That's what she developed for me.

"On either side of me in this frame are the grandparents who have all passed. They're protecting me. They're blowing, chasing an ill wind. They're sending a cool breeze that's a respite, at the same time it's inspiring. I didn't really get to know my grandparents, but I look for what I can get from them this way. These are my familial ancestors, and this is the ethnic hug you get from someone close to you. To the sides of this panel are two eyes. They're 'evil eyes' reflecting back harm, keeping it away.

"This bottom panel is a picture of my nuclear family. It's taken from a photo where my mother and I are sandwiching my father. I've drawn a heart in and around this picture. The heart surrounds us. My parents were separated, and it was my wish to keep the family together that I'm expressing here."[1]

She is most well-known for her masterful and satirical sculptural beadwork that gives visual form to political concepts such as racism, sexism, feminism, and antifeminism. Beads were first used as accents on her quilts, but then beads became her primary art form. Beads appeal to her for many reasons, including their circular symbolism and ethnic history. Joyce has traveled widely, to West Africa, the Americas, Europe, and Asia, allowing all cultures to affect her art. Yoruba beadworking traditions from Nigeria influenced her, as well as Yoruba beadworking in the New World. Her necklaces are spontaneous, with forms that weave in and out of web-like structures.[2] Her 1986 sculpture *Nanny Now, Nigger Later*, was featured in the traveling exhibition, "Next Generation: Southern Black Aesthetic."[3] Her beadwork is as improvisational as her performances. She may start with an idea and then improvise freely, allowing messages and symbols to emerge from the beads.[4]

Recently, Joyce Scott completed a series of quilts on the aftermath of nuclear holocaust, and has written a one-woman show, *Generic Interference, Genetic Engineering*, in which she plays many characters including the last woman on earth.[5] Joyce Scott's arts often draw from an autobiographical dialogue about body language, body type, and self-image. She has toured with actress Kay Lawal in *Thunder Thigh Review*, a constantly evolving series of vignettes about being overweight, black, and female. Her performances and her sculptures are particularly enlivened by her clear sense of the humor of the absurd and the stereotyped—forceful, sarcastic, idiosyncratic.[6] She says of her varied art forms, "They are

fertile ground for each other. It's all the same form of communication, just different languages. It feeds my brain, and one art form clarifies or elicits experimentation with the other. In theater I'm often verbalizing what I want to do visually."

See figures 159, 160.

SARAH MARY TAYLOR
Mississippi
Born August 12, 1916, Andine, Mississippi

Sarah Mary Taylor is Pearlie Posey's only daughter and Pecolia Warner's niece. She has spent most of her life on plantations in the Mississippi Delta. Married for the first time in 1931, Sarah Mary had five more marriages until she was widowed in 1970. She has been a cook, a field hand, and a housekeeper, but now she is retired and lives in a small Mississippi town.

As a child, Sarah Mary learned to quilt by sewing on her mother's quilts. She did not piece and quilt her own quilts until she married and left her mother's house. The first quilt she pieced and quilted by herself was made of blue-jean and overall patches. Many of Sarah Mary's early quilts were pieced in large blocks from the skirts of used dresses; four of these blocks made an ample quilt top. Old flour sacks were sewn together as linings, and Sarah Mary spread other sacks or combed cotton in the center of her quilts as batting. Quilting was not a matter of creativity or relaxation for her; it was a matter of necessity and expe-

diency. Her attitude changed in 1980, when, inspired by the attention her aunt Pecolia Warner received for her quilts, Sarah Mary made the first in a continuing series of appliqué quilts.

Sarah Mary begins her quilts by cutting out paper templates for the appliqués. Sometimes she draws figures free-hand; sometimes she copies pictures she has seen in newspapers, magazines, or catalogs. The diverse designs Sarah Mary employs are an accurate mirror of the different influences on her life—the images she chooses are just as likely to be drawn from American popular culture as from rural Mississippi Delta life. Unlike West African appliqué textiles, Sarah Mary's quilts are not narrative nor do they use standardized pictorial vocabulary; she selects and arranges her designs according to what she finds appealing, amusing, or important. When she has cut cloth figures for a quilt she places them on blocks, similar to but smaller than the blocks she once made from dress skirts. She likes to place one figure centrally in the block, clustering other figures around it if space allows. When she has completed her blocks, Sarah Mary usually sews them together with pieced vertical strips.

Clear, vibrant colors distinguish Sarah Mary Taylor's quilts. She is extremely conscious of her color combinations and very careful in her selection: "I tries to match pieces up like I'd wear clothes....I like to wear colors what's suitable to each other...." Red is her favorite color, but she also likes brilliant hues of blue and green, and for highlights she chooses black and white. Sarah Mary juxtaposes her colors to produce the greatest possible distinctions. She tries to "match" colors, which she defines as bordering one color with another "that brings everything out." The African-American and African preferences for bold, contrasting colors and stunning designs are quite evident in Sarah Mary Taylor's quilts.

Sarah Mary does not, herself, use any of the quilts she makes. They are sold, given away to friends (Sarah Mary has no children), or stored in one of the many closets of her rambling house. For Sarah Mary, quilting is an artistic endeavor: "When I be doing it, be trying to see how pretty I can make it, just how I picture it in my mind." She doesn't quilt compulsively or continually, but if she is inspired with a design idea in the middle of the night, she will get out of bed and draw it. She enjoys the variety of appliqué, and greatly prefers this technique to the traditional geometric piecing style she learned as a young woman. Appliqué quilts offer a flexible format that provides a maximum of freedom for artistic and personal expression. The bold colors and central frontal shapes reflect her straightforwardness, while her appliqué designs and arrangements suggest her ironic humor. She is proud of her work, and pleased by the enthusiasm and awe with which her friends greet her quilts: "They think they're beautiful. Say they don't even have the patience to do it."

Like many contemporary artists Sarah Mary Taylor concentrates on originality in her designs. Excited by her successes, she now approaches each new quilt as a creative challenge: "Every time I piece one I tries to make something different from what I made. I don't want what I been piecing; let me find something different."

See figures 87, 88, 112, 122, 123, 141, 144, 145, 146, 148, 149.

LUCINDA TOOMER
Born February 5, 1890, Steward County, Georgia
Died September, 1983, Columbus, Georgia

Lucinda Hodrick Toomer was the oldest daughter of seven children born to Orange and Sophie Stokes Hodrick. Lucinda grew up on her parents' farm and in 1908 married Jim Toomer, with whom she lived for "sixty-nine years, two months and a few days." The Toomers farmed peanuts and cotton on forty acres in southwestern Georgia. Lucinda remembers a higher quality life on the farm: "We just had a better time than we do now. Because everything was coming, and everything people had, they made."

The importance Lucinda attached to handcrafting is evident in her quilts, each meticulously and lovingly executed. Lucinda began sewing and quilting when she was twelve years old. Her mother would come into the children's room at night and rouse Lucinda to teach her to

quilt. Lucinda recalled: "She would take her thimble and thump me in the head and wake me up and learn me how and I'm so glad she done it. I sure thank her for it and I'm glad she did."

Mother and daughter quilted together until Lucinda married at the age of eighteen; as a wedding gift from her mother Lucinda received the eight quilts she had made at home. Lucinda's quilt production never flagged since she learned the art. When questioned about the great quantity of quilts she produced Lucinda replied: "I didn't make them to use. I just made them 'cause I know how."

It was important to her that she exercise her skills and knowledge. On a typical day Lucinda rose at dawn and after a brief breakfast and some light housekeeping, began to work on her quilts. She preferred to cut pieces in the morning, sorting them in boxes according to shape and color. She would often string similar pieces on a thread to keep them separate from other scraps. Lucinda used scraps from her own sewing to make her quilts, and also purchased bags of scraps from local garment factories. Lucinda sewed in the evening, working until nearly midnight. When she had three or four quilt tops pieced she would buy cotton batting and material for the linings. Lucinda created most of her own quilt patterns, adapting unnamed patterns learned from her mother as well as patterns she saw in books and magazines. She ordered her quilt top designs with strips because "a strip divides so you can see plainer."

She was extremely sensitive to the visual impact of her quilts, and was careful to juxtapose colors in ways that intensify the hues: "I get any color, you know, and I try to match with a different color...to make them work...see, that makes it show up." Red was her favorite color because of its vividness: "I put it where it will show up the pieces...red shows up in a quilt better than anything else...you can see red a long while." This concern with visibility from a distance is clearly related to the communicative function of West African textiles.

Lucinda combined her quilt pieces with great care—each piece is individually distinguishable and simultaneously part of an overall design. She explained: "I like to make them and put different pieces in there to make it show up, what it is...if you know what to make of it and make a change of it, there's something good in it." Just as she varied her pieces, Lucinda would not duplicate the same pattern in successive quilt blocks but chose to take one pattern and manipulate it in various ways. Visual improvisations established Lucinda as an artist in total control of her art form in the same way as thematic musical improvisations indicate a master jazz musician. The emphasis on improvisations is pervasive in African and African-American art forms.

Lucinda had few people with whom to share her quilts (two children died in infancy); she used very few herself. She recognized that her production far surpassed her own

needs, and admitted: "I never use them. I didn't make them to use...I just do it. I get joy out of it." Lucinda would not make quilts for anyone else, and kept as many of her quilts as she could because "I just feel they're worth something." The worth Lucinda spoke of is not so much monetary, but emotional and psychological. Lucinda regarded the quilts as extensions of herself; like children, Lucinda's quilts served as a comfort in old age:

"I just sit down here and sew. There's nobody here but me. I got nobody to talk to if I got something like that on my mind....This is company to me....I say, well, Lord, I got nothing to do and that's my company sitting down here that I'd be doing it."

See figures 2, 53, 54, 55, 58, 59, 118.

PECOLIA WARNER
Born March 9, 1901, Rose Hill, Mississippi
Died March 25, 1983, Yazoo City, Mississippi

Pecolia Jackson Warner was the ninth child in a family of eleven children. Her mother, Katie Brant, had five children by her first husband, and six children with her second, William Jackson. The family lived and worked on a plantation in the Mississippi Delta. Pecolia's mother, a college graduate, had been a schoolteacher before she married. Determined that her children be educated, she taught them at home when they were small, and in the evenings when they were old enough to spend days working in the fields. In addition, she trained Pecolia in the skills that Pecolia used to support herself as a cook, housekeeper, nurse's aide, and professional quilter. Pecolia learned to make quilts by watching her mother: "I just be sitting side of her. I'd get the scissors and cut me out something, and be doing it just like I see her doing. And she bought me a little old thimble and a needle and everything. That's the way I learned how to sew. From then on I'd be sewing and piecing and if I didn't do it right she'd pull it out and make me do it again." The first quilt top Pecolia pieced by herself was made of "strings," small rectangular scraps sewn into strips: "I got little strings like your fingers and commenced to sewing them together. As I got them long enough for the bed, I pieced up sixteen of them, and my mother gave me some old stuff to strip it with. And when I got me a strip, then she quilted it out for me and she named it Spider Leg." Pecolia's mother used hanging frames for quilting, but Pecolia always preferred putting her frames on sawhorses; she also quilted on her bed, and even used her dining-room table as a quilting surface.

Pecolia first married in 1921. She had three more marriages until 1972, when she married Sam Warner. In 1939 she moved to New Orleans, where she lived for twenty-one years. In 1950 she migrated to Chicago, finally returning to her native Mississippi in 1968. She never had children. For most of her life, Pecolia cooked and cleaned for other people, but always found time to make quilts: "From the time I learned how, I lived in big cities, I made quilts, and I sold them. They wasn't paying much, but I sold them, to keep myself company, keep my mind occupied....I made quilts and I worked. I stayed on the premises in the day because of the kids and cooking. The nights, when I got off, I'd go into my room, get my quilt pattern and things, go to sewing. When the baby's asleep and I'm done cooking, I'm still sewing. To keep my mind occupied; I could always find something to do." The hallmark of Pecolia's quilting style is her technical and artistic mastery. Pecolia's quilts radiate her self-confidence. There was nothing haphazard about her handiwork; she was careful and sure in her piecing: "When you're cutting little bitty pieces, you've got to study how to put them together, and you want it to hit just right."

Pecolia never reproduced exactly a pattern seen in another quilt or in pattern books, or even the patterns learned from her mother. Every pattern Pecolia employed she modified, making each one wholly her own. Often she dreamed of new patterns, or created one drawing upon her experiences: "I learned to piece up a Bird Trap, by the way my brother used to make them out of wood. I'd get me some material and cut it out like he had it built out of wood." Pecolia used color to personalize the most common patterns. She was very particular about her colors and used nearly a hundred different hues in her

finest quilts. If she was making a quilt top and could not find a satisfactory color among her scraps, she would purchase material specifically for certain pieces. She placed colors with a concern for contrast and movement, but never allowed her complex color arrangements to overwhelm a pattern. Instead, Pecolia's colors added another dimension to her quilts—while they reinforced her chosen pattern, simultaneously the interplay of lights and darks created an independent optical effect.

Pecolia acknowledged that making quilts is hard work, but this did not discourage her. She sold some of her quilts, but also gave many away: "I don't necessarily altogether piece them for myself. I like to help people with them…just giving them for the 'remember me.'" Piecing and quilting occupied much of Pecolia's free time; she enjoyed it because "that keeps me from holding my hands…I like to be doing something, stay in practice." The most important motivation for Pecolia's quilting was the belief that through her art she fulfilled her worldly purpose:

"It's a gift from God to be able to do this because if it weren't for Him I couldn't do it. I wouldn't have the knowledge to do it.…I worked that to grow up in me, of making quilts. That was a gift, that's my talent. Making quilts, that's my calling. And since I learned when I was young I haven't forgotten it."

See figures 7, 26, 31, 32, 39, 61, 114, 115.

YVONNE WELLS
Tuscaloosa, Alabama

Yvonne Wells is a schoolteacher from Tuscaloosa, Alabama. She began to make quilts about 1979, without any training and only a limited exposure to quilting in her childhood. She says, "I started quilting in 1979 after making a small wrap to be used by the fireplace. I had seen my mother quilt but did not help in making them. I taught myself and have had no formal training in quilt-making. I consider myself a quilt artist and take pride in making big, bold, primitive, and unusual quilts."

Robert Cargo notes that the colors, designs, techniques, and the materials used reflect Yvonne Wells's independent spirit and her lively imagination. Her appliqué quilts display large, bold patterns, frequently of her own creation, unusual color combinations, and occasionally manufactured elements, such as socks, lace, upholstery materials, etc.[1]

Fran Dorsey writes, "Her quilts are receiving growing recognition,[2] but this has not affected her drive to satisfy herself first, rather than the public. The quilts are dense in meaning, and their visual impact is deliberately enhanced by the use of naïve figures and strong color."[3]

Yvonne Wells says, "You can always recognize the traditional quilters who come by and see my quilts. They sort of cringe, they fold their arms in front of them as if to protect themselves from the cold. When they come up to my work they think to themselves, 'God, what has happened here.'"[4] She is strongly influenced by Christian symbolism and her appliquéd quilts often depict biblical themes, such as the Crucifixion.[5] The little triangles included in her recent quilts as a personal trademark represent the Trinity, but are referred to by Yvonne as "my little friends." The color purple symbolizes to her God's presence. Her husband, children, and grandchildren are very appreciative and supportive of her art.

See figures 91, 92.

19

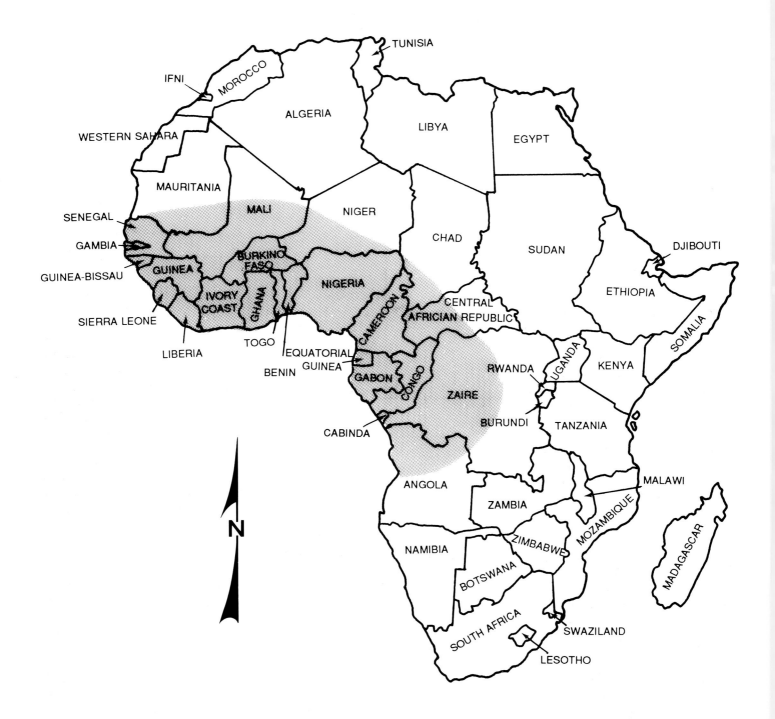

CONTEMPORARY AFRICA

3. Contemporary Africa. The shaded area shows those African countries whose peoples had the greatest influence on African-American cultures in the New World.

Introduction

Some African-American quilts are the visual equivalent of blues, jazz, or gospel, rich with color and symbolism. Characterized by strips, bright colors, large designs, asymmetry, multiple patterns, improvisations, and symbolic forms, these African-American quilts have their roots in African textile techniques and cultural traditions.[1]

The antecedents of contemporary African textiles and African-American quilts were developed in Africa as far back as two thousand years ago, when cotton was domesticated along the Niger River in Mali, and used for fishnets and woven cloth.[2] The actual links between African and African-American textile traditions can be traced to the years between 1650 and 1850, when Africans were brought to Latin America, the Caribbean, and the United States. African influence on the history of music, dance, and speech in the New World has long been documented,[3] but African influence on American folk art such as quiltmaking is less well known.[4] Yet it is possible to trace African textile techniques, aesthetic traditions, and religious symbols that were adapted by African-American textile innovators to the needs and resources of a new world.

Four civilizations in West and Central Africa (fig. 3) had profound influences on African-American folk art: the Mande-speaking peoples (in the modern countries of Guinea, Mali, Senegal, and Burkino Faso); the Yoruba and Fon peoples (in The Republic of Benin and Nigeria); the Ejagham peoples (in Nigeria and Cameroons); and the Kongo and Kongo-influenced peoples (in Zaire and Angola).[5]

African-American quilts are unique, resulting from mixtures of various African, Native American, and European traditions that took place as a result of trading in Brazil, Surinam, Haiti, Cuba; other Caribbean islands, Mexico, and the southern United States (fig. 4).

Although men had traditionally been the primary textile artists in Africa, American plantation owners adhered to the European system of labor division. Thus African women became the principal weavers, seamstresses, and quilters in southern society. African women produced utilitarian and decorative quilts for both black (fig. 5) and white households. Many of their quilts were done in the traditional Anglo-American styles. However, those quilts made for personal, often utilitarian, uses by African-Americans were designed and stitched with African traditions in mind. Thus African-American women preserved many African textile traditions and passed them on from generation to generation over several hundred years. Because improvisation is basic to many African aesthetic traditions, this heritage is not static. Each generation, indeed each quilter, is free to borrow from other traditions and add elements from his or her own cultural history. Contemporary African-American quilters are generally unaware of the continuities between African textiles and their quilt designs, but the design and symbolic similarities are so striking as to prompt some historical explanation.[6]

Like Anglo-American quilt tops, African-American quilt tops are made either by sewing pieces of cloth together (piecing), or by sewing cut-out shapes onto a larger fabric (appliqué). Quilts tops are stitched to an inner padding and a bottom cloth by the quilting technique. Quilting is seen in ancient Egyptian robes,[7] in nineteenth- and twentieth-century cloth armor made to protect horses and cavalrymen,[8] and in protective charms of cloth and leather. Piecing can be traced back to an Egyptian canopy quilt made from squares of dyed gazelle leather and dating to 980 B.C.[9] Piecing was also known in eighth-century India, and in Chinese the term, "po-na i" means "something made of a hundred patches."[10]

Similar designs in African quilted textiles (fig. 6) and African-American quilts (fig. 7) might be coincidental, due to the technical process of piecing that reduces cloth to geometric shapes—squares and triangles[11] (fig. 8). All these techniques—piecing, appliqué, and quilting—were known in Africa, Europe, Asia, and the United States; yet some African-American quilts are profoundly different from European or Anglo-American quilts. The difference lies in historically dissimilar aesthetic principles, with both technical and religious dimensions.

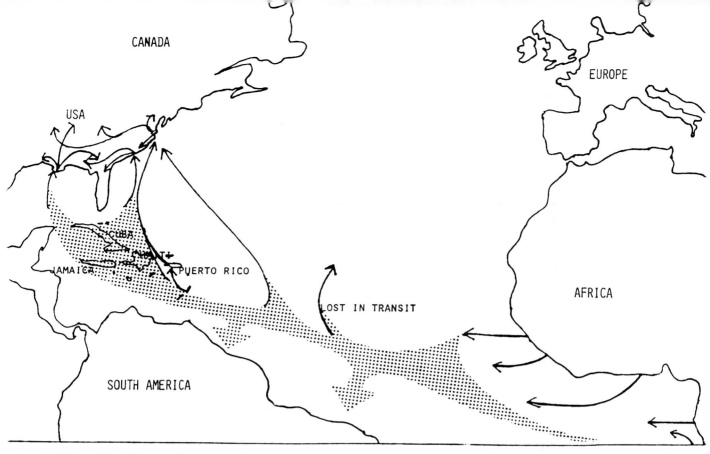

4. Map of Caribbean trade routes. African-American arts are unique, resulting from creolizations of various African, Native American, and European traditions that took place as a result of trading in Brazil, Surinam, Haiti, Cuba, other Caribbean islands, Mexico, and the southern United States.

5. Susie Ponds's bedroom, 1979. Susie Ponds made this quilt to brighten up a room in her log cabin in Waverly, Alabama. Photograph by Maude Wahlman.

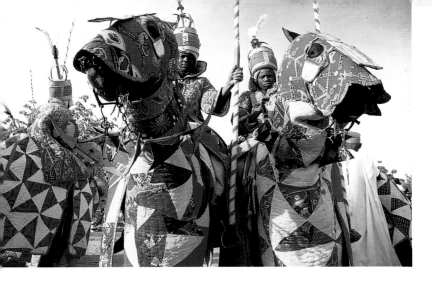

6. Quilted horse armor, Niamey, Niger, 1971. Hausa riders and horses taking part in an Independence Day celebration. Here we see a patchwork pattern that is identical to the American patchwork design called Box. Eliot Elisofon photograph. (National Museum of African Art, Smithsonian Institution, Washington, D.C.)

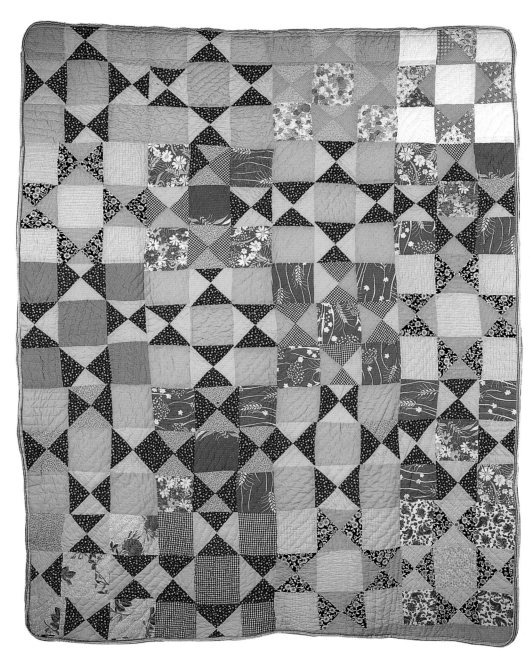

7. Bow Tie or Box quilt by Pecolia Warner, Yazoo City, Mississippi, 1980. 83″ x 65″. The Box pattern is also seen on West African cloth armor for horses (fig. 6). There is probably no connection between the African and African-American use of the same design. The Box pattern in America is a result of the coincidental arranging of geometric shapes of cloth. Collected by Maude Wahlman. (Private collection)

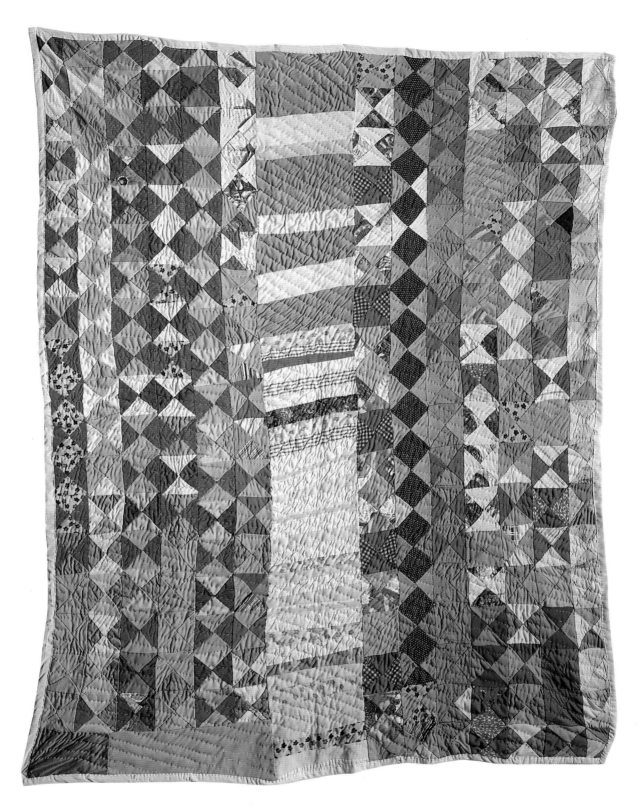

8. Strip and Bow Tie Variation quilt by Dennis Jones (1898–1988), Vienna, Alabama, 1975. 77½″ x 59½″. It is surprising that we do not see more quilts by male quilters in the United States, for narrow-loom weaving was done in West Africa by men working in guilds. Here is one example by a man obviously familiar with West African traditions and aesthetic preferences. (Museum of American Folk Art, New York; Gift of Helen and Robert Cargo) 1991 .19 .1

CHAPTER 1:
Some Aesthetic Traditions

The use of strips is a chief construction technique, a dominant design element, and a symbolic form in West African, Caribbean, and African-American textiles. Beginning in the eleventh century (fig. 9), most cloth in West Africa has been constructed from strips woven on small portable men's looms.[1] Probably invented by Mande peoples, strip-weaving technology (fig. 10) spread via Mande Dyula traders throughout West Africa.[2]

These long, narrow strips, once used as a form of currency, are woven plain or with patterns. Some strips are lightly tacked together, so as to allow air through while hung up as screens. The Tuareg use such cloths as tent hangings (fig. 11). Woven strips are often sewn together (fig. 12) into larger fabrics to be worn as clothing or displayed as wall hangings and banners. This technical process of sewing long woven strips together to make larger fabrics usually worn as clothing, as in a seventeenth-century coat,[3] is so old in West Africa that it has become a tradition, and has moved into the realm of aesthetic preference.

Blue-and-white designs, as in the earliest cloths, are still made (fig. 13) with domestic cotton dyed blue from a native indigo plant. Later, more colorful fabrics were made by unraveling European cloth and reweaving the bright colors African-style.[4] *Nadsuaso* cloth, made by the Asante weavers in Ghana, is the best known of the colorful West African textiles (fig. 14). It was once made from silk, but has been made with rayon since about 1947.[5]

Strips were preferred in many African textiles whether they were woven, tie-dyed[6] (figs. 15, 16), starch-resist-dyed (fig. 17), or wax-resist-dyed (fig. 18). Cloth strips were a portable art that permitted flexible designs. Strips were such a strong tradition that they became an essential part of ceremonial costumes. For example, the Yoruba *Egungun* society, in Nigeria, exists to honor ancestors, and commissions festival costumes (fig. 19) that are worn by young men who personify the spirit of an ancestor.[7]

Patchwork

Sewing strips together to form a larger textile is a form of patchwork. Many other examples of patchwork occur in the history of African textiles. Notable examples include cotton *Jibbeh*,[8] Fante Asafo flags,[9] *Egungun* costumes of the Yoruba people,[10] Cameroon costumes,[11] and patched-together barkcloth made primarily by the Kuba[12] and the Pygmies in central Africa. Mbuti artists also paint barkcloth (fig. 20) with designs that resemble strips and patchwork.[13]

African Textiles in the New World

A preference for strip textiles continued in the New World. In Brazil the Yoruba *Egungun* costume reappears, complete with flying strips.[14] A Brazilian doll (fig. 21) wears the fancy costume of a Yoruba priestess; part of that costume is a single strip of cloth worn around the neck, chosen because it resembles a single strip of West African handwoven cloth. The small strip features bright horizontal bands of color, as it would in West Africa.[15]

In Surinam, on the north coast of South America, nineteenth-century black plantation women on the coast made patchwork textiles, called *mamio*, which means "different pieces of cloth sewn together." Black women continued to use African textile ideas when they ran away from plantations to Maroon societies in the Surinam rain forest. An 1823 illustration[16] shows a Mande-like loincloth made from three strips of cotton, two patterned and the center one plain, as in nineteenth-century Asante cloth from Ghana. Both Djuka and Saramaka women continue to cut strips from imported commercial cloth, and to save the strips until they want to make an African-style cape (fig. 22) called *Aseésènte* for their men.[17] Then they sew the strips together, the aesthetic being determined by conversations among various women.[18]

In Haiti, Africans made strip clothing—shirts, called *Mayo*, in red and white, or red, white, and blue, worn for protection against evil by those who believe in *Vodun*.[19]

African-American Strip Textiles

While men did most of the weaving in Africa, in all probability it was women who most often created textiles in the New World, and it was women who maintained the strip aesthetic. They combined remembered traditions with Euro-American traditions for making textiles, to create unique creolized art forms: woven blankets, African-American quilts, and appliquéd funerary umbrellas. Their combined ideas would have been passed down from one generation to the next, most probably without verbal explanation for the meanings behind the aesthetic preferences.

African-American textiles often emphasize strips. West African women who came to the United States would have remembered West African cloth made from narrow strips sewn together. Strip textile traditions probably came to the United States via Charleston, South Carolina, and Jamestown, Virginia, in the sixteenth and seventeenth centuries, when West Africans were in demand due to their knowledge of rice cultivation.[20] A rare painting from

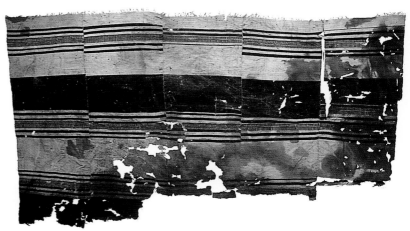

9. Fragment of woven cotton cloth, Sanga Region, Mali, West Africa, 11th to 12th century. From a cave burial in the high cliffs of Bandiagara. See Karl-Ferdinand Schaedler, *Weaving in Africa*. Photograph by G. Jansen. Courtesy Institute voor Antropobiologie, Rijks-universiteit Utrecht.

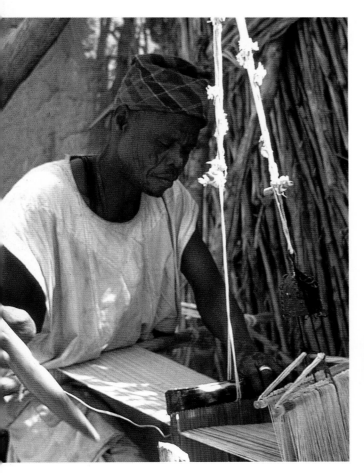

10. Hausa man weaving on a narrow loom, Funtua village, Nigeria, 1972. Men weave in groups on narrow portable looms that can be moved to find the best shade and the best conversation.

11. Tuareg tent cloth (detail), Peul people, Niger, 1973. 96″ x 60″. A detail of the center strips showing gaps in the sewing to let air flow through. An example of asymmetrical arrangement of fourteen strips. Collected by Maude Wahlman. (Private collection)

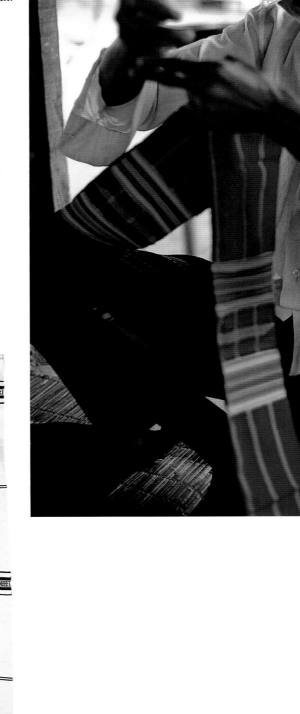

12. Asante man sewing strips together, Accra, Ghana, 1973. Photograph by James Wahlman.

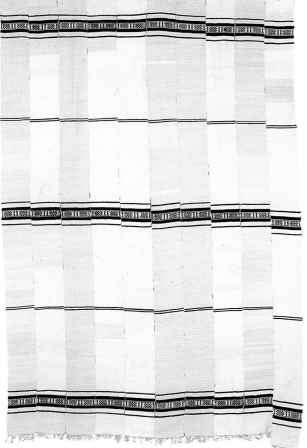

13. Woven cotton blanket, Mande people, Senegal, West Africa, 1973. 88″ x 56″. Made from ten strips sewn together, this blue and white textile recreates the earliest patterned cloth woven in West Africa. Collected by Maude and James Wahlman. (Private collection)

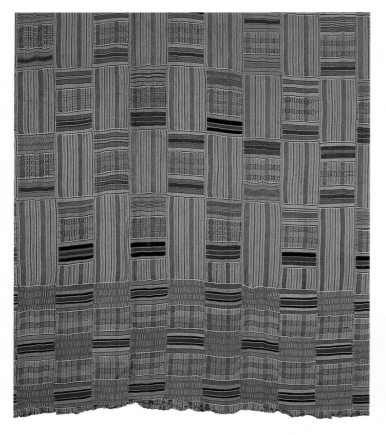

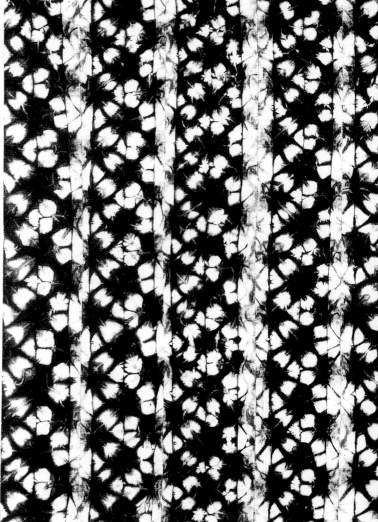

14. Detail of a yellow and turquoise rayon *nasadua* wrap, Asante people, Bonwire, Ghana, 20th century. This is an excellent example of men's weave done with imported threads. The use of European colored thread dates back to the 17th century when the Asante unraveled imported European cloth for the colored threads that were then rewoven in Asante style. The patterns are done on a background called *mamponhemmaa*, meaning "Queen Mother of Mampon." See Karl-Ferdinand Schaedler, *Weaving in Africa*. (Tribal Spirit Collections, Huntington, Massachusetts)

15. Tie-dye on sixteen strips, Dioula People, Senegal, West Africa, 1953. 66″ x 41¾″. Each strip was tie-dyed before being sewn together. (Museum fur Volkerkunde, Basel, Switzerland)

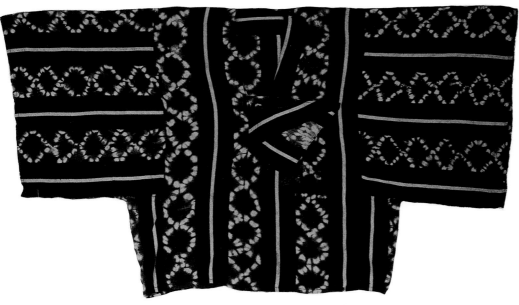

16. Tie-dye strip shirt, Mende dyer, Sierra Leone, 1975. 31″ x 54″. The tie-dyed strips alternate with plain strips in the construction of this shirt. Collected by Maude and James Wahlman. (Private collection)

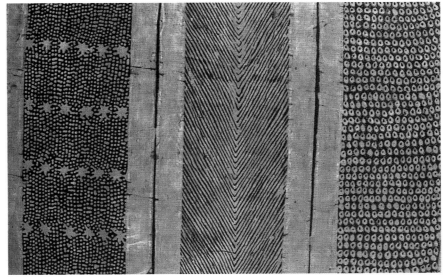

17. Starch-resist *adire* (detail), Yoruba people, Nigeria, 1973. *Adire* is made by resisting indigo-blue dye by sewing patterns tightly or by painting cloth with cassava starch. Lately, stencils have been invented to speed up the process. Yoruba mythology attributes the origins of *adire* to a goddess, Yemoja, whose color is blue. The starch-resist *adire* is divided into squares decorated with a variety of patterns. Collected by Maude and James Wahlman. (Private collection)

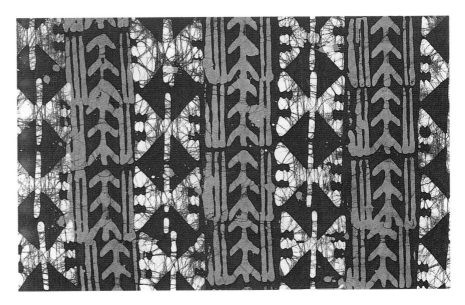

18. Wax resist (detail) by Mrs. Abator Williams, Sierra Leone, 1970. This textile was created by a woman dyer who stamped plain white cloth with a carved wooden stamp that had been dipped in wax. The cloth was then immersed in a brown kola-nut dye, dried, and stamped on top of the brown with another carved wooden stamp covered with wax. Then the cloth was submerged in indigo-blue dye, rinsed, and allowed to dry. The designs are arranged in strips. Collected by Maude and James Wahlman. (Private collection)

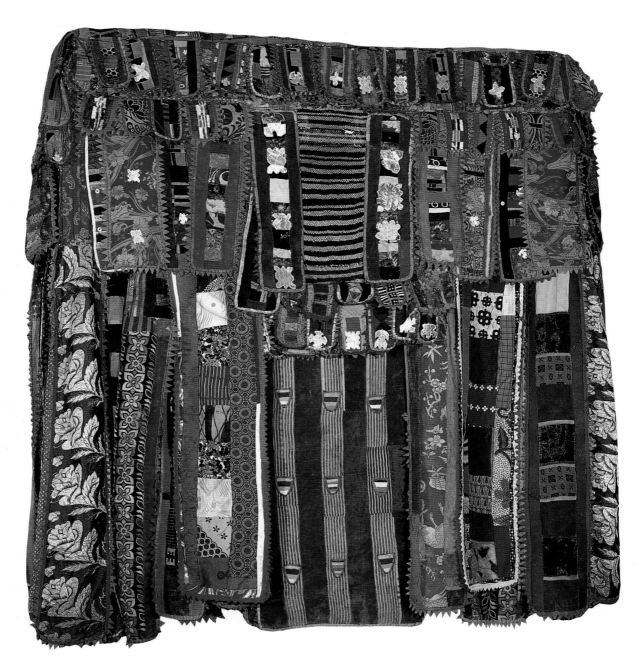

19. *Egungun* dance costume, Yoruba people, Nigeria, 20th century. 61″ x 70″. *Egungun* costumes are made to honor the spirits of ancestors. As the devotee dances, the strips fly out, thus enlarging the spiritual space and calling the spirit back to the present. (Birmingham Museum of Art, Birmingham, Alabama; Gift of Sol and Josephine Levitt)

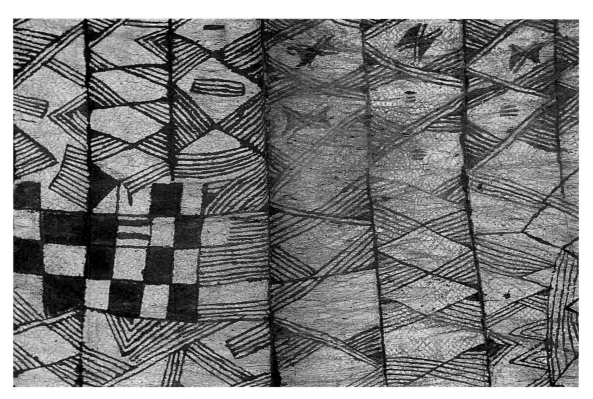

20. Painted barkcloth, Mbuti Pygmies, Zaire, 1979. 38″ x 25″. Note the experimentation with a checkered design. Photograph by Robert Farris Thompson.

21. *Oshun* doll, Yoruba people, Brazil, 1940s. H. 16″. The doll represents a Yoruba priestess, and the cloth scarf, an essential part of the costume, closely resembles a West Africa narrow-woven strip. Given by Melville and Frances Herskovits to their daughter Jean Herskovits. (Private collection)

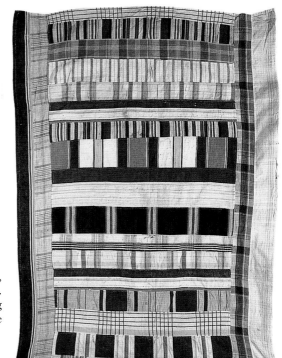

22. Strip cape, Saramaka people, Surinam, South America, 1930s. 36″ x 32″. This cape was made with vertical strips. (Frances and Melville Herskovits Collection at the Schomburg Center for Research on Black Culture, New York Public Library)

31

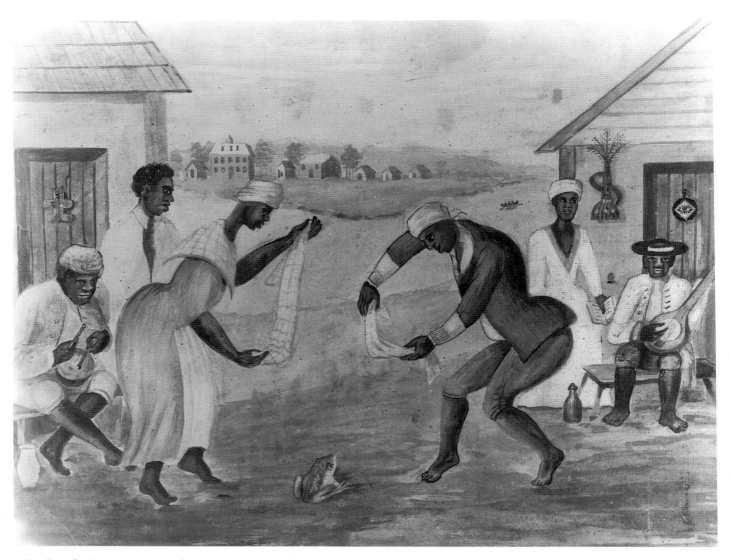

23. *Couple Dancing*, artist unknown, American, 19th century. Notice the two strips of white cloth. (Mint Museum, Charlotte, North Carolina)

North Carolina (fig. 23) shows a couple dancing, while holding narrow strips of cloth.[21]

Strip clothing was also made in the United States, as may be seen in a 1930s photograph by Eudora Welty of a young girl in a dress made from strips of light and dark stripped material.[22] The strips are sewn together in both vertical and horizontal directions. Strips also dominate many quilt patterns. Some quilters in rural Alabama and Mississippi say that the first quilt-top pattern taught to young girls is called Lazy Gal. An example (fig. 24), made for me in 1983 by Pearlie Posey, consists of plain strips sewn to each other in a vertical fashion. Some strip quilts made from blue denim scraps are called "blue-jean quilts" by African Americans and "britchy quilts" by "white

folks." An excellent example was made by Catherine Somerville (fig. 25).

Many strip quilts are made from the smallest usable rectangles of cloth, called "strings." One old strip-pattern quilt, made from "strings" of cloth, comparable to woven bands of color, is called Spider Leg (fig. 26) by Pecolia Warner. Pecolia Warner called its blocked version Twin Sisters or Spider Web.

Pecolia Warner learned to make quilts by watching her mother. "I just be sitting side of her. I'd get the scissors and cut me out something, and be doing it just like I see her doing. And she bought me a little old thimble and a needle and everything. That's the way I learned how to sew. From then on I'd be sewing and piecing and if I didn't do

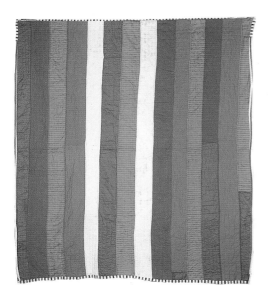

24. Lazy Gal quilt by Pearlie Posey, Yazoo City, Mississippi, 1983. 82″ x 71″. Pearlie Posey says this is one of the first patterns taught to young African-American girls when they are learning how to make quilts. The pattern is derived directly from West African textiles made by sewing together narrow strips of woven cloth. Collected by Maude Wahlman. (Private collection)

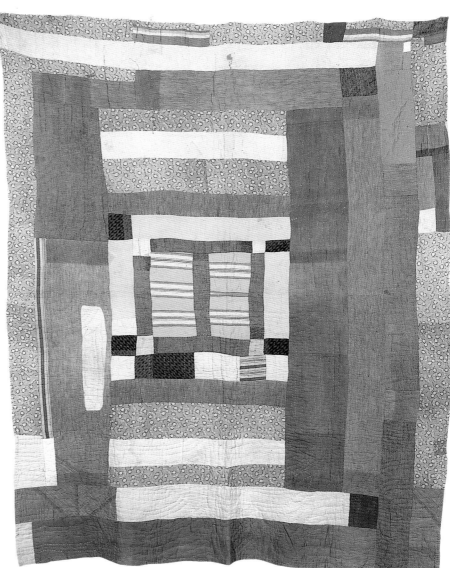

25. Strip quilt by Catherine Somerville, Alabama, 1940. 74″ x 58″. Made from denim scraps, this is a classic example of a utilitarian quilt made with West African aesthetic traditions in mind. (Robert Cargo Folk Art Gallery, Tuscaloosa, Alabama)

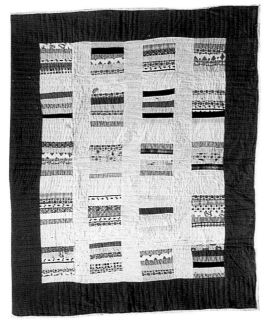

26. Spider Leg quilt by Pecolia Warner, Yazoo City, Mississippi. 75″ x 70″. Many strip quilts are made from the smallest usable rectangles of cloth, called "strings." One old strip-pattern quilt, made from "strings" of cloth, comparable to woven bands of color, is called Spider Leg by Pecolia Warner. Collected by William Ferris. (Center for Southern Folklore, Memphis, Tennessee)

33

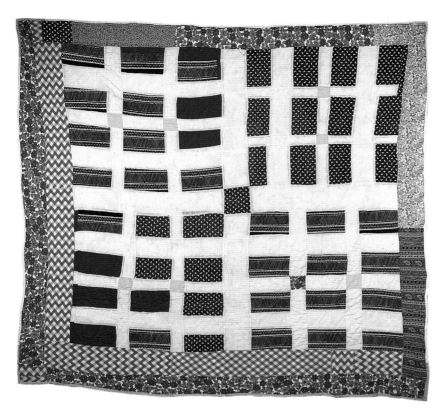

27. Blue and white Strip quilt by Martha Jane Pettway, Boykin, Alabama, 1979. 80″ x 71″. Exhibited in "Ten Afro-American Quilters." Although she has never been out of Alabama, Martha Jane Pettway has reproduced the color and style of the earliest West African textiles of around A.D. 1000, which were made of natural white cotton with designs created from indigo-blue dye extracted from leaves of plants that grow wild in West Africa. Is this near replication of the oldest patterned cloth coincidental, or does it indicate cultural textile traditions that are maintained in the New World? Collected by Maude Wahlman. (Private collection)

28. Strip quilt by Martha Jane Pettway, Boykin, Alabama, 1981. 74″ x 72″. Once again this is an example of "strings" of color that have been pieced together into vertical strips, then sewn together in a West African style. Collected by Maude Wahlman. (Private collection)

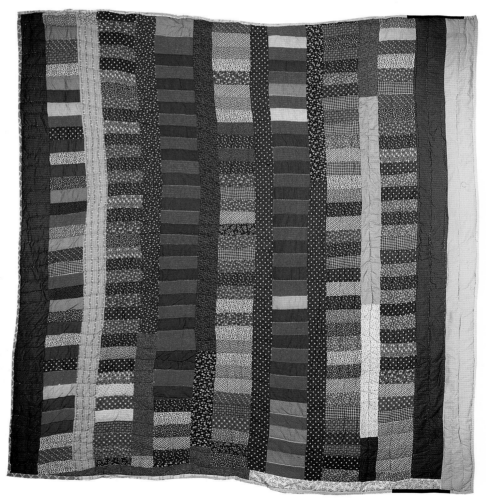

it right she'd pull it out and make me do it again." The first quilt top Pecolia pieced by herself was made of "strings," the small rectangular scraps sewn into strips: "I got little strings like your fingers and commenced to sewing them together. As I got them long enough for the bed, I pieced up sixteen of them, and my mother gave me some old stuff to strip it with. And when I got me a strip, then she quilted it out for me and she named it Spider Leg."

Many African-American quilters, like Martha Jane Pettway and Mary Maxtion, speak of "strip quilts," "to strip a quilt," and of how strips bring out the design. Whether made from single pieces or small scraps of cloth, the strips are apparent in most quilt designs (figs. 27, 28, 29, 30, 31, 32). Strips and strings are sometimes used in Anglo-American quilts, but as one of many geometric patterns. In West African textiles, and in African-American quilts, strips are a dominant design element as well as a chief construction technique.[23] Nora Ezell says,

I finished a quilt of strings and patches this evening. I like to do them because I can use all the little and big pieces. I hardly ever buy material. I have a dear friend who may buy a hundred dollars worth of material to make a quilt. That's not what quilting is all about. Scrap quilts are the prettiest quilts, more so than the ones where people try to match all the pieces up.[24]

Large Shapes, Strong Colors

Large shapes and strong contrasting colors,[25] such as the indigo blue-and-white found in early and contemporary West African cloth (see figs. 13, 44) ensure that a person can recognize the pattern in a cloth from a distance and in strong sunlight. It can be important to recognize patterns from a distance if one needs to give a proper greeting to someone. Important people wear cloth with complex patterns and a great deal of color. Because colors are prestigious in cloth, Africans eventually imported European cloth so as to unravel it and reweave the colored threads into their own bold cloth.[26] African-American women in Surinam value strong colors in their pieced textiles. They say that the colors should "shine" or "burn," and that the color of one piece should "lift up" the one next to it—that is, it should provide strong contrast.[27]

Contemporary African-American quilters like Jewell Allen (fig. 33), Mozell Benson, Alean Pearson, Nora Ezell, and Leola Pettway use bold colors and large designs (figs. 34, 35, 36, 37, 38, 39, 40, 41, 42, 43, 44) as part of their textile aesthetic, perhaps due to memories their ancestors would have had of the communicative function of African fabrics. Memories of aesthetic preferences outlive memories of African functions. A Mississippi quilter, Pecolia Warner, speaks of colors that must "hit" each other right, and of "whooping" together two contrasting colors.[28] A whoop is an African-American yodel, as in Pygmy music.[29]

Plummer T Pettway is very careful when combining her pieces, cautioning that "you have to think about the next color."[30] Nora Ezell says, "A lot of people have asked me about my colors. I don't care about color combinations. I do what looks good, but I keep the pattern in mind. I never saw a black flower so I won't put one in a quilt. I don't know which colors blend or fight. As long as it suits me, it's okay."[31]

Lucinda Toomer was extremely sensitive to the visual impact of her quilts and was careful to juxtapose colors in ways that intensify the hues: "I get any color, you know, and I try to match with a different color...to make them work...see, that makes it show up." Red was her favorite color because of its vividness: "I put it where it will show up the pieces...red shows up in a quilt better than anything else....You can see red a long while."

Small stitches are not always important, especially for utilitarian quilts. Bright colors and large designs are more important, since they can be seen from a distance (see fig. 53).[32] Quilts are cleaned semiannually and hung on clotheslines to dry, advertising a quilter's skill to all who drive by.

Asymmetry

In West Africa, when woven strips with patterns are sewn together to make a larger fabric, the resulting cloth may have asymmetrical and unpredictable designs (fig. 45). A sixteenth-century bronze figure shows a Nigerian priest wearing a strip-woven cloth with asymmetrical designs.[33] "Offbeat" patterns, as Robert Farris Thompson[34] calls them, are one option in West and Central African fabrics. When strips are sewn together, the colored or patterned weft blocks are staggered in relation to those in other strips. Roy Sieber has noted that "the careful matching of the ends of the cloth dispels the impression of an uncalculated overall design."[35]

Women's Weave

Women also weave, but on wide stationary looms in their homes where they cook and care for children.[36] "Women's weave" features wide panels with vertical designs (fig. 46) that may look, from a distance, like the strips of the older "men's weave." While "men's weave" is abundant and sold commercially, "women's weave" is more for personal use.

African wide-loom weaving frequently features asymmetrical alignments (fig. 47). Wide-loom weaving was also once done by black women in the United States, the same women who made quilts and probably transmitted and preserved African textile traditions. Luiza Combs was born in Guinea (c. 1853), West Africa, but came at about age ten to Tennessee, where she wove textiles and made quilts. One example of her wide-loom weaving survives (fig. 48). Made in 1890 with bright colors and horizontal stripes, it was woven in two panels that were stitched together in an asymmetrical style similar to

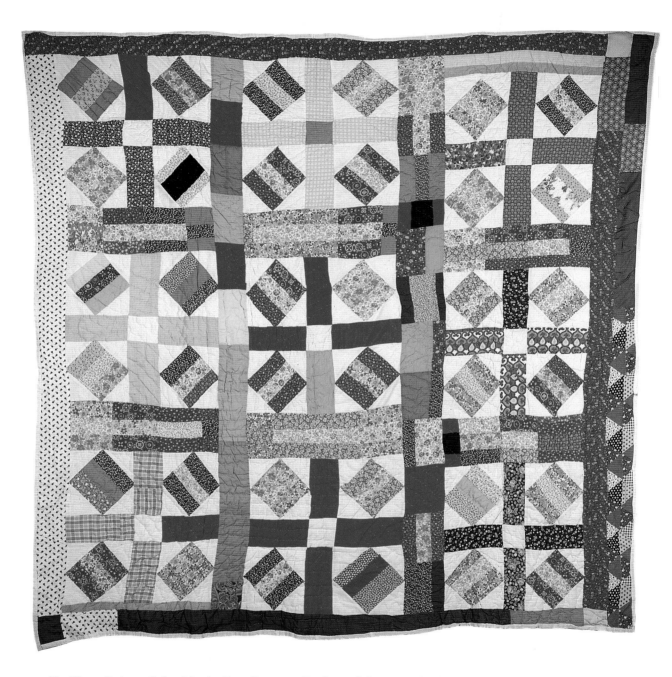

29. Three-Strip quilt by Martha Jane Pettway, Boykin, Alabama, 1979. 76″ x 71″. Exhibited in "Ten Afro-American Quilters." Another example of how African-American quilters manipulate common elements, in this case, three "strings" of cloth, to create unique designs. This quilt is made from scraps bought from the Martin Luther King Freedom Quilting Bee. Collected by Maude Wahlman. (Private collection)

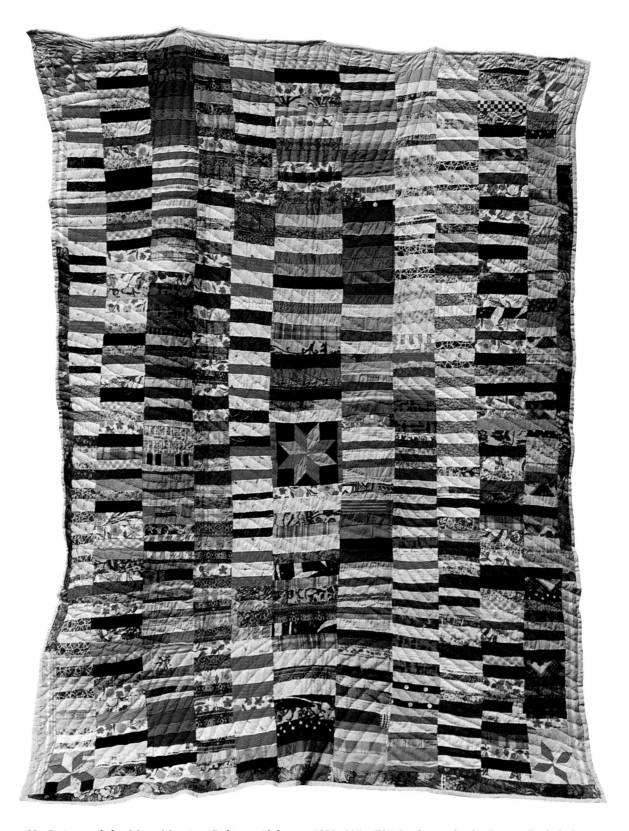

30. String quilt by Mary Maxtion, Boligee, Alabama, 1989. 96″ x 70″. In this quilt, the "strings" of cloth are equivalent to woven blocks of color in West African men's weave.

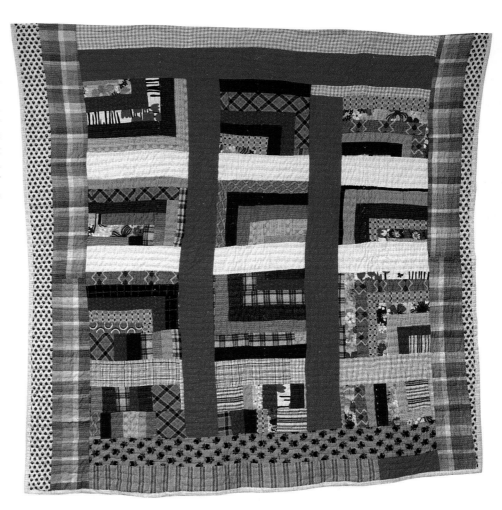

31. Cattle Guard quilt by Pecolia Warner, Yazoo City, Mississippi. 65″ x 65″. This strip quilt, with big red vertical bars that can be seen clearly from a distance, also demonstrates the aesthetic principle of bright colors and large designs. Collected by William Ferris. (Center for Southern Folklore, Memphis, Tennessee)

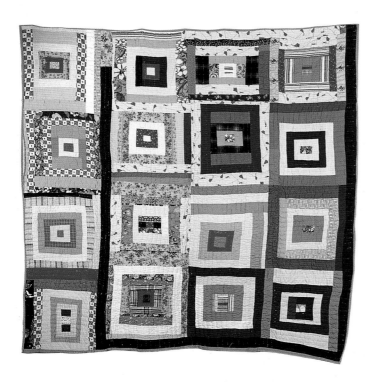

32. Log Cabin Variation quilt by Pecolia Warner, Yazoo City, Mississippi, 1982. 81″ x 81″. Strips can also be turned in many angles to create a variety of patterns. Here, Pecolia Warner created a Log Cabin design from strings of cloth. (Museum of American Folk Art, New York; Gift of Maude and James Wahlman) 1991 .32 .3

33. Jewell Allen, Tennessee, 1983. Jewel Allen is one of a few African-American men who make quilts. Photograph by Ray Allen.

34. Log Cabin quilt by Jewell Allen, Tennessee. Few African-American male quilters are known, but they do exist. Jewell Allen makes dramatic quilts like this large Log Cabin. Photograph by Ray Allen.

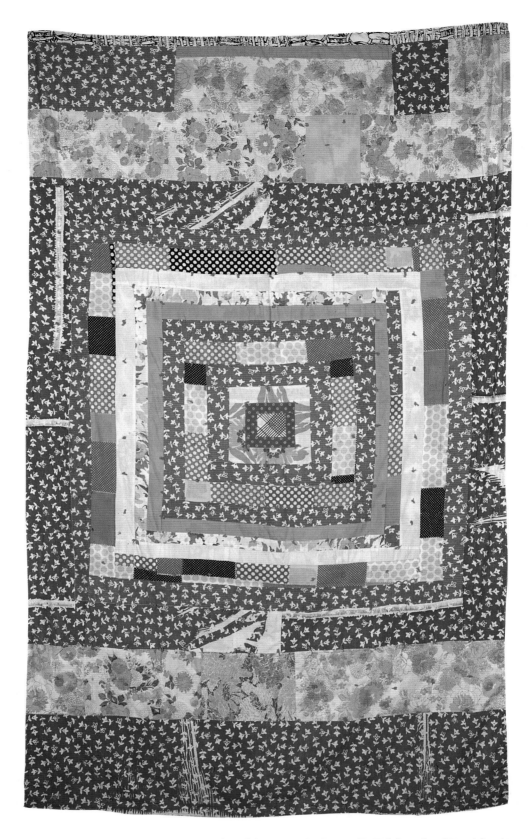

35. Log Cabin quilt by Mozell Benson, Waverly, Alabama, 1979. 84″ x 48″. Exhibited in "Ten Afro-American Quilters." Featuring strips, this quilt is an excellent example of the African-American textile aesthetic that emphasizes bright colors and large designs. Collected by Maude Wahlman. (Private collection)

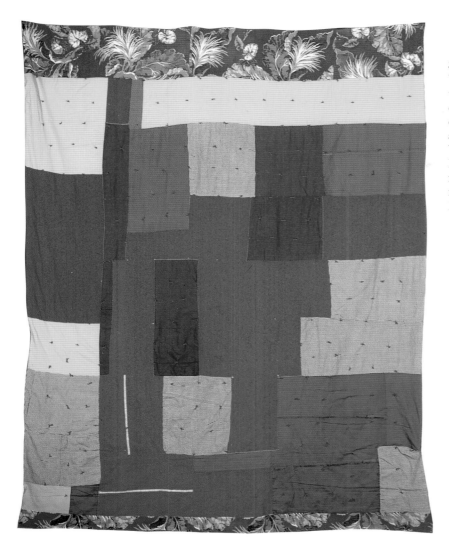

36. Strip Variation quilt by Mozell Benson, Waverly, Alabama, 1991. 90″ x 72″. This utilitarian quilt is made from salvaged pieces of cloth chosen for their bright contrasting colors. The result is similar to a modern abstract painting. Collected by Maude Wahlman. (Museum of American Folk Art, New York; This purchase was made possible in part by a grant from the National Endowment for the Arts, a Federal Agency) 1991 .13 .9

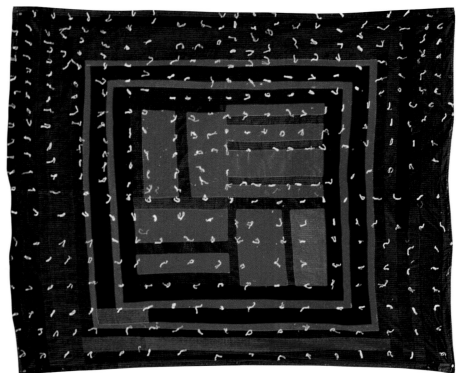

37. Log Cabin quilt by Elizabeth Munn, c. 1951. 72″ x 83″. This quilt is a fine example of the use of bold colors and large designs. Collected by Eli Leon.

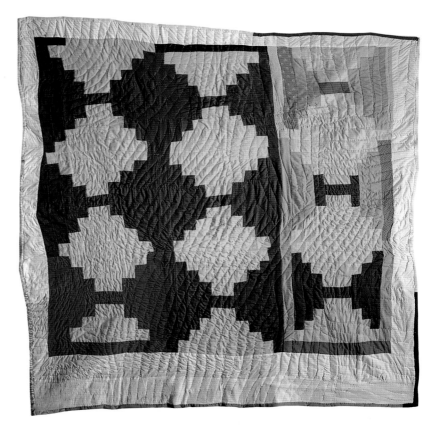

38. Log Cabin Courthouse Steps quilt by Plummer T Pettway, Boykin, Alabama, 1991. 72″ x 70″. Another example of how African-American women take Anglo-American patterns and enlarge them to create works of art that communicate like large paintings. Collected by Robert Cargo. (Museum of American Folk Art, New York; Gift of Helen and Robert Cargo) 1991 .33 .1

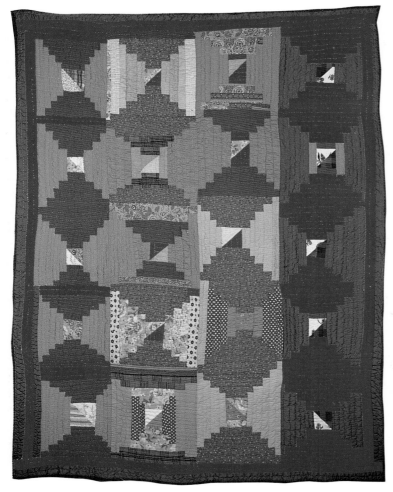

39. Log Cabin Courthouse Steps quilt by Pecolia Warner, Yazoo City, Mississippi, 1980. 69″ x 67″. Exhibited in "Ten Afro-American Quilters." A marvelous example of the way in which an African-American artist can Africanize a simple pattern by enlarging it, using bright contrasting colors, and improvising so that each square is slightly different. Collected by Maude Wahlman. (Private collection)

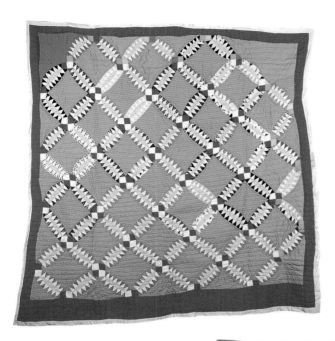

40. Rattlesnake quilt by Alean Pearson, Oxford, Mississippi, 1985. 87½" x 83". By manipulating small triangles often used to create symmetrical geometric patterns, Alean Pearson has created a bold modern design called Rattlesnake. Collected by Maude Wahlman. (Museum of American Folk Art, New York; This purchase was made possible in part by a grant from the National Endowment for the Arts, a Federal Agency) 1991 .13 .7

41. Snail Trail quilt by Mary Maxtion, Boligee, Alabama, 1990. 90" x 77". Another modern painting in cloth that takes a small pattern and blows it up, creating a dramatically different image, easily seen from a distance. Collected by Robert Cargo. (Museum of American Folk Art, New York; This purchase was made possible in part by a grant from the National Endowment for the Arts, a Federal Agency) 1991 .13 .2

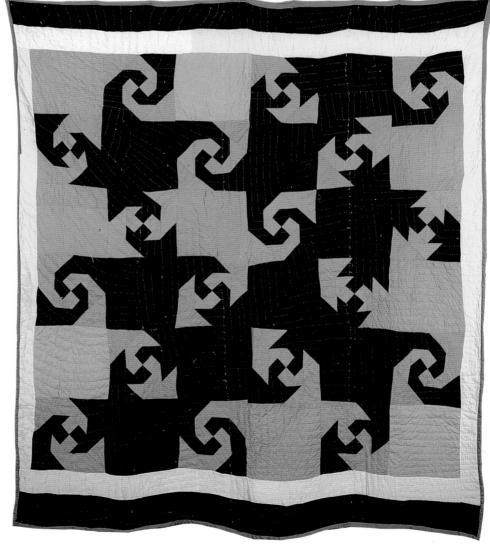

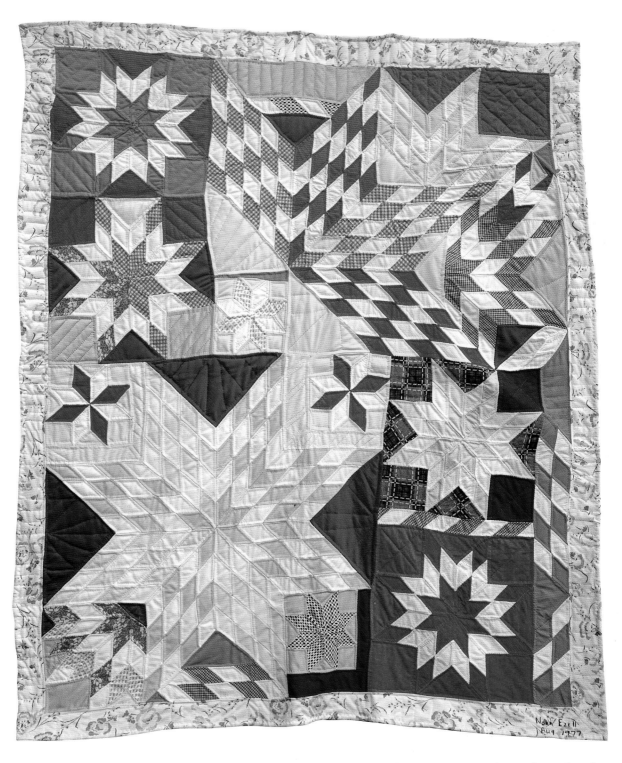

42. Star Quilt by Nora Ezell, Eutaw, Alabama, August 1977. 94″ x 74″. Exhibited in "For John Cox' Daughter." Here the quilter has deliberately fractured the typical star pattern to create an asymmetrical tour de force, a masterful composition that might only be dared by a folk artist very assured and proud of her textile tradition. The quilt is signed by the artist. Collected by Robert Cargo. (Museum of American Folk Art, New York; This purchase was made possible in part by a grant from the National Endowment for the Arts, a Federal Agency) 1991 .13 .1

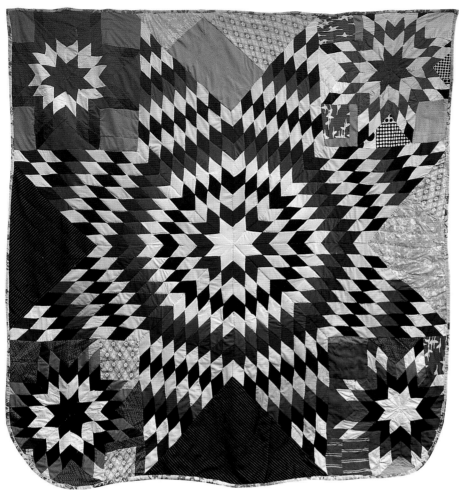

43. Star of Bethlehem quilt by Leola Pettway, Boykin, Alabama, 1991. 100″ x 96″. Again, an African American artist takes a typical Anglo pattern and Africanizes it by blowing it up large so as to communicate her talents from a distance. I saw this quilt, on a backyard clothesline, out of the corner of my eye, while driving past Leola's house. It stopped me. Collected by Maude Wahlman. (Museum of American Folk Art, New York; This purchase was made possible in part by a grant from the National Endowment for the Arts, a Federal Agency) 1991 .13 .4

44. Blue and white woven cloth, Peul people, West Africa. This men's-weave textile is interesting because of the use of indigo-blue and white and the asymmetrical arrangement of the strips with designs that resemble the Nine Patch pattern in American quilting. Collected by Frances and Melville Herskovits. (Schomburg Center Research on Black Culture, New York Public Library)

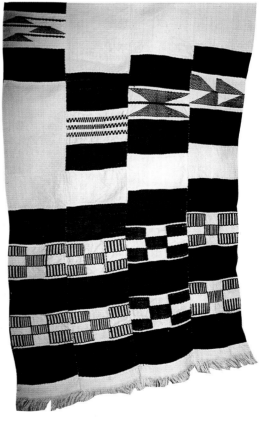

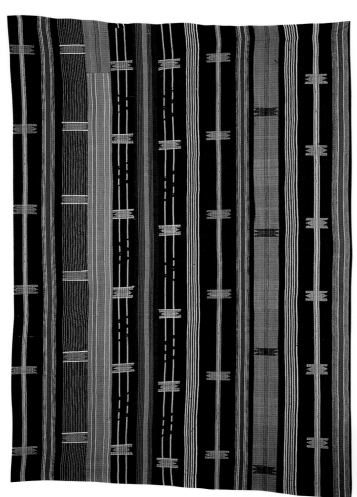

45. Men's weave, Yoruba people, Nigeria, 1960s. 73″ x 53½″. This textile displays an asymmetrical arrangement of strips to create an unpredictable pattern. Collected in Nigeria by Charles Counts. (Private collection)

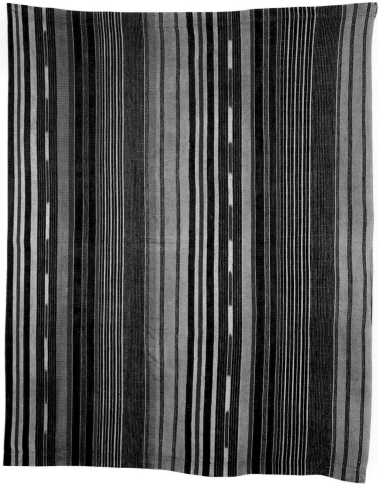

46. Women's weave, Yoruba people, Nigeria, 1950s. 64″ x 50″. The textile illustrates the assimilation of the older men's-weave style in women's weaving traditions. This textile has only two pieces seamed in the center. The emphasis on vertical stripes creates the impression of men's weave from a distance. Collected in Nigeria by Justine Cordwell. (Private collection)

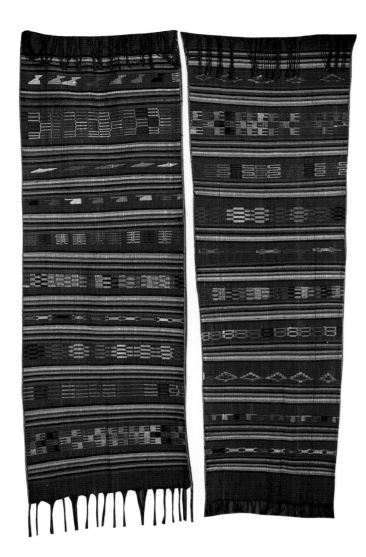

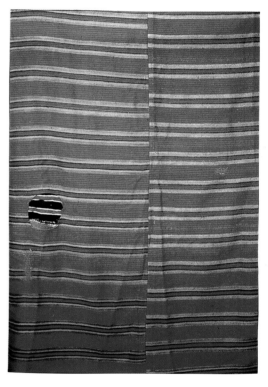

47. Women's weave, Igbo people, Nigeria. 80″ x 27″. This textile illustrates the African aesthetic of asymmetry, a deliberate staggering of design elements from one half of the textile to the other. Collected by Charles Counts in Nigeria. (Permanent Art Collections, University of Central Florida; Gift of William and Alice Jenkins)

48. Woven blanket by Luiza Combs, Tennessee, c. 1890. 61″ x 79½″. Inherited by Kenneth Combs, this handwoven wool blanket illustrates a deliberately offset matching of the two sides of the blanket, just as in some African women's weave.

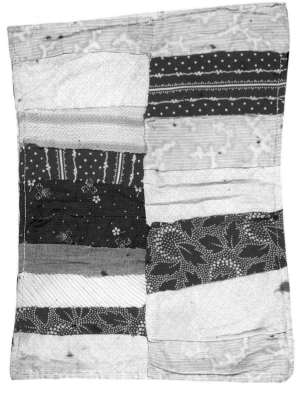

49. Doll quilt, artist unknown, North Carolina, 20th century. 9″ x 6¾″. Even this doll quilt illustrates African-American aesthetic principles of strips, bright colors, large designs, and asymmetry. Collected by Stuart Schwartz. (Private collection)

West African woven cloth. Judith Chase, in reference to African-American woven cloth, comments that:

> Most of the old coverlets were woven in two strips, seamed down the center to make them wide enough to cover a bed. Interestingly enough, there sometimes appears to be no attempt to match the pattern where the seam is made. Considering the obvious dexterity of the weaver, this may be an Africanism. Black slaves oftentimes refused to plow a straight furrow, or follow a straight line in a pattern without occasionally deviating to foil the malevolent spirits.[37]

We find even stronger asymmetrical tendencies in central African textile designs made by Kongo, Pygmy, and Kuba peoples.[38]

Some African-American quilters, like Alice Bolling, also emphasize asymmetrical patterns. Contemporary examples often feature horizontal strips sewn together in panels which are offset when joined. Even an African-American doll quilt (fig. 49) was made with bright colors, strips, and an asymmetrical design. Other African-American quilts feature more subtle variations between the vertical strips (figs. 50, 51, 52, 53, 54, 55).

Improvisation

Asymmetrical arrangements of cloth are a form of improvisation, found in West and Central African textiles. Kongo people praise talented expressions of sound and vision with the phrase *veti dikita*, meaning "the mind plays the pattern strongly."[39] Improvisation (break-patterning or flexible patterning) in Kuba raffia cloth[40] and painted Pygmy textiles has also been linked to spirit possession. The Kongo scholar Fu-Kiau Bunseki says, "Every time there is a break in pattern [it] is the rebirth of [ancestral] power in you."[41]

African-American quilters often adopt what we think of as traditional Euro-American quilt patterns, and "African-Americanize" them by establishing a pattern in one square and varying it in size, arrangement, and color in successive squares (figs. 56, 57, 58, 59, 60, 61). Their use of lines, designs, and colors varies with a persistence that goes beyond a possible lack of cloth in any particular size, color, or pattern.[42] As Eli Leon says, "An improvisational pattern is always conceptualized as a range of possible structures."[43] Plummer T Pettway places her colors at uneven intervals, so that her patterns appear to be constantly shifting. Her quilts (fig. 62) have an elusive quality—the use of improvisation, and the manipulation of prints and hues, create an effect of constant surprise. Lureca Outland uses more uniform colors but achieves a similar effect (figs. 63, 64).

Multiple Patterning

Improvisation, as seen in asymmetrical textiles, shades into multiple patterning. Eli Leon describes this transition as flexible patterning.[44] Improvisation and multiple patterning form another aesthetic tradition shared by the people who made African and Caribbean textiles and African-American quilts. Multiple patterns are important in African royal and priestly fabrics, for the number and complexity of patterns in a fabric increase in accordance with the owner's status.[45] Cloth woven for priests (fig. 65) and kings (fig. 66) may feature various woven patterns within each strip, as well as a variety of strips with each one featuring a different pattern.[46] Multiple-patterned cloth communicates the prestige, power, and wealth of the wearer, for only the well-educated and the wealthy can name the different patterns (fig. 67) and can afford to pay master weavers.[47]

African cloth thus has social and political significance, for it is worn and displayed as an indicator of wealth, occupation, social status, and history. Robert Farris Thompson has also suggested that certain West African asymmetrical and multiple-patterned strip cloths have more than an aesthetic function; the complex designs serve to keep evil spirits away, because "evil travels in straight lines."[48] If the patterns do not line up easily, the belief is that evil spirits will be confused and slowed down. Thus the textile becomes protective.

In Surinam, multiple patterning appears in a festive costume for a special African-American hostess called *A meki Sanni* (meaning "she makes the moves").[49] Her dress is made from patterned and vertically stripped handkerchiefs and is similar to Maroon-made hammocks with multiple patterns.[50]

Contemporary African-American quilts often are made with four different patterns in four large corners. Plummer T Pettway, from rural Alabama, believes that many different patterns and shapes make the best quilts. "You can't match them. No. It takes all kinds of pieces to piece a quilt."[51]

Many of these contemporary quilts may not communicate an owner's status or a religious identification, but they do retain an African aesthetic preference for improvisation, for variations on a theme, and for multiple patterns (figs. 68, 69). Improvisation and multiple patterning are also protective, for copying is impossible. While ostensibly reproducing Euro-American patterns, many African-American quilters maintain African principles of asymmetry, improvisation, multiple patterning, and unpredictable rhythms and tensions similar to those found in other African-American arts such as blues, jazz, black English, and dance.

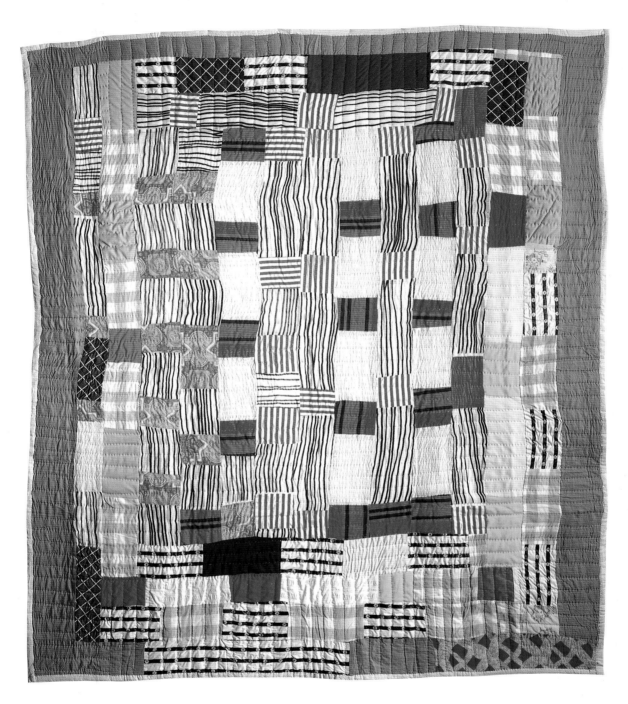

50. Strip quilt by Idabell Bester, Alabama, 1980. 83″ x 71″. Quilted by Losie Webb in 1990. This is another example of a utilitarian quilt made instinctively in the West African tradition of compiling design elements into strips that are then sewn together in a vertical format. The quilter has utilized manufactured materials with vertical black and white strips similar to patterns created with warp threads on West African men's looms. (Museum of American Folk Art, New York; Gift of Helen and Robert Cargo) 1991 .19 .4

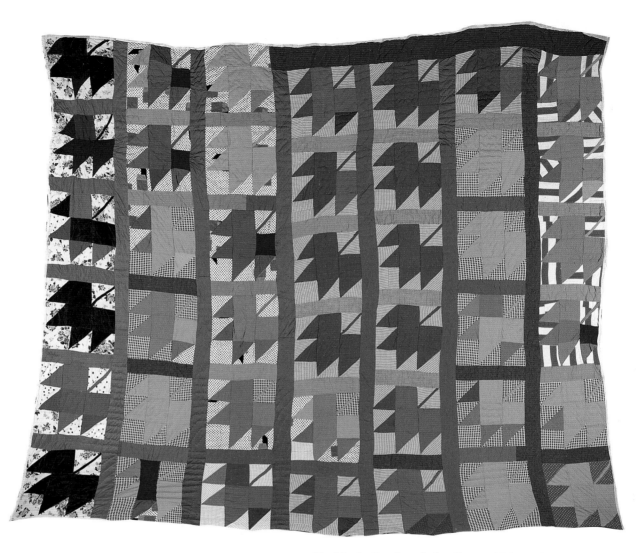

51. Maple Leaf quilt by Lizzie Nelson, Tennessee, 1983. 94″ x 104″. An excellent example of asymmetry. Collected by Maude Wahlman and Riki Saltzman. (Private collection)

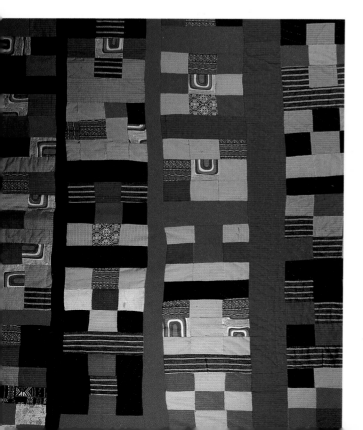

52. Strip quilt (detail) by Martha Jane Pettway, Boykin, Alabama, 1974. Featuring very bright colors, this strip quilt also emphasizes asymmetrical arrangements of squares between the vertical strips. Collected by John Scully. (Private collection)

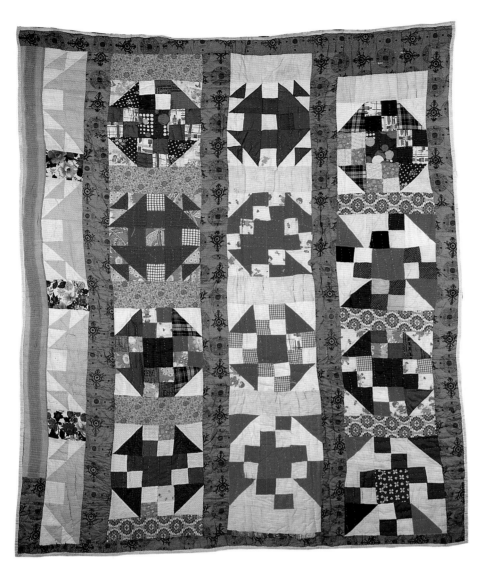

53. Diamond Strip quilt by Lucinda Toomer, Macon, Georgia, 1981. 80″ x 66″. Another variation on the Box pattern, this quilt shows how a quilter skillfully manipulates a simple pattern to create twelve variations on a theme. The same principle is found in African-American jazz and blues. Collected by Maude Wahlman. (Private collection)

54. Le Moyne Star Variation quilt by Lucinda Toomer, Macon, Georgia, 1981. 72″ x 70″. This quilt intrigued me because of the triple red and white strips and the asymmetry of their arrangement. (Museum of American Folk Art, New York; Gift of Maude and James Wahlman) 1991 .32 .1

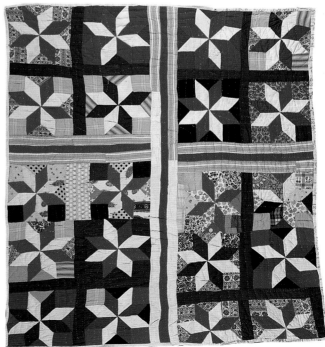

51

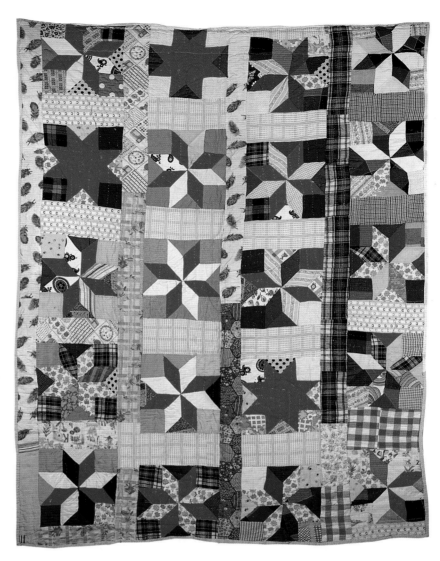

55. Strip-Star quilt by Lucinda Toomer, Macon, Georgia, 1981. 83″ x 63″. Lucinda Toomer, winner of a National Heritage Award, was a master of improvisation and asymmetrical textile design. Collected by Maude Wahlman. (Private collection)

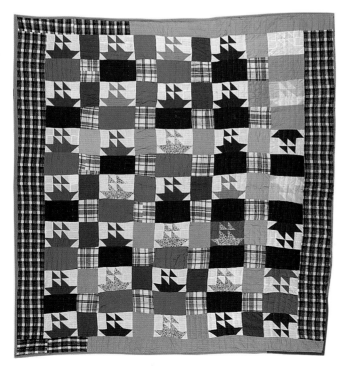

56. Sailboats quilt by Alean Pearson, Oxford, Mississippi, 1985. 90″ x 72″. Although the ships are pieced in a similar manner, one sees subtle improvisations. Collected by Maude Wahlman. (Museum of American Folk Art, New York; This purchase was made possible in part by a grant from the National Endowment for the Arts, a Federal Agency) 1991 .13 .8

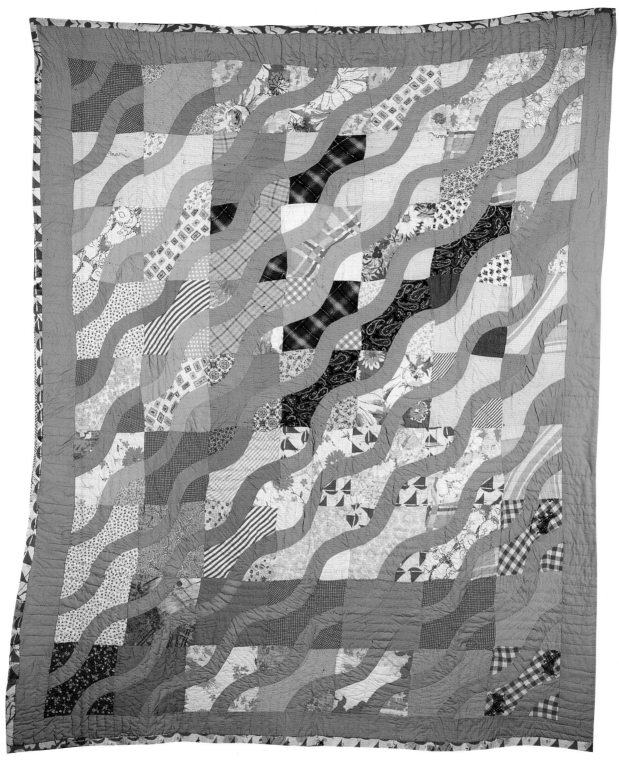

57. Green Snake quilt by Susie Ponds, Waverly, Alabama, 1979. 80″ x 64″. Exhibited in "Ten Afro-American Quilters." Snakes can represent Damballah, the Fon and Haitian god, also represented by a rainbow. Collected by Maude Wahlman. (Private collection)

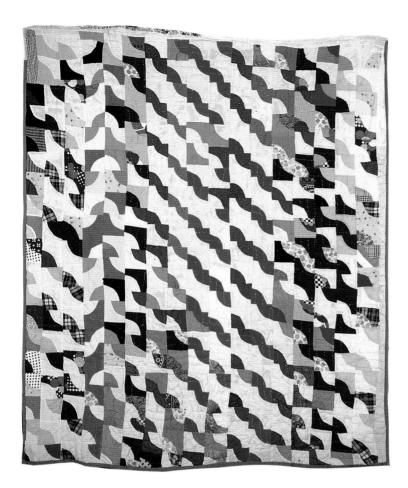

58. Drunkard's Path quilt by Lucinda Toomer, Macon, Georgia, 1981. 79″ x 66″. Exhibited in "Ten Afro-American Quilters." A classic example of improvisation. Lucinda Toomer has taken the basic pattern for Drunkard's Path and manipulated it to suit her own unique vision, yet it is constructed from strips, as in West Africa. Collected by Maude Wahlman. (Private collection)

59. Star quilt by Lucinda Toomer, Macon, Georgia, 1979. 71″ x 69¾″. Otherwise known as the Le Moyne Star pattern, this older quilt by Lucinda Toomer shows her more subtle use of color. Collected by Maude Wahlman. (Private collection)

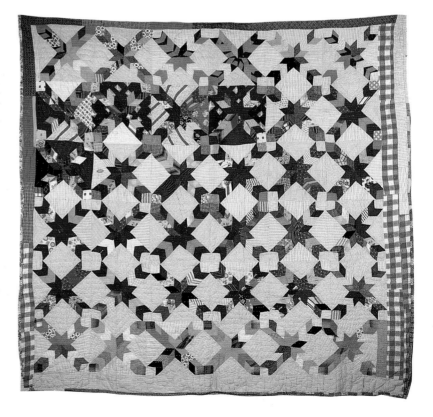

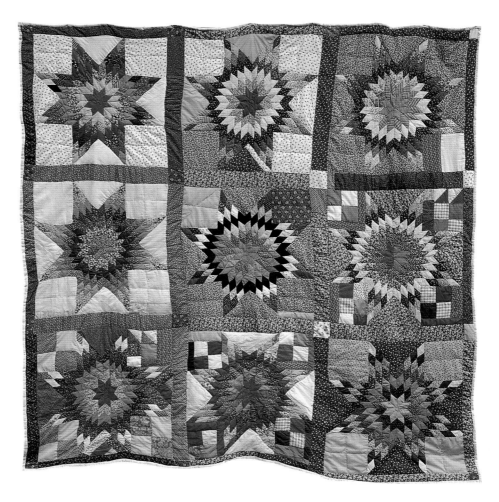

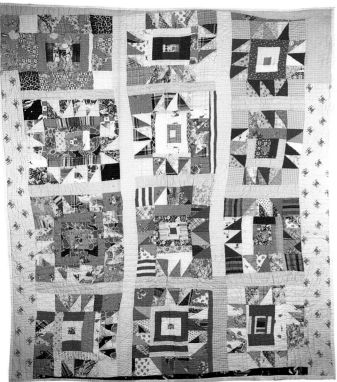

60. Star Variation quilt by Leola Pettway, Boykin, Alabama, 1991. 81″ x 78″. Using materials purchased from the Martin Luther King Freedom Quilting Bee where she worked, Leola Pettway has created a classic example of multiple patterning, similar in spirit to the West African prestige textiles woven for kings and priests. Scarcity of cloth was not a problem when the quilt was created; a deliberate aesthetic is evident. Collected by Maude Wahlman. (Museum of American Folk Art, New York; This purchase was made possible in part by a grant from the National Endowment for the Arts, a Federal Agency) 1991 .13 .3

61. Bird Trap quilt by Pecolia Warner, Yazoo City, Mississippi, 1982. 83″ x 68″. Exhibited in "Ten Afro-American Quilters." Made of twelve different squares, each composed from her own combination of a Log Cabin pattern and triangles, this is a classic example of a multiple-pattern quilt, exhibiting the African-American aesthetic of improvisation. Collected by Maude Wahlman. (Private collection)

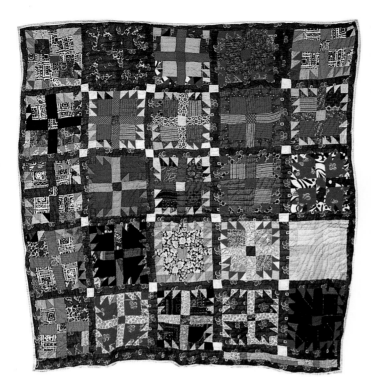

62. Cotton Leaf quilt by Plummer T Pettway, Boykin, Alabama, 1982. 76″ x 76″. This quilt illustrates the African and African-American principle of multiple patterning and improvisation in that the Cotton Leaf pattern does not repeat without multiple variations or improvisations upon the basic pattern. Collected by Maude Wahlman. (Private collection)

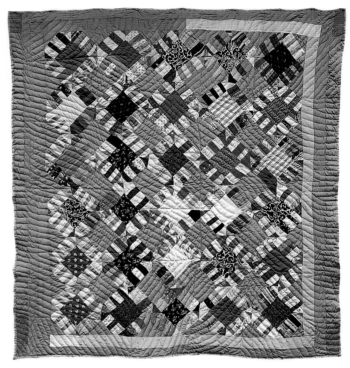

63. Wedding Ring quilt by Lureca Outland, Boligee, Alabama, 1991. 81″ x 75″. Here is improvisation in its finest form. The quilter refers to this as a Wedding Ring quilt, and we see here a squared version of the traditional Double Wedding Ring pattern. Collected by Maude Wahlman. (Museum of American Folk Art, New York; This purchase was made possible in part by a grant from the National Endowment for the Arts, a Federal Agency) 1991 .13 .5

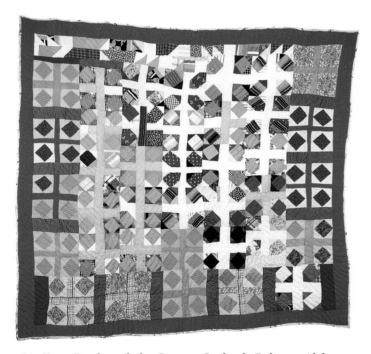

64. Four Patch quilt by Lureca Outland, Boligee, Alabama, 1991. 87″ x 83″. Another example of improvisation. In this instance the quilter varies the colors around her diamonds. The diamond is a common form in African-American culture; one sees it in arts, on graves, on houses, and in paintings. It is thought to represent the four directions, or the four moments of the Kongo sun: birth, life, death, and rebirth. Collected by Maude Wahlman. (Museum of American Folk Art, New York; This purchase was made possible in part by a grant from the National Endowment for the Arts, a Federal Agency) 1991 .13 .6

65. Asante chief wearing *asasia* cloth with multiple patterns, Ghana, West Africa, 1976. Ejisuhene Nana Diko Pim III, wearing an *asasia adweneasa*, a silk cloth made only for the royal family. Photograph by Doran Ross reproduced from *The Arts of Ghana* by Herbert Cole and Doran Ross, 1977, plate IV. *Asasia adweneasa* means "My skill is exhausted."

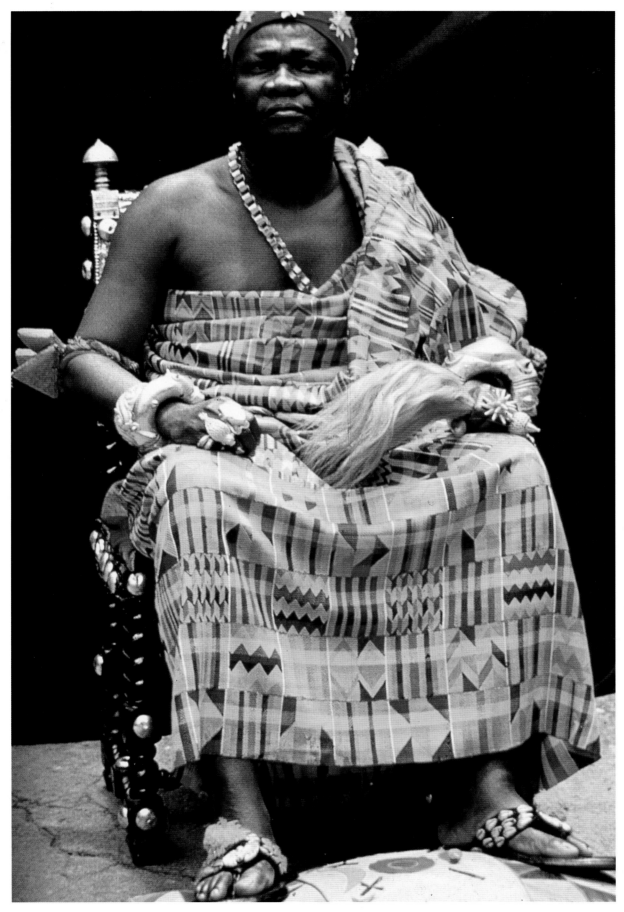

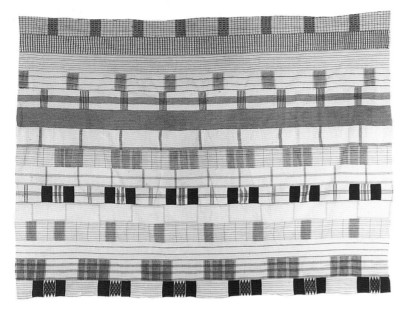

66. Men's weave, Akan people, Bonwire, Ghana. 60″ x 72″. This black and white priest's robe was made from fifteen strips of narrow woven cotton, each with a different pattern. Collected by Labelle Prussin. (Museum of Cultural History, University of California, Los Angeles)

67. *Nasadua* cloth, Asante people, Bonwire, Ghana, 20th century. 54¾″ x 32″. A woman's wrapper made by stitching together ten narrow handwoven strips. Made of costly threads and woven into elaborate patterns, these cloths are worn by the elite. Cotton, silk, natural and synthetic dyes. (The Venice and Alistair Lamb collection, jointly owned by the National Museum of African Art and the National Museum of Natural History, Smithsonian Institution, Washington, D.C.)

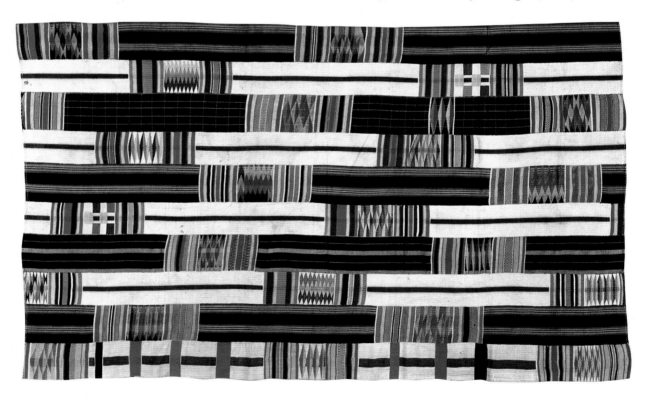

68. Bow Tie quilt by Kattie Pennington, Texas, 1980s. 60″ x 80″. A classic example of African-American multiple patterning. Collected by Eli Leon.

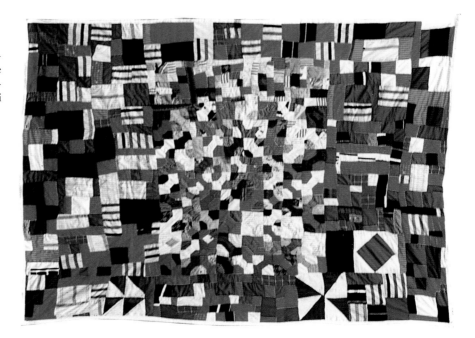

69. Sampler Variation quilt by Mozell Benson, Waverly, Alabama, 1985. 90″ x 70″. Another example of how a creative African-American artist draws on pan-African traditions of multiple patterning, yet is creative. Mozell has compiled various different patterns to create a quilt design that is exciting, but not predictable. Therefore, it cannot be copied easily. Collected by Maude Wahlman. (Museum of American Folk Art, New York; This purchase was made possible in part by a grant from the National Endowment for the Arts, a Federal Agency) 1991 .13 .10

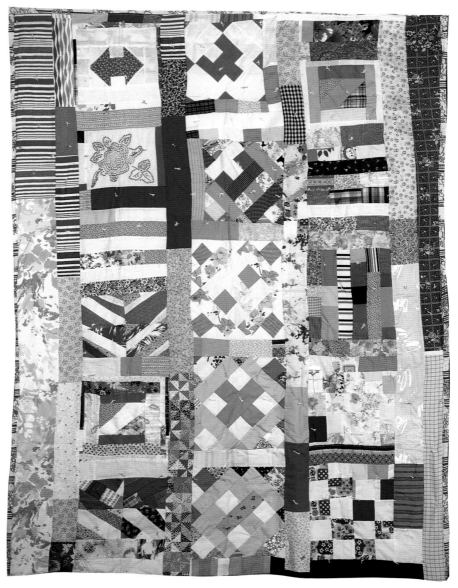

CHAPTER 2:
Appliqué Traditions

Besides piecing, in which strip patterns may dominate, another basic quilt-top construction technique known in Europe, Africa, and the United States is *appliqué*, the art of sewing cut-out shapes onto the surface of bags, banners, caps, costumes, flags, funerary cloths, umbrellas, and wall hangings. While Euro-American appliquéd quilts are primarily decorative, African-American appliquéd quilts often express stories and ideas in the same manner as appliquéd textiles do in Africa.

With bold appliquéd shapes, African cultures recorded court histories, religious values, and personal histories of famous individuals, using designs symbolizing power, skill, leadership, wisdom, courage, balance, composure, and other personal and religious qualities. The best-known African appliquéd cloth was made by the Fon people of The Republic of Benin (formerly Dahomey) (fig. 70). Originally, these cloths were made by a guild of male artisans to decorate the walls of the royal palace and to depict historic events. The technique was similarly used to decorate royal umbrellas,[1] flags, costumes, and banners. As we will see, West and Central African cultures used woven and appliquéd textiles (fig. 71) to encode various writing systems, and protective charm traditions.

One nineteenth-century appliqué now in a museum in Whydah, The Republic of Benin, was done in sixteen squares illustrating the capture of a Ewe group, their voyage to Brazil, and their return home to Whydah.[2] Similar appliqué traditions still occur in Surinam, St. Martin, and Haiti, although many contemporary examples, like those from The Republic of Benin, now illustrate one large scene.

Haitian flags, featuring painted and appliquéd scenes embellished with sequins and beads, are a creolized art with numerous possible roots: European flags, Fon banners, Fante flags, Tuareg saddle bags (fig. 72), Yoruba beadwork and leatherwork (fig. 73), Ejagham cloths, Ibibio funerary hangings (fig. 74),[3] Kongo flags in Zaire and Angola, and the famous Kuba appliquéd dance skirts (see fig. 71).

Designed to communicate respect and honor for *Vodun* gods, Haitian flags also announce the coming of a particular spirit to a shrine at a ceremony.[4] After independence in 1804, many Haitians migrated to New Orleans, where further innovations fused various African textile ideas and Euro-American images. Thompson has noted that the Kongo idea of agitating cloth or a flag, to open the door to the other world with honor, continues in the use of African-American jazz funeral-march umbrel-

las made in bright appliquéd colors and adorned with bells, feathers, flowers, and ribbons.[5]

Religious imagery is seen in appliquéd Bible stories. Two 1775 Bible cloths from New Orleans (fig. 75) may be the earliest example. Although it cannot be proven that these textiles were made by a black woman, certain features indicate strong continuities with African techniques and ideographic symbols.[6] Florence Peto wrote:

> Although there is no available history to help identify the origin of the items... they are among the most interesting and unique patchwork creations that I have encountered. Two panels (9′9″ long; 6′6″ wide), consist each of thirty-six appliquéd picture blocks, which tell the story of the Testaments, Old and New respectively. They have a Latin, old-world appearance, although they are said to derive from New Orleans, where they quite possibly adorned the walls of a convent or private chapel.[7] The technique employed in applying the patches differs markedly from that used generally by American colonial and pioneer needleworkers; they suggest the fingers of a Creole woman. No edges have been turned under; patches have been applied and then outlined with a thin, round, black-and-white cord held in place with couching stitches.... The episode blocks, seven inches square, are separated by three-inch-wide bands of old gold cloth to which have been appliquéd the Greek fret border in white—all edges outlined with cord. The upper inscription, Dictus Anno Sancto, may be translated "Dedicated to the Holy Year." The lower inscription [reads] "1775."[8]

The raw edges of the appliquéd figures on these two Bible cloths, a characteristic shared by many African-American appliqué quilts, are like those of the leather cut-out shapes on Yoruba *Egungun* costumes and on bags used by priests for the god *Shango* (see fig. 73). These bags (*Laba Shango*) feature square frames with appliquéd human figures posed in the sign for lightning, with one arm up, one arm down,

which also signifies motion in the Ejagham writing system

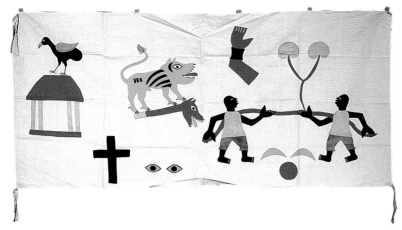

70. Appliquéd banner, Fon people, Republic of Benin, 1971. All the shapes used in this appliquéd cloth have symbolic meaning in Fon culture. The cross in particular stands originally for Lisa, the sun god/goddess. The snake in the tree is for Dan, another Fon god who is recreated in Haiti as Damballah. Photograph by Melville J. Herskovits. (Frances and Melville Herskovits Collection, Schomburg Center for the Study of Black Culture, New York Public Library).

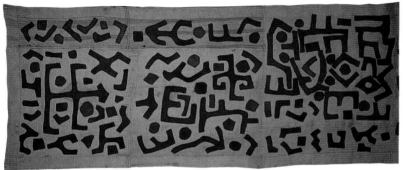

71. Appliquéd skirt, Kuba people, Zaire, Africa. 30″ x 186″. Worn as a woman's wrapper, this cloth features numerous appliquéd shapes. Note, in particular, the horizontal figure. Some scholars feel that these appliquéd shapes are derived from a system of symbolic forms. (Tribal Spirit Collections, Huntington, Massachusetts)

72. Embroidered saddlebag, Tuareg people, Niger, 1972. 18¼″ x 13½″. This leatherwork shows a division of space into squares that are embellished with a variety of designs as in African-American quilt tops. One also sees African embroidery and appliqué techniques, the same skills used in creating African-American quilts. Collected by Maude Wahlman. (Private collection)

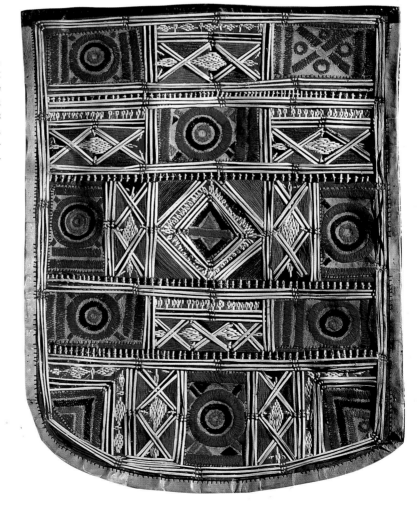

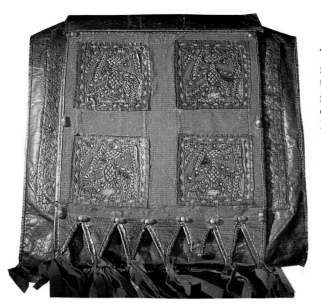

73. Priest's bag *(Laba Shango)*, Yoruba people, Nigeria, 20th century. Cloth and leather. This bag is made to be carried by priests who honor *Shango*, the Yoruba god of thunder and lightning. Designs for *Eshu*, another Yoruba god, are appliquéd on the outside. (Field Museum of Natural History, Chicago, Illinois)

74. Funerary shrine hanging, Annang-Ibibio people, Nigeria, 1950. This pieced and appliquéd textile shows one of the many possible African appliqué traditions that could have provided models for African-American appliqué textiles. The children of the deceased man commissioned a local artist to create this memorial cloth made with piecing and appliqué techniques. The appliquéd forms in the center depict important events in the life of the deceased. Photograph by Keith Nicklin and Jill Salmons.

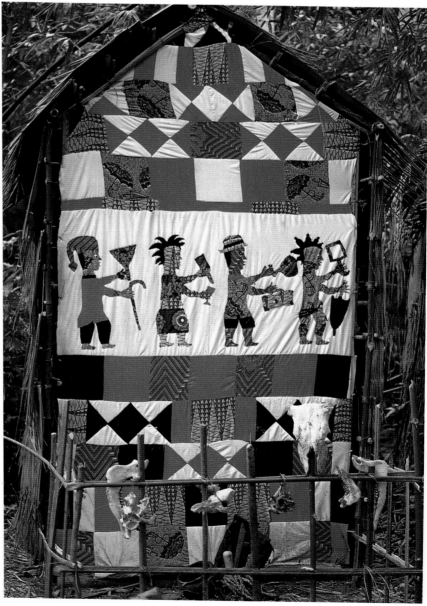

75. Appliquéd textile by a Creole woman, New Orleans, Louisiana, 1775. 117″ x 78″. Now lost. Published by Florence Peto in *Historic Quilts* as having been made by a Creole woman. The edges of the appliqué shapes are not turned under, but are covered with cording.

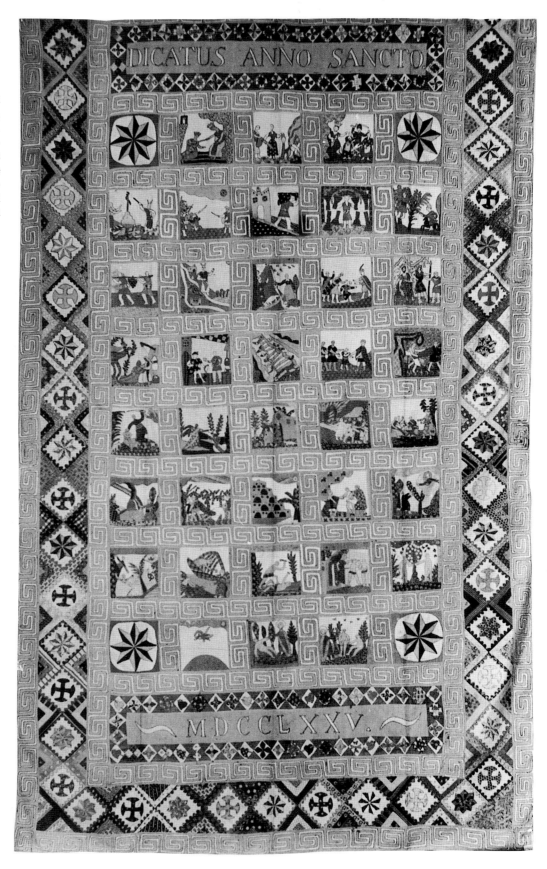

(Nsibidi). The ideographic designs surrounding the 1775 textiles are also similar to Ejagham signs for speech and motion.

Two African-American machine-appliquéd quilts, made in Athens, Georgia, by Harriet Powers (1837–1911) (fig. 76) in 1885 and 1895 (figs. 77, 78) illustrate scenes from the Bible as well as local historical events. Africans traditionally would use stories to teach, remember historical events, encode religious values, and entertain. In true African tradition, Harriet Powers recorded on her quilts the stories she had heard. Each scene is placed within a square outlined with narrow strips. Both quilts are made in three rows, but the earlier quilt has eleven scenes and the later one fifteen. Figures, animals, elaborate suns, stars, and objects are created with cut-out shapes sewn onto plain cloth. In reference to these quilts, Marie-Jeanne Adams notes, "the details of the stitching show that the squares were put together in vertical columns, which is evidence that on some level of her thought, Mrs. Powers grouped the scenes in vertical order"[9] (as in African strip-weaving traditions).

Adams speculates about possible African influences on Harriet Powers, who was born in Georgia in 1837:

> By the time her parents' generation would have come to the South, most slaves were being imported from the Kongo and Angola. Even if they came from West Africa and from Dahomey, they would not necessarily be knowledgeable in the appliqué techniques. [Fon] appliquéd cloths were made…in the capital city of Abomey by family guilds of tailors, all retainers of the monarch, and the guilds included only men and young boys. It seems most likely that she could have acquired a knowledge of [this] African style by hearsay only from other, older house slaves of her "old miss" or from her parents or other older persons.[10]

The earliest Powers quilt was exhibited at the Athens, Georgia, Cotton Fair of 1886. Purchased in 1891 by Jennie Smith, it was eventually given to the Smithsonian Institution. A second Bible quilt was reportedly exhibited at the Negro Pavilion at the Tennessee Centennial Exposition in Nashville, Tennessee, in 1897. Wives of Atlanta University professors subsequently acquired it as a gift for the Reverend Charles Cuthbert Hall. This quilt was given to the Boston Museum of Fine Arts in 1964.

The existence of the earlier 1775 Creole Bible textiles indicates the probabilities of an African-American Bible cloth tradition, not just the invention of Harriet Powers. Gladys-Marie Fry refers to the flourishing appliqué tra-

dition in the South from 1775 to 1875.[11] Lucine Finch interviewed Harriet Powers for an article published in 1914, and an account of an African-American woman's experiences in making an appliquéd Bible quilt appeared in 1922 in *Atlantic Monthly*.[12] Appliquéd scenes illustrating Biblical events are also described in the 1929 novel, *Black April*, by Julia Peterkin. It is possible that Peterkin saw the Harriet Powers Bible quilt on exhibition in Athens, Georgia, in 1886, or in Nashville, Tennessee, in 1897, or that she read the 1914 or 1922 articles. In Peterkin's chapter "The Quilting," the quilters are resting and Maum Hannah goes to a shed room.

> Presently she came back smiling, with a folded quilt on her arm. "Let's look at de ole Bible quilt chillen. It'll do yunnuh good." She held up one corner and motioned to deaf and dumb Gussie to hold up the other so all the squares could be seen. There were twenty, every one a picture out of the Bible. The first one, next to Gussie's hand, was Adam and Eve and the serpent. Adam's shirt was blue, his pants brown, and his head a small patch of yellow. Eve had on a red handkerchief, a purple wide-skirted dress; and a tall black serpent stood straight up on the end of its tail. The next square had two men, one standing up, the other down—Cain and Abel. The red patch under Abel was his blood, spilled on the ground by Cain's sin. Maum Hannah pointed out Noah and the ark; Joseph and Mary and the little baby Jesus; and last of all, Jesus standing alone by the cross. As Maum Hannah took them one by one, all twenty, she told each marvelous story.

My theory concerning southern Bible quilts is that they may also have been used as adult baptismal robes. The sizes of the Powers textiles are not ideal for use on a bed. Both of Powers' textiles would, however, make spectacular baptismal robes, with a horizontal display of religious messages across the back.

I believe that Harriet Powers may have been a conjure-woman or an elder member of a Masonic lodge, or both. To conjure is to call upon spiritual powers to activate a charm, to cure a sickness, or to heal an emotional wound. In the United States, African-Americans with spiritual talents are sometimes referred to as conjuremen or conjure-women. The apron she is wearing in the photograph (fig. 76) is certainly not a domestic apron; rather it is a ceremonial apron, with Fon and Kongo signs and a zigzag lower edge, as seen in West African ceremonial aprons. Recent research for a film indicates that both Harriet Powers and her husband were probably members of Masonic organizations in Athens or Clarke County, Georgia.[13] I think the 1897 portrait of Harriet Powers was probably taken on a ceremonial occasion, such as when

76. Harriet Powers (1837–1911), Athens, Georgia, c. 1897. Harriet Powers was photographed in a fancy dress and wearing a ceremonial apron decorated with appliquéd symbols also seen in Fon culture, Kongo culture, and Masonic secret societies. The photograph may have been taken to commemorate her installation in a new rank in an African-American secret society. (Museum of Fine Arts, Boston)

77. Bible textile by Harriet Powers, Athens, Georgia, c. 1886. 73¾″ x 88½″. Harriet Powers may have been a conjurewoman, a Masonic elder, or a Mother of a Church, or all three. Her command of appliqué techniques, Fon symbols, Kongo symbols, Masonic symbols, and biblical scenes is powerful and extensive, as seen in this, the earlier of two known textiles that may have been used in baptismal ceremonies. They certainly were used to code knowledge for the next generation. After selling this quilt to Jennie Smith, Harriet Powers went back to see it several times, perhaps to refresh her memory of the symbols so as to make her other known biblical textile. (National Museum of Natural History, Smithsonian Institution, Washington, D.C.)

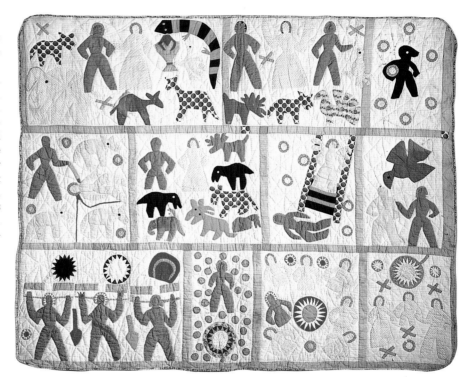

78. Bible textile by Harriet Powers, Athens, Georgia, c. 1896. 69″ x 105″. This textile was originally given by the wives of Atlanta University professors to the Reverend Cuthbert Hall, a white trustee of the historically black college. In it, Harriet Powers illustrates scenes from the Bible as well as historic events and local myths, while using symbols with roots in West Africa, Central Africa, and Haiti. For a community in which most members could neither read or write, quilts were used to transmit information and preserve culture, both overt and hidden. Therefore, it is not surprising to find an inherent complexity in Powers' artwork. (Museum of Fine Arts, Boston; Gift of Maxim Karolik, 1964)

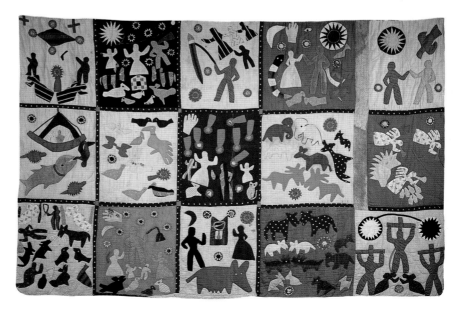

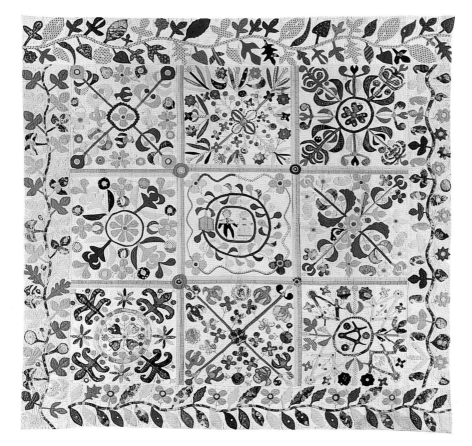

79. The Marriage Quilt, artist unknown, Virginia, 1865. 92½″ x 94″. Although we do not know who made this quilt, we can see a mastery of appliqué and symbolic forms. The center square features a couple surrounded by concentric rings with healing leaves, an Ejagham symbol for the coming together of peoples for an important event. Other squares feature symmetrical flowery designs reminiscent of Haitian *Vèvè* signs. One square shows a symbol that in Ejagham culture represents marriage or love. It is also a Masonic sign, and is also seen in Haiti. Although we cannot yet prove that this is an African-American quilt, that possibility cannot yet be denied. (Atlanta Historical Society, Atlanta, Georgia)

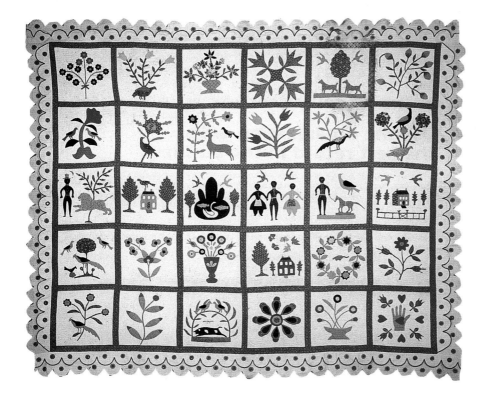

80. Black Family Album quilt by Sara Ann Wilson, New Jersey or New York, 1854. 85″ x 100″. An excellent example of appliqué art, with figures in the center depicted in black cloth. This quilt celebrates family life. Photograph courtesy America Hurrah Antiques, N.Y.C.

she achieved a certain rank, or when her quilt was exhibited in Nashville.

Another Bible textile, from 1900–1910, and also from Georgia, has recently surfaced.[14] It shows four squares and depicts Adam and Eve and the Crucifixion only. A remnant of the African-American Bible textile tradition has been captured by Eudora Welty in a photograph taken in Mississippi of "A Slave's Apron showing Souls in Progress to Heaven or Hell."[15] Thirty appliquéd figures, animals, and houses are placed on a checked material. Two scenes on dark squares are stylistically reminiscent of squares in Harriet Powers' quilts. These black squares represent Hell; white frames on the upper part of the apron represent Heaven. A 1974 example of a Bible quilt was made by Lorraine Maham in Philadelphia.[16] Nora Ezell, from Alabama, has made one Bible quilt and is working on another. She says,

> I made a Bible Story Quilt. I hadn't planned it for anyone. I was working on it in Birmingham. Jim Hedges, from Chattanooga, Tennessee, was there. He had seen the Stitching Memories exhibit in Memphis and wanted one of my quilts. He put a down payment on the Bible Story Quilt and bought a Donkey Quilt. The quilt had squares with Christ on the Cross, Mary and her Baby, Samson, Christ with the Lambs, the Flight to Egypt, and Moses. There are nine blocks. It took one thousand hours to complete. I keep a log of my hours on story quilts; I allow myself three dollars an hour. I never do more than one of a story quilt because I don't have any patterns. I'm going to do a different Bible Story Quilt for a woman in Louisville."[17]

African-American appliquéd quilts often mirror the diverse influences that shape the lives of black women in the United States. Most quilters do not appliqué Biblical scenes, but rather images derived from their daily lives (figs. 79, 80). Elizabeth Hobbs Keckley made a medallion silk quilt (fig. 81) between 1860 and 1880, using scraps reportedly from gowns worn by Mary Todd Lincoln. Since she was a seamstress for Mrs. Lincoln, she had the opportunity to save leftover fabric.[18] Her fancy quilt incorporated appliquéd eagles, piecing, tassels, and embroidery techniques, and the word "Liberty."[19]

Contemporary African-American quilters such as Clementine Hunter (fig. 82) appliqué quilts with shapes drawn from their imaginations, from black culture (figs. 83, 84, 85), and from popular American culture shaped by magazines, television, and advertising (fig. 86). Some women, like Lillian Beattie and Sarah Mary Taylor, cut out magazine illustrations and reproduce them in cloth.[20] Others are inspired by animal pictures and search for appropriate fuzzy, animal-like materials; a few make paper templates from dreamed designs; and some, like Pearlie Posey and Sarah Mary Taylor, continue using people or doll forms, as well as hands.

Pearlie Posey (1894–1984), recalled that her grandmother taught her "how to hoe, plow, split rails, make fences, all that." She also taught her to quilt. Pearlie remembers quilting after returning from the fields: "When the sun went down, you could take your mule out and go on home and feed your mule, and if it was still light, why you could sit down and quilt two or three, a few rows." Piecing and quilting were social activities when Pearlie was young: "In my time, would be a family there and a family there and a family there and we would get together and tear up old clothes, overalls and linings and everything and piece quilt tops and linings....If I was ready to quilt one, well, four or five women Sunday morning come to my house and put one in. That's the way we quilted, just quilt and laugh and enjoy ourselves."[21]

When her daughter Sarah Mary Taylor made appliquéd quilts (figs. 87, 88) in 1980, Pearlie was intrigued by the new design and eager to learn the appliqué technique: "My baby there started making them and I started trying to do what she did...I knew how to piece these nine-patches and these other things, but I didn't know anything about how to do them, do fancy quilts."[22] Pearlie borrowed Sarah Mary's cardboard designs for cutting out appliqué shapes and began making appliqué quilts of her own (fig. 89). Because of her failing eyesight, Pearlie depended upon Sarah Mary to cut out the original patterns. Pearlie Posey preferred small, intricate appliquéd shapes that she could arrange in intimate groupings: "I just like mine mixed up...I'll have a bird sitting over yonder, something else sitting over there, something else sitting over there"[23] (fig. 90).

Yvonne Wells is an educated teacher who is a sophisticated folk artist. She creates appliqué quilts that sometimes depict biblical themes (fig. 91) as well as social commentary (fig. 92).

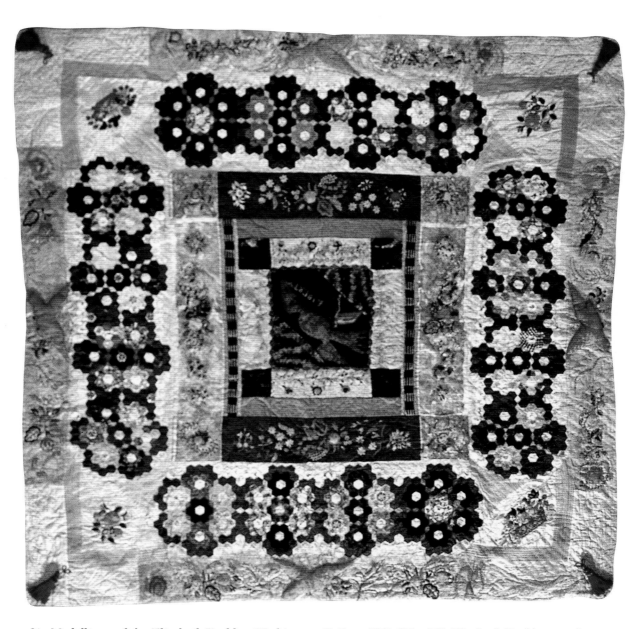

81. Medallion quilt by Elizabeth Keckley, Washington, D.C., c. 1870. 81″ x 86″. Elizabeth Keckley may have made this quilt while she was working as a seamstress for Mary Todd Lincoln, and she may have used scraps from cloth she used to make gowns for Mrs. Lincoln. It shows skills in appliqué, embroidery, and piecing. (Collection of Ross Trump)

82. Clementine Hunter. Photograph by Richard Gasperi, Natchitoches, Louisiana.

83. Melrose Plantation quilt by Clementine Hunter, Natchitoches, Louisiana, 1938. 72″ x 54″. Showing the architecture and the daily life of Melrose Plantation, this quilt possesses the same cultural information that we find in many of Clementine Hunter's paintings.

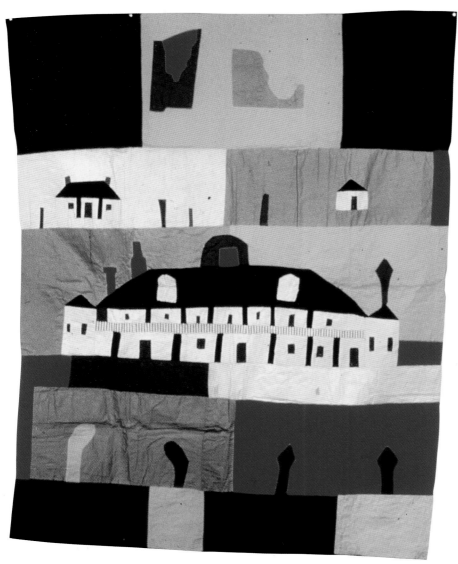

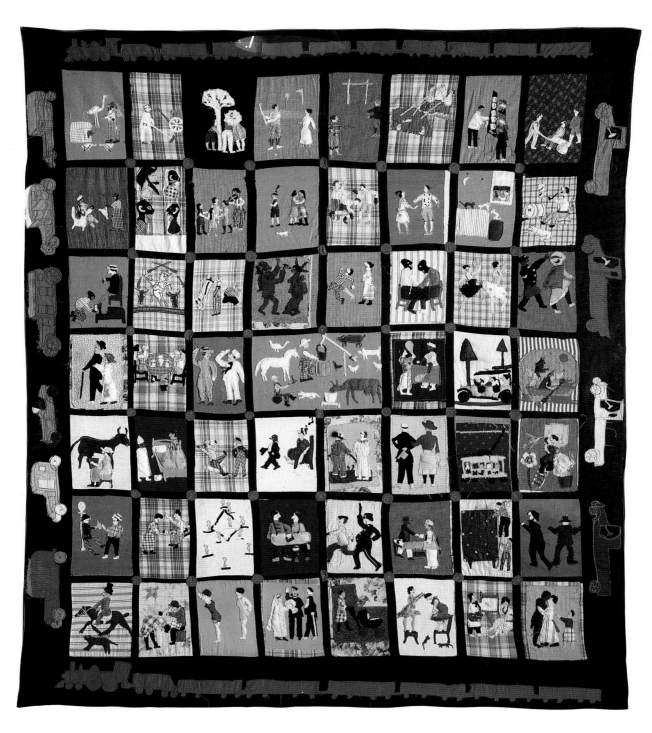

84. Appliqué quilt, *Scenes from Life in 1930* by Mrs. Cecil White, Hartford, Connecticut, c. 1930. 77″ x 66″. This is one of the liveliest and best-known examples of American folk art in the quilt medium. Some scholars believe that Mrs. White was an African-American, while Julie Silber, curator of the Esprit Collection, feels that she may not have been. (Esprit Collection, San Francisco, California)

85. Jones Valley quilt by Nora Ezell, Alabama, 1987. 96″ x 72″. Jones Valley was an early name for Birmingham, Alabama, the town where Nora Ezell grew up. This is a memory quilt depicting scenes from Nora's childhood. (Collection of Robert Cargo)

86. People quilt by Lillian Beattie, Tennessee, 1979. 70″ x 50″. Lillian Beattie loved to cut images from magazines and then reproduce them in cloth on single-color backgrounds. Photograph by Maude Wahlman. (Collection of Katie Weiss)

87. Birds quilt by Sarah Mary Taylor, Yazoo City, Mississippi, 1980. 74″ x 65″. This represents an early experiment in appliqué by Sarah Mary Taylor. Collected by Maude Wahlman. (Private collection)

88. Ball Players quilt by Sarah Mary Taylor, Yazoo City, Mississippi, 1982. 83″ x 73″. Exhibited in "Ten Afro-American Quilters." The more appliqué quilts she made, the more Sarah Mary Taylor experimented with images and colors, and the more she perfected her art. This image was taken from a magazine and reproduced as a paper template that could be used over and over to cut cloth shapes used in many quilts. Collected by Maude Wahlman. (Private collection)

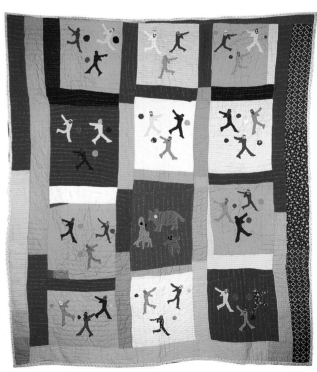

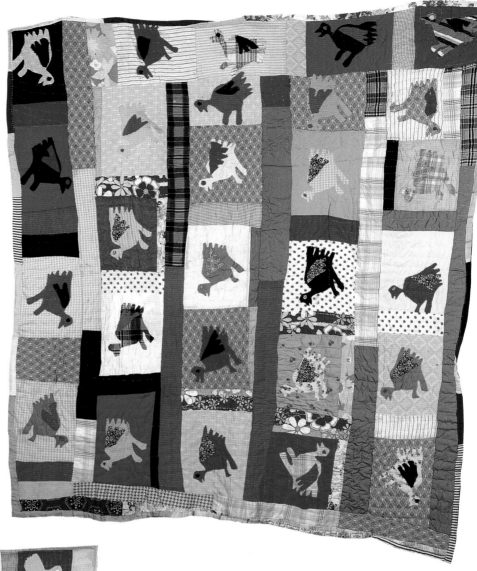

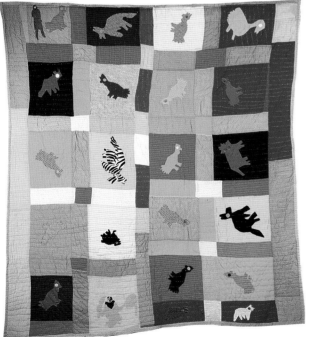

89. Hens quilt by Pearlie Posey, Yazoo City, Mississippi, 1981. 77″ x 61″. Organized in horizontal strips with appliquéd hens, this quilt aptly demonstrates African-American use of everyday forms in functional quilts meant to delight the eye. Pearlie Posey learned to make traditional pieced quilts from her grandmother and to make "fancy" appliquéd quilts from her daughter, Sarah Mary Taylor. (Museum of American Folk Art, New York; Gift of Maude and James Wahlman) 1991 .32 .2

90. Pastel Animals quilt by Pearlie Posey, Yazoo City, Mississippi, 1982. 82″ x 70″. Exhibited in "Ten Afro-American Quilters." Pearlie Posey has said that the gray figure in the lower left square represents Christ. Collected by Maude Wahlman. (Private collection)

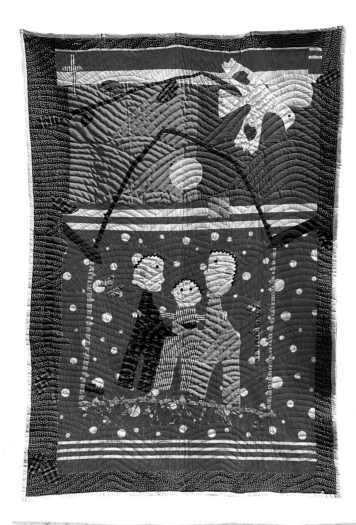

91. Fiery Furnace quilt by Yvonne Wells, Tuscaloosa, Alabama, 1991. 89″ x 57″. The fiery furnace refers to the biblical story of Shadrach, Meshach, and Abed-nego being thrown into the furnace by Nebuchadnezzar (Daniel, chapters 20-24). Like Faith Ringgold, Wini McQueen, Joyce Scott, and Jesse Lane, Yvonne Wells represents the modern generation of African-American women who are not folk artists, but who carry on the messages that have been encoded by their mothers in folk arts for so long.

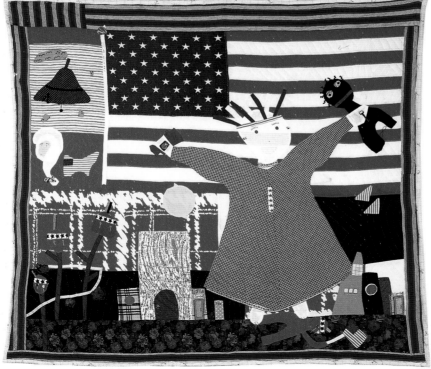

92. Being in Total Control of Herself quilt by Yvonne Wells, Tuscaloosa, Alabama, 1990. 70½″ x 81½″. Yvonne Wells is a self-taught quilter and a well-educated school teacher. "Being in Total Control of Herself" refers to American women as symbolized by the Statue of Liberty. (Collection of the artist)

74

CHAPTER 3:
Tracing Religious Symbols

An analysis of African-American folk art suggests a cultural strategy of sorting African heritages into luxuries to be jettisoned or essential intellectual tools with which to comprehend a new world. Protective religious ideas, encoded into folk art, were intellectual tools of survival. Writing and healing charms are two significant religious concepts which had profound influence on traditional African-American folk art. In general, it appears that many African-American painters were influenced by African and African-Caribbean ground painting and ideographic traditions, and many African-American sculptors were influenced by African and African-Caribbean charm-making traditions. Many African-American quilters, however, seem to have been influenced by both religious signs and charm traditions.

However, because knowledge of some folk-art techniques is usually passed from one generation to the next by example, often without verbal explanations for the religious significance of forms, many African-Americans are unaware of the meanings behind the forms they use in their art. Some forms can be understood and explained by examining selected folk arts from a historical perspective. As children, many African-Americans were exposed to traditional religious concepts and symbolic visual forms which later surface in their adult art. These arts revive a past cultural environment which emphasized religious forms with meanings which could not always be put into words. Robert Farris Thompson records similar instances for African art which contain concepts that may be too important to put into speech.[1] Many African-American folk artists create art with visual ties to African and African–Latin American religious concepts. They may be consciously or unconsciously reviving and reformulating aspects of earlier cultural systems which valued certain forms highly.

The famous art historian, George Kubler, once noted that ideas encoded in objects sometimes last longer than those retained in words:

> The artist is not a free agent obeying only his own will. His situation is rigidly bound by a chain of prior events. The chain is invisible to him and it limits his motion. He is not aware of it as a chain but only as a *vis à tergo*, as the force of events behind him. The conditions imposed by these prior events require of him either that he follow obediently in the path of tradition, or that he rebel against the tradition. In either case, his decision is not a free one; it is dictated by prior events of which he senses only dimly and indirectly the overpowering urgency, and by his own congenital peculiarities of temperament... the individual is driven in every action by forces of an intensity absent from other lives; he is possessed by his vision of the possible, and he is obsessed by the urgency of its realization, in a solitary posture of intense effort, traditionally represented by the figures of the poet or the muse.[2]

Let us examine the ways in which African-American women quilters have preserved important aspects of traditional African value systems, particularly writing systems and charm traditions. We have seen how asymmetry, improvisation, and multiple patterning function in certain West African strip textiles and how these tendencies and Central African break patterning may be more than aesthetic preferences; these traditions may also be protective. The complex designs serve to keep evil spirits away, as "evil travels in straight lines."[3] If the patterns do not line up easily, the belief is that evil spirits will be confused and slowed down.

We will look at African scripts or ideographic systems, then see how these ideas and forms are recombined in various new ways in African–Latin American signs and, in particular, in textiles. Then when we look at certain African-American quilts with symbolic designs, we will do so with an informed eye and a historic awareness of previous manipulations of symbolic designs. Next we can make the same geographic journey from Africa to the New World and the United States while examining the history of protective religious charms.

Protective African Scripts

In Africa, among the Mande, Fon, Ejagham, Yoruba, Kongo, and other cultures, indigenous and imported writing is associated with knowledge, power, and intelligence, and thus is considered sacred and protective. African signs were sewn, dyed, painted, or woven into cloth; and Central African artifacts were often read as aspects of a Kongo religious cosmogram.

In West Africa, Bamana women paint cloth (fig. 93), called *Bogolanfini* (which has been woven by men on a narrow loom and then sewn into fabrics), with designs

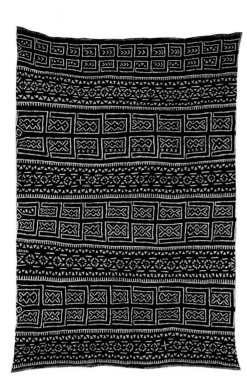

93. *Bogolanfini* wrapper, Bamana people, Mali, 1973. 59″ x 39″. *Bogolanfini* cloth is made from white cotton strips handwoven by men, then dyed by women using a mud-type dye with iron. The iron serves as a mordant, binding the color to the cloth. The fabric is made into men's hunting costumes and women's wrappers, and it is considered protective because the designs incorporate writing that code secret ideas. The geometric designs are believed to be based on an old indigenous syllabary similar to the Vai syllabary. Collected by Maude Wahlman. (Private collection)

94. Vai syllabary, Vai people, West Africa, 20th century. One of many indigenous secret writing systems in Africa, the Vai syllabary was revealed in the 20th century but is believed to be based on an earlier, indigenous secret-society syllabary.

THE COMPLETE VAI SYLLABARY

normal syllables	i	a	u	e	ɛ	ɔ	o
p							
b							
ɓ							
mɓ							
kp							
mgb							
gb							
f							
v							
t							
d							
⊥							
ɋ							
nd							
s							
z							
o							
j							
nj							
y							
k							
jg							
g							
h							
w							
h̃							
m							
n							
ny							
ŋ							
nasal syllables	ĩ	ã	ũ		ɛ̃	ɔ̃	syllabic nasal

76

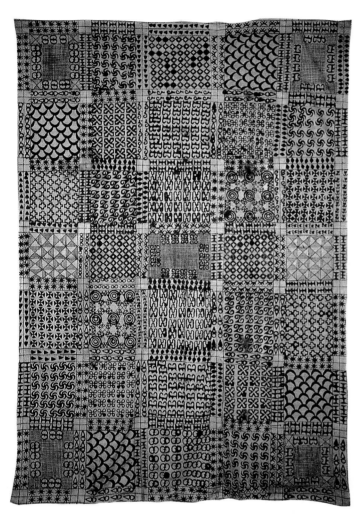

95. *Adinkra* cloth, Asante people, Ghana. 112¼" x 76¼". Made from cotton cloth that has been stamped with calabashes carved in symbolic shapes and dipped in a black bark dye. *Adinkra* designs, like *Bogolanfini* patterns, are probably derived from secret-society scripts. (National Museum of African Art, Smithsonian Institution, Washington, D.C.)

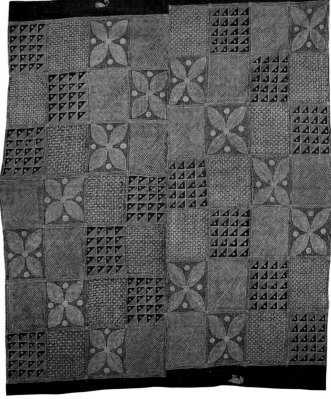

96. Starch resist *(Adire)*, Yoruba people, Nigeria, 1975. 78" x 63". *Adire* cloths are made by men and women, using starch to resist the indigo-blue dye on one side of the cloth, creating blue-on-blue patterns. The Yoruba goddess, *Yemoja*, is thought to have taught women her symbols, which are those seen on *Adire* cloths. Collected by Maude Wahlman. (Private collection)

similar to a syllabary (fig. 94) invented by the Vai people in the nineteenth century, but thought to have much older precedents. *Bogolanfini* fabrics were used for women's wrapper-skirts and protective clothing for hunters. Of Bamana cloths it has been written, "The Mande themselves coded, in discretionary irregularities of design, visual analogues to danger, matters too serious to impart directly."[4]

Many West African peoples encase little scraps of religious writing (from the Bible, the Koran, or indigenous writing) in protective charms covered with cloth, leather, or metal that are worn around the neck or sewn to cloth gowns, to quilted war shirts, and to quilted horse armor.[5] These quilted war shirts and horse blankets are protective due to the padding as well as to the practice of sewing numerous protective cloth charms containing scripts onto or inside the quilting.

Adinkra is the Asante name for their printed textile (fig. 95) originally reserved for funerals[6] that encodes symbolic signs in the designs.[7] The designs are stamped onto cloth with a carved calabash rind that has been dipped into black dye made from the bark of a particular tree.[8] The Asante similarly use symbolic designs in their lost-wax cast-brass and gold weights made to weigh gold dust. The circle and the cross represent Nyame, a sun-god.[9] Asante designs appear to be derived from an earlier indigenous writing system.

In The Republic of Benin, the Fon people practice a religion concerned with honoring ancestors who become familial gods (*vodu*), and public gods (Sky, Earth, Sea, and Thunder gods and goddesses)[10] represented by various signs. *Dambada Hwedo*, the personification of unnamed Fon ancestors, reappears as *Damballah-Wedo*, *Vodun* gods, in Haiti. Then there are *Toxosu*, souls of abnormal individuals believed to live in the water.[11] Painted religious designs on the ground and simple spotted red-and-white designs appear on the outsides of *Tçxçsu* temples, made to honor the ancestral spirits of malformed and aborted children, otherwise referred to as "little people."[12]

The Fon have a non-Christian cross sign for the sun-god, *Lisa*, who is also symbolized by a chameleon.[13] These crosses are often found on appliquéd banners (see fig. 70) made for societies, as well as on the walls of the palace of King Glele. Melville Herskovits attributed the style of appliqué-cloth art to the clay bas-relief designs found on the outside walls of kings' palaces, and near doorways of compounds of chiefs, nobles, and priests.[14] Dancers for the Earth cult also wear costumes that use crosses appliquéd in red or black on breeches.[15] Lisa and the god of war, Gu, are thought to have founded the family clans, and thus are ancestral to family gods.[16]

In Nigeria, the Yoruba people believe in a cosmos with two realms, the visible and the invisible, visualized as a circle with intersecting lines to represent the crossroads where the two realms meet.[17] The invisible world is presided over by a supreme god, *Olodumare*, or *Olorun*, and pantheon of gods or spirits who answer to *Olodumare* and can bring health, children, honor, fortune, and serenity to believers. Some *Orisha*, as they are called, are primordial beings; others were humans—culture heroes and ancestors; still others were natural forces such as rivers, rocks, hills, or trees.[18] All beings, spiritual or living, possess *ashe*, or the innate power to make things happen and change.[19] During training for initiation into a religious society, candidates' heads are shaved, bathed, anointed, and painted with substances, colors, and patterns to attract and direct important spirits.[20]

Yemoja, the Yoruba goddess of motherhood, mother of many other gods, is associated with the Ogun River in Nigeria and the ocean in the New World. One legend says that *Yemoja* dyed cloth blue, her color. Yoruba women have invented a stenciled cloth with symbolic designs (fig. 96) in blue that may have derived from an earlier symbolic system meant to represent *Yemoja*'s animals. In Brazil, *Yemoja* is a national deity,[21] and she is known as well in Puerto Rico and Cuba.

In Nigeria, the Ejagham people are known for their 400-year-old writing system (fig. 97), called *Nsibidi*.[22] It was most likely invented by women, for you see it in their body painting and tattoos, and on their *Nimm* secret society buildings and ritual fans,[23] calabashes,[24] stools, skin-covered masks, and textiles, and on woven, dyed, and pieced costumes made for the men's Ngbe (Leopard) secret society.[25] For the Ejagham, the leopard is the symbol of power, intelligence, and cool leadership.[26] Ejagham women make woven costumes and resist-dyed and appliqué cloths featuring checks, triangles, and other *Nsibidi* signs. These textiles are worn by dancers or hung in shrines. Ejagham men make stools and skin-covered masks decorated with *Nsibidi* signs learned from the women.

Six hundred ninety *Nsibidi* symbols are known.[27] Light and dark triangles or squares represent leopard spots; intersecting arcs represent love or marriage. Arcs separated by a line stand for divorce. A circle bisected with a cross, and featuring four small circles in each quadrant, represents the Ejagham belief in spiritual as well as physical vision (fig. 98).[28] We see this sign again in Cuba and in African-American folk arts.

Women in other Nigerian cultures also make resist-dyed textiles with signs that may derive from *Nsibidi*. Efut, Igbo, and Ibibio women use *Nsibidi*-derived designs on dyed (fig. 99) and appliqué cloths, costumes, and engraved brass trays. Nsibidi designs were similarly drawn on the ground and used in gestures.

Some appear in the previously mentioned Vai syllabary from Liberia, and in a script invented around 1896 by a Bamun king, Sultan Njoya, in the nearby Cameroons area. Kubik compares Bamun script to old rock engravings in

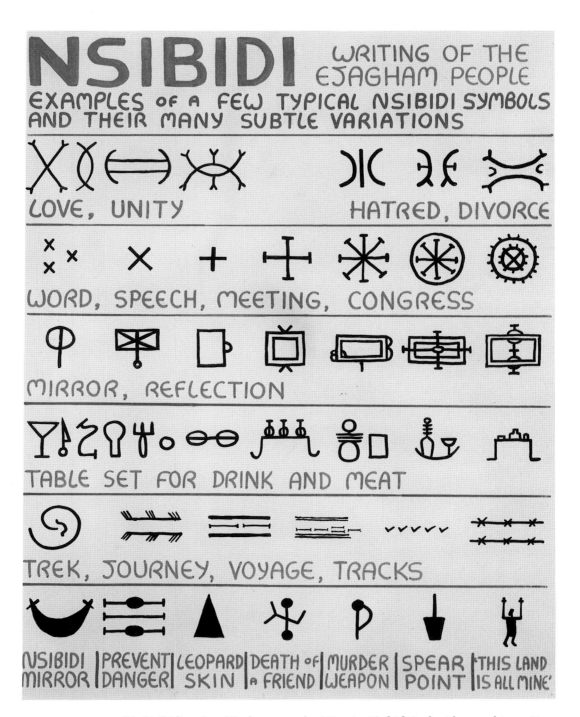

NSIBIDI WRITING OF THE EJAGHAM PEOPLE

EXAMPLES OF A FEW TYPICAL NSIBIDI SYMBOLS AND THEIR MANY SUBTLE VARIATIONS

LOVE, UNITY HATRED, DIVORCE

WORD, SPEECH, MEETING, CONGRESS

MIRROR, REFLECTION

TABLE SET FOR DRINK AND MEAT

TREK, JOURNEY, VOYAGE, TRACKS

NSIBIDI MIRROR | PREVENT DANGER | LEOPARD SKIN | DEATH of a FRIEND | MURDER WEAPON | SPEAR POINT | 'THIS LAND IS ALL MINE'

97. *Nsibidi* script, Ejagham people, Nigeria. *Nsibidi* is the ideographic writing system of the Ejagham people of Nigeria. One sees it on tombstones, secret society buildings, costumes, ritual fans, headdresses, textiles, and in gestures and body and ground painting. Based on information in books by P. Amaury Talbot.

98. *Nsibidi* sign for physical and spiritual vision, Ejagham people, Nigeria. We will see this sign again in Cuba and in African-American folk arts in the United States.

Ejagham *Nsibidi* sign for
physical and spiritual vision, Nigeria

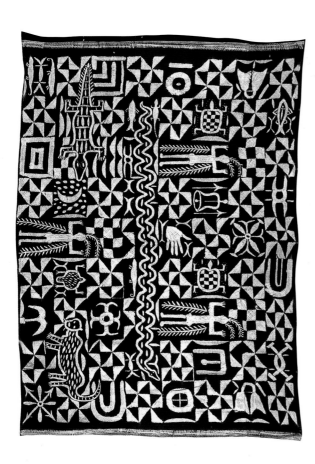

99. *Ukara* cloth, Ekpe society, Igbo people, Nigeria, 1980s. 106" x 70". Other Nigerian cultures have borrowed the idea of the Leopard *(Ekpe)* Society and *Nsibidi* designs that they also use in creating textiles. This cotton cloth is designed and resist-dyed by women controlling their *Nsibidi* designs. The *Ekpe* society honors the cool powers of the leopard, and men join who want to learn to govern calmly and wisely. Light and dark triangles and squares represent leopard spots. (Birmingham Museum of Art, Birmingham, Alabama; Museum Purchase)

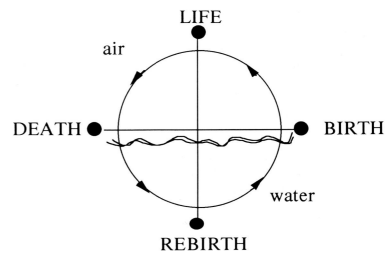

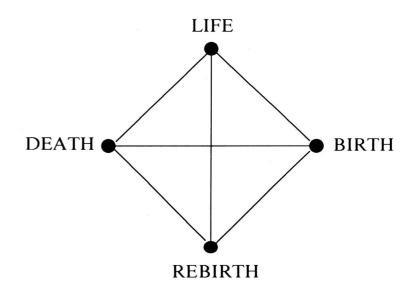

100. Cosmograms, Kongo people, Zaire. The Kongo cosmogram represents birth, life, death, and rebirth in the underwater world of the ancestors. Also referred to as the four moments of the sun, it symbolizes the four stations in the cycle of life. Souls of ancestors are believed to reside under water until reborn into the bodies of descendants. Simple and calligraphic versions of the cosmogram are found in ground paintings, graveyard arts, and on masks, sculpture, and textiles.

KONGO COSMOGRAMS

Angola.[29] We will see some of these same patterns in many African-American quilts (see figs. 113, 115, 118, 119, 120, 122), perhaps made by women who remembered *Nsibidi* writing, or the concept of the leopard society.[30]

Central African peoples, influenced by the religion of the Kongo people, practiced a healing, curing religion, promoted by priests who used symbolic art forms related to the Kongo cosmogram (fig. 100). This circle or diamond with four points represents birth, life, death, and rebirth in the world of the ancestors under the sea.[31] The top of the circle can be considered the noontime of life, the peak of power and potential. Its opposite, the midnight sun at the bottom, represents the power and position of the ancestors below the sea. To the left is the position of dusk, death, and transition from the land of the living to the watery world of the ancestors. To the right is the position of the rising sun, or birth. The horizontal axis represents the transition between air and water.

Kongo priests draw the cosmogram on the earth, and Kongo and related peoples bury their mummified chiefs in red cloth figures often decorated with the sign of the cosmogram.[32] Images like these red mummies appear in African–Latin American arts, in *Vodun* dolls in the United States, and in African-American quilts made in Mississippi.

Contemporary Mbuti people of the Ituri Forest area of Zaire are known for their painted barkcloth (fig. 101) decorated with ideographic and asymmetrical designs with jump styles, break patterns, and stress improvisation, as in West African prestige cloth.[33] Thompson notes,

> Richness of ideographic allusion was a strong point among some hunters and women talking about bark cloth, as summarized by the following observation: "I like this bark cloth because all the patterns are well arranged, all the designs themselves are good because they recall something."[34]

Some think the Mbuti influenced Kongo and Kuba textile arts. We certainly see the Mbuti emphasis on improvisational aesthetic and symbolic content in Kuba textiles (fig. 102), which so often carry diamond-shaped patterns, easily interpreted as the Kongo cosmogram.[35]

New World Scripts

In the New World, various mixtures of West African (Vai, Fon) and Nigerian *(Nsibidi)* scripts, the Yoruba concept of a crossroads, and the Kongo cosmogram fuse to create numerous new scripts, which are seen in folk art, including textiles. African-Brazilian signs, called marked points *(pontos riscados* or points drawn), can be found in ground paintings and on a green silk sash for the Yoruba god *Ogun*, as well as on a red 1969 charm.[36]

In Surinam, forms similar to signs in the Maroon ideographic system called *Afaka*, are appliquéd and embroidered by women onto loincloths and capes (fig. 103) for their men,[37] and painted by men onto houses and paddles, as well as carved on stools and houseparts. In St. Vincent, British West Indies, an African Christian made a copy onto cardboard of the chalk design that he had drawn on the floor of a mourning room before a service at which three pilgrims were "laid on the ground." He offered meanings for seventeen of the symbols, and commented, "Each pointer has a different alphabet. A working mother in the spirit can point souls, that is, can make chalk marks on the floor; not all will know it"[38] (fig. 104).

Cuban *Anaforuana* signs are seen on contemporary banners (fig. 105) that often feature four eyes for real and for spiritual vision, and in the reappearance of the men's secret-society costume featuring *Nsibidi* checks to represent leopard's spots and power.[39] Similar costumes are now seen in Miami, Florida, and some of these signs continue in African-American quilt-top designs.

Haitian ideographic signs, called *vèvè*, derive from a mixture of Fon, Yoruba, Ejagham, and Kongo traditions. People from all these cultures were taken to Haiti in the seventeenth and eighteenth centuries, and gradually their religions and their graphic forms merged with Catholicism into the *Vodun* religion. In Haitian art we see the reappearance of the Kongo cosmogram in textiles, ground painting, cut-steel sculptures, and in paintings depicting marriages, ceremonies, life, death, the watery ancestral world, and the rebirth of souls.[40]

Some Haitian textiles are considered protective. A pieced shirt, called a *Mayo*, features red and white, or red, white, and blue strips, and is worn for protection against evil.[41] And Melville Herskovits wrote of a multicolored garment called a *rade de penitence*, which he described as "a complex merging of European and African secular and religious customs.... For men this takes the form of a multicolored shirt, for women a dress whose colors are dictated by the loa [god]. In one instance a man wore a red shirt with black crosses appliquéd on it."[42] A similar shirt was illustrated in a 1985 issue of *National Geographic* magazine.[43]

Haitian *Vodun* flags (fig. 106), featuring sequined signs to honor syncretic gods, are touched together at the beginning of a *Vodun* ceremony. The flags announce the coming of a particular spirit to a shrine. *Mpeeve*, the Kikongo word for flag, refers to both fluttering and the presence of unseen spirits.[44] Related to *Vodun* flags are *Rara* (from Yoruba, meaning noisy)[45] festival tunics (fig. 107) and capes, vivid assemblages of paper, cloth, mirrors, and sequins, often with a sign for a god, which are worn by *major joncs*, men designated to recruit followers, attract donors, and protect the Rara band from magical attacks.[46]

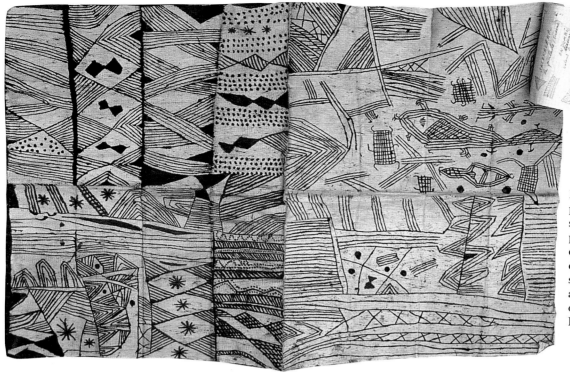

101. Painted barkcloth, Mbuti people, Zaire. 23″ x 37″. Some scholars think that Kuba appliquéd and embroidered designs may have been influenced by Mbuti painted designs, which may be linked to a symbol system of some antiquity. Photograph by Robert Farris Thompson.

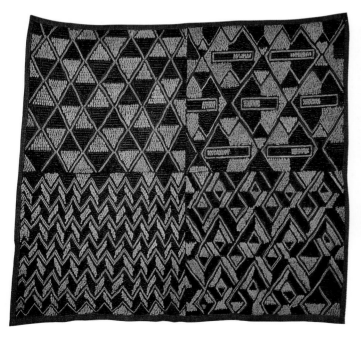

102. Woven raffia cloth, Kuba people, Zaire. 26″ x 24″. The triangles in this textile would not carry the same meaning that is associated with checks in Ejagham or Igbo textiles, but diamond shapes can refer to the Kongo cosmogram. Collected by Deborah Garner and Jay Bommer. (Private collection)

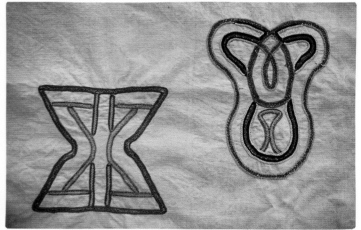

103. Embroidered cape, Djuka people, Surinam, 20th century. 30″ x 38″. The embroidered designs are derived from the writing system called *Afaka* after its inventor. *Afaka* is derived mainly from *Adinkra* designs and Ejagham *Nsibidi* script, but other African writing systems presumably were also incorporated. *Afaka*-derived designs are also found on carved calabashes, stools, paddles, combs, houseparts, and painted paddles and houses. Photograph by Maude Wahlman. (American Museum of National History, New York)

104. Ground painting, St. Vincent, British West Indies, before 1968. 12″ x 13½″. An African Christian made a copy on cardboard of the chalk design that he had drawn on the floor of a mourning room before a service at which three pilgrims were "laid on the ground." He offered meanings for seventeen of the symbols and commented, "Each pointer has a different alphabet. A working mother in the spirit can point souls, that is, can make chalk marks on the floor; not all will know it." Collected by Jeannett Henney in St. Vincent.

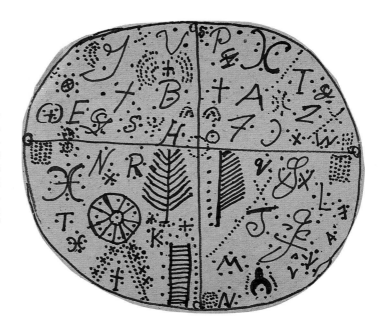

105. *Anaforuana* banner by Yuppi Pratt, Cuba, 1989. 35½″ x 37½″. African-Cubans incorporated aspects of several African ideographic systems (mainly *Nsibidi* and the Kongo cosmogram) to create *Anaforuana*, their own unique symbol system. A young artist, Yuppi Pratt, deliberately incorporates *Anaforuana* designs in his banners painted on cloth. Collected and documented by Judith Bettelheim. (Private collection)

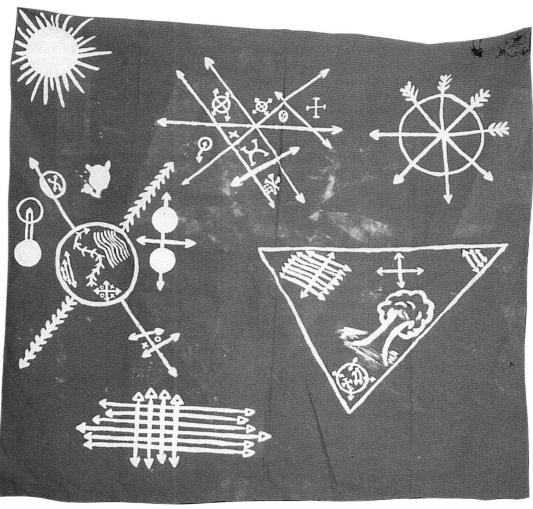

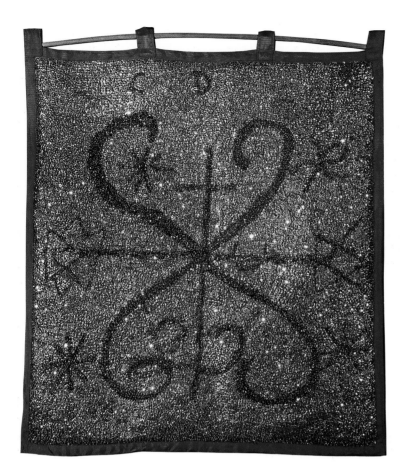

106. *Vodun* flag for *Damballah*, Haitian people, Haiti. 32″ x 27″. The *Vodun* religion of Haiti is based on several African religions and Catholicism. *Vodun* incorporates numerous African ground-painting traditions in its script, called *Vèvè*. This flag is embroidered with sequins that form *Vèvè* designs for *Damballah*, a West African god of the Fon people, represented by a rainbow or a snake. He reappears in Haiti, where the snake motif is most common. The cross is both Catholic and a reference to the Kongo cosmogram. The stars can be derived from Ejagham protective signs. Collected by Richard Gasperi. (Private collection)

107. *Rara* shirt, Haitian people, Haiti. 1990. 34″ x 17″. We see examples of *Vèvè* embroidered with sequins on this *Rara* costume worn by members of a musical troupe as they travel before Mardi Gras. The main *Vèvè* sign depicted is a heart, symbol for *Erzulie*, Haitian goddess of love, influenced by memories of the Yoruba goddess of love, *Oshun*. Collected by Robert Cargo. (Private collection)

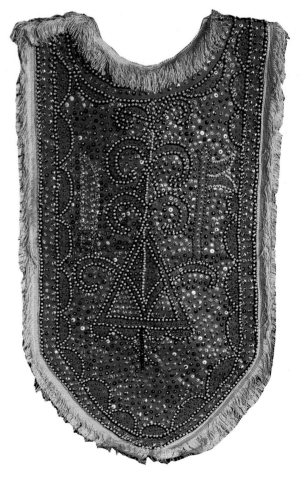

African-American Signs

After Haitian independence in 1804, many free Africans came to New Orleans, and the *Vodun* religion spread throughout the southern United States. Vestiges of African-American protective-writing traditions, often incorporating Masonic symbols, occur in folk art. As do their counterparts in Brazil, Cuba, Haiti, and Surinam, African-Americans use symbols on many levels. On one level symbols can be explained as Christian or Masonic, while on another level the same symbols have deeper African meanings revealed only under special circumstances to special people.

An exploration of Prince Hall Masonic symbols led to evidence that the manipulation of secret symbols by African-American secret society members contributed to the success of the American Underground Railway.[47] Gladys-Marie Fry writes that quilts were used to send messages through the underground railroad. Log Cabin quilts made with black cloth were hung on a line to indicate a safe house of refuge.[48] Joyce Scott reports, "My mother was told that slaves would work out a quilt, piece by piece, field by field, until they had an actual map, an escape route. And they used that map to find out how to get off the plantation."[49] Elizabeth Scott's Star quilt records the positions of stars as they appeared in the South Carolina sky. She mentions a special shooting star in the center of the quilt. Her parents called it a devil star, one that could be seen only every ten years by looking through a wax cloth.[50]

All this brings us to questions regarding symbols in African and New World secret societies. Symbols are embedded in works of art; artifacts are history-encoded. We need to read African-American art more carefully to discover fully the complexities of African-American history.

Protective Writing

Certain writing continued to have protective powers in African-American culture, even when the writing was in English. Newsprint has been placed on the walls of Southern homes, and in shoes as well, partly for protection against the weather, but in African-American homes (fig. 108) to protect against evil enslaving spirits, in the belief that "evil spirits would have to stop and read the words of each chopped up column" before they could do any harm.[51] Trudier Harris tells me this concept derives from the African-American practice of leaving a Bible open at night so that the power of religious words would protect a family against nighttime evil.[52] And Roger Abrahams communicates that in many early literate cultures, if one wanted a wish fulfilled, or wanted protection for a child, one put a Bible under the pillow.[53] Rose Perry Davis reports that when her brother, Pam Perry, went to war, he sewed a copy of the Twenty-third Psalm inside his hat.[54]

Busy African-American quilts are protective in the same sense as newspapered walls, with their hard-to-read, asymmetrical designs and multiple patterns. In particular, a quilt of around 1900 from Triune, Tennessee, by Josie Covington (fig. 109) can be compared to newsprint on walls.[55] Both convey multiple messages in printed words and magazine photos, or in ideographic Nine Patch, Wild Geese, and triangle images.

Willie Williams, from Mississippi, takes the newspapers-on-the-wall tradition and frames it, using magazine cut-outs (fig. 110). And, of course, Romare Bearden was influenced by this tradition in his well-known collages (fig. 111). Quilters from his hometown of Charlotte, North Carolina, also affected his art. He remembered quilting bees and used those memories in some of his own collages (*Quilting Time, Patchwork Quilt 1969, Patchwork Quilt 1970*). He even compares his use of collage with what quilting ladies were doing.[56] African-American painters (including Horace Pippin,[57] Jacob Lawrence,[58] John Biggers[59]) were also obviously influenced by African arts and African-American quiltmaking traditions.

Many African-American painters also incorporate vestiges of half-remembered writing systems in their arts. In Georgia, J.B. Murry painted secret signs that he says must be read by looking through a glass of water,[60] and Nellie Mae Rowe featured *vèvè*-like designs in many of her paintings.[61] Minnie Evans, from North Carolina, clearly depicted the Kongo cosmogram in numerous drawings.[62]

Quilts with letters on them may not necessarily refer to secret scripts. Quilters often celebrate the first letter of their first name (fig. 112) for purely decorative reasons. However, we also find script-like quilts. A strip quilt made between 1825 and 1850 by African-Americans living at Jackson Hill, Georgia, was done in a Wild Geese pattern, with rows of triangles separated by wide strips.[63] A twentieth-century example of the Wild Geese quilt, made by Seleen Rimbart of Tennessee, features a diagonal improvisation (fig. 113) upon the pattern, while still using strips.[64] The Wild Geese pattern was and is popular all over the United States, especially among African-American women. Its popularity may derive from the symbolic significance of the triangles. Among the Ejagham and related peoples of Nigeria, Talbot noted that triangles serve as symbols for leopards' spots and for footprints in a path, or a journey.[65] The cognitive similarity between journey and flying geese is easy to understand. In Anglo-American quilts, the Wild Geese pattern usually features identical triangles, while in many African-American quilts the triangles vary in color and sometimes shape.

One particularly intriguing quilt (see fig. 79) was made in Virginia around 1840–1850 by an unidentified quilter. A curator recognized Masonic and seemingly Pennsylvania German elements among the designs,[66] but the American

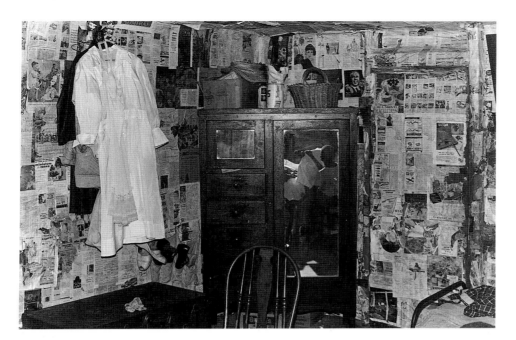

108. Newsprint on walls, Amanda Gordon's house, Mississippi. Putting newsprint on walls probably derives from the West African belief that writing is protective because it incorporates knowledge. Thus writing or vestiges of writing are seen in West African textiles and religious costumes. In African-American homes, putting newsprint or magazines on the walls keeps out the cold and it also keeps evil spirits busy, for it is believed that they must read everything before they can do any harm. Photograph by William Ferris, Jr.

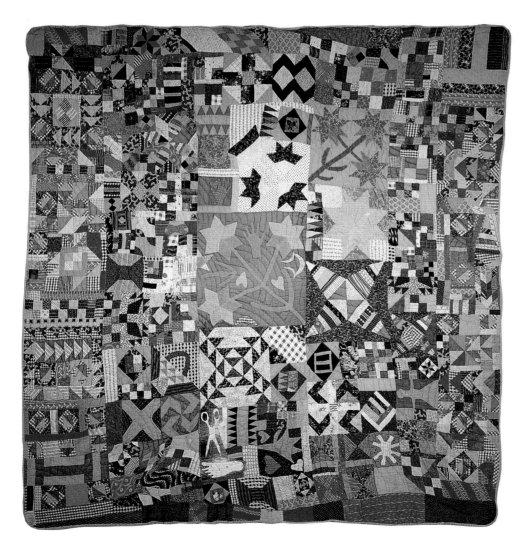

109. Album quilt by Josie Covington, Triune, Tennessee, 1895. 81″ x 80″. First published by John Vlach in 1978, this quilt exemplifies the African-American principle of protective multiple patterning because evil spirits would have to decode the complex mixture of many patterns before they could do any harm. Also note the appliquéd hand and foot, for "hand" is another term for the protective African-American charm, *Mojo*.

110. Collage by Willie Williams, Mississippi, 1984. 12½″ x 16″. Drawing on the African-American tradition of newspapered walls to protect a house from evil spirits, Willie Williams transforms the tradition into a joyful celebration of American images. Collected by Terry Buffington. (Private collection)

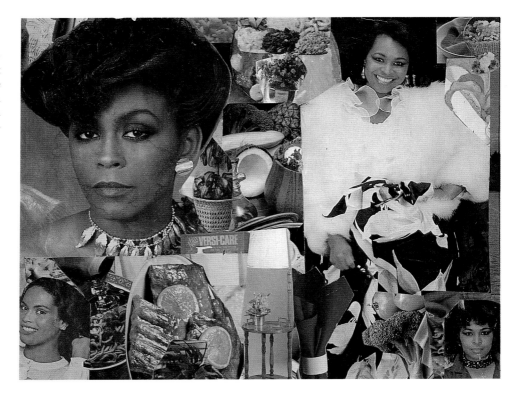

111. *Ritual Bayou* by Romare Bearden (1912–1988), 1972. 16¾″ x 21¼″. Drawing on the African-American tradition of newspapered walls to protect against evil spirits, Romare Bearden created a fine multiple collage. One can see the cultural sources in the multiplicity of symbols. (Cornell Fine Arts Museum, Rollins College; Gift of Mr. and Mrs. Robert L. Gardner)

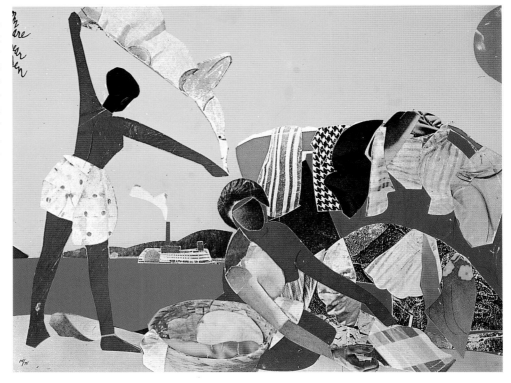

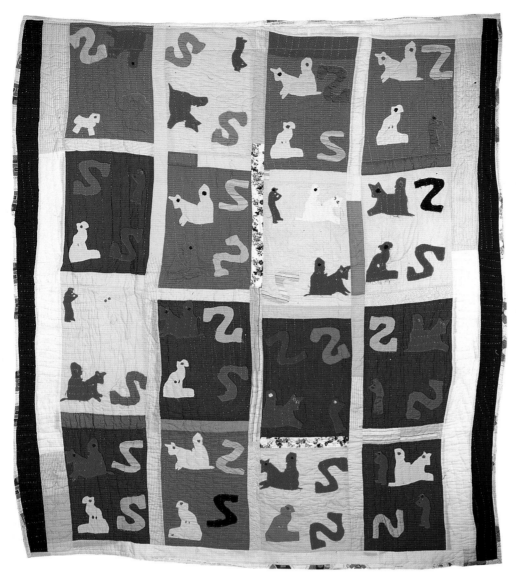

112. S quilt by Sarah Mary Taylor, Yazoo City, Mississippi, 1983. 87″ x 75½″. Because writing incorporates knowledge it is considered protective in West Africa, and so writing is incorporated in charms as well as found on ceremonial costumes. Thus it is not surprising to find letters used on a quilt top. Here Sarah Mary Taylor celebrates the first initial of her first name in this S quilt. Collected by Maude Wahlman. (Private collection)

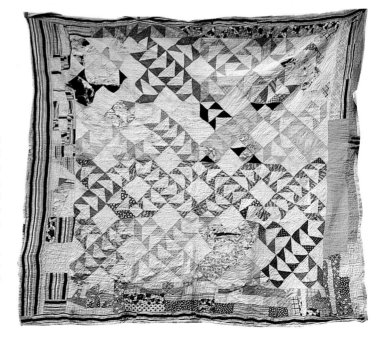

113. Wild Geese quilt by Zeleen Rimbert, Alabama, c. 1920. 70″ x 65″. The Wild Geese pattern is popular all over the United States, especially among African-American quilters. Its popularity may derive from the historic significance of the triangles. In Nigeria, triangles symbolize leopards spots, footprints in a path, or a journey. Photograph by Dominic Parisi, 1975. (Collection of the quilter)

art historian, Jules Prown, denies any Pennsylvania German connections.[67] A closer look and a knowledge of Haitian ideograms makes one think of the mixture of *Vodun* and Masonic signs in *vèvè*. The quilt has different designs arranged in nine squares with narrow strips between each square, and a floral border. The seven crossed designs are especially similar to Haitian *vèvè*. The central design shows a couple surrounded by two concentric circles, which is why it has been called a wedding quilt. An alternative explanation would be to compare this design to the Ejagham sign for a lodge with a meeting.[68] The lower right square incorporates some designs that look like the Masonic bisecting forms of two compasses. A similar design is seen in the Ejagham *Nsibidi* script and in African-Surinam *Afaka* script. In both cultures, the sign below

refers to love or marriage. The lower center square is full of stars, Ejagham signs of speech, and perhaps a reference to the North Star that guided many north to freedom. The Big Dipper was known as "The Drinking Gourd" to African-Americans.[69]

It may not be possible to prove that this is an African-American Masonic quilt, but that possibility cannot be denied. A similar appliquéd quilt top with *vèvè*-like designs can be seen in *Stitched from the Soul: Slave Quilts from the Ante-Bellum South*, by Gladys-Marie Fry.[70] The appliquéd quilt top, embroidered with the date March 19, 1852, was made by a man named "Yellow Bill," a resident of the William Dean Plantation in New Orleans. Another small appliquéd quilt with symbolic motifs (diamonds, crosses, and suns) may have been made as a memorial for a child, or as a protective quilt to ensure the renewed health of a sick child, or as a baptismal robe.[71] The symbols are variations on the Kongo cosmogram, a sign of rebirth.

The Biblical Textiles of Harriet Powers

One can decode the various symbols in Harriet Powers' two Bible textiles (see figs. 77, 78) from Fon, Kongo, Christian, and Masonic viewpoints,[72] further evidence to me that Harriet Powers was a powerful person who was encoding important cultural information into an art form that was acceptable for the 1880s and was not threatening to white people. Harriet Powers' use of symbols in her appliquéd Bible quilts reveals a knowledge of how to manipulate symbolic designs on several levels. On one level the symbols can be read as Christian; on another level they can be interpreted to explain Fon and Kongo cosmology. The Fon have a cross sign for their sun-god,

Lisa, also represented by a chameleon.[73] The Kongo diamond represents the four moments of the sun. Crosses, diamonds, chameleons (in the garden of Eden), and multiple suns are seen on Harriet Powers' quilts. Sea Island, Georgia, Gullah peoples speak of a protective cross made on the ground.[74] On a third level Powers' appliquéd symbols may be references to the secret signs of Masonic lodges.[75] And on a fourth level, the symbols she uses may also refer to the workings of the underground railroad.[76]

Appliquéd suns are the most elaborate pieced shapes in the two nineteenth-century quilts by Harriet Powers. African-American quiltmakers could have preferred sun-like designs because they remembered either Ejagham, Kongo, Haitian, or Cuban designs, or because they were similar to Anglo-American patterns such as the Mariner's Compass. I postulate that sun-like motifs were originally maintained due to memories of the Kongo cosmogram, but later the original meanings were forgotten. Considering the fact that one third of all African-Americans in the United States came from Zaire and Angola, this is not improbable.

I suggested in October 1990 that the apron worn by Harriet Powers in the only known photograph taken of her is not a domestic apron but a ceremonial one, as it has appliquéd symbols for a bright sun, a dark sun, and a cross, all religious symbols in West and Central Africa. It has an elaborate zigzag border, as on ceremonial aprons found among the Fon and Yoruba peoples of West Africa. A contemporary Masonic apron purchased in Athens, Georgia, shows a common Masonic symbol appliquéd on the front. The symbol of the compass and the ruler derives from an abstraction of the cross of Solomon. The top and bottom parallel lines have been removed so that one sees two intersecting arcs, later represented by the compass and the square. This sign is similar to the Ejagham sign for

love or marriage.[77] Harriet Powers may have held a high office in one of the secret Masonic societies for women,

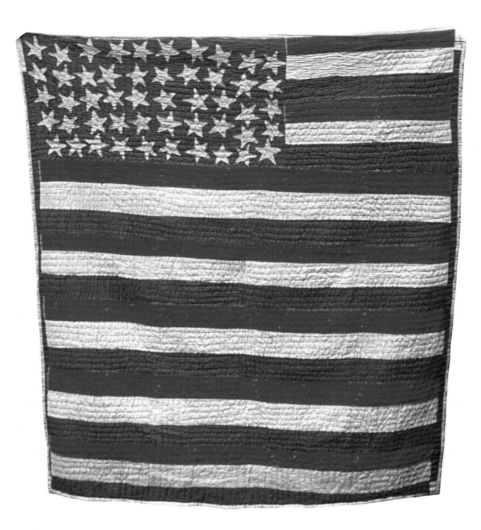

114. Flag quilt by Pecolia Warner, Yazoo City, Mississippi. 85″ x 75″. Pecolia said that she dreamed about making this quilt after having seen an American flag at the post office. In her interpretation it has become an African-American version of a protective Haitian *moyo* shirt. Collected by William Ferris. (Center for Southern Folklore, Memphis, Tennessee)

115. Love Knot quilt by Pecolia Warner, Yazoo City, Mississippi, 1982. 85″ x 74″. Pecolia referred to the four octagonal shapes in each square as the "eyes" (i.e. the burners) of a stove. Historically, they bring to mind the Ejagham belief in four eyes, the eyes of physical and spiritual vision. Collected by Maude Wahlman. (Private collection)

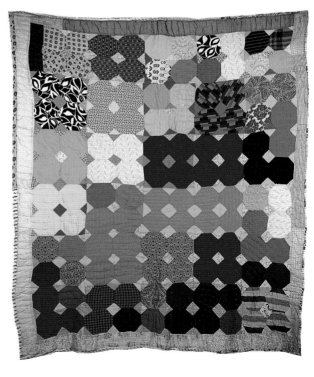

and she or her husband or son could have belonged to the International Order of the Good Templars, a secret organization that did admit women early in its existence.[78]

A Flag Quilt

In 1980 Pecolia Warner made her Flag quilt (fig. 114), a red, white, and blue stripped version of a United States flag. She said, "I had just laid down the other night. And I seen myself piecing a quilt. I got up and told Sam about it. I said, 'Sam, I seen a pattern in my sleep, a United States flag.' I said, 'I can piece that.' I saw the flag at the Post Office. I can piece that, I dreamed of it."[79] In her hands it has become an African-American version of the protective Haitian Mayo, a shirt with strips, red, white, and blue colors, large designs, asymmetry, at least two patterns, and stars that resemble the Ejagham symbol for speech and are also a protective sign for Africans in Haiti.

The Broken Stove or Love Knot pattern is also popular among African-American quilters. Pecolia Warner referred to the round shapes in her Love Knot quilt (fig. 115) as the "eyes" of the stove and of the quilt. The four eyes may allude to the Ejagham belief in two sets of eyes, the second set being for spiritual vision (see fig. 98). The concept reoccurs in Cuban scripts (*Anaforuana*) in combination with the Kongo cosmogram. There the circle is divided into four, with a small circle in each quadrant.[80] Joanna and Plummer T Pettway create quilt blocks (fig. 116) with four appliquéd circles, resembling the Ejagham precedent.

Checks

Checks are another popular old African-American quilt-top pattern remembered from early childhood (figs. 117, 118). Checked designs can be made from the smallest scraps, and also allow for maximum contrast between squares without elaborate preplanning.[81] Checked designs are transformed into the popular Nine Patch block design also often seen in Anglo-American quiltmaking traditions. I think that the ancestors of some African-American quilters, like Martha Jane Pettway and her daughters Joanna and Plummer T adopted Nine Patch and other checked and triangular patterns (fig. 119, 120), like Wild Goose Chase, because they resembled the nine-square patterns of West African weaving,[82] the Nigerian leopard society resist cloths,[83] or the checked designs so often seen in Kuba raffia cloth.[84] Another quilter from Boykin, Alabama, said in 1981,

We got pretty patterns. My daddy would work across the river in the white folks' yards, and he'd always bring newspapers home to paper the house for Christmas, and us see them different puzzles and things in the newspapers. Us would set down and cut up some cloth, make something like that puzzle in the newspaper and name it whatever us wanted to name it.... Some of those patterns was named Hand in the Wrist, Finger Five, and Nine Patch.[85]

Crosses, Circles, and Diamonds

Cross-like patterns occur frequently in African-American quilts (figs. 121, 122, 123). Although now interpreted as Christian crosses, they could once have been adopted because of a resemblance to the Yoruba belief in sacred crossroads, or the Kongo symbol for the four points of the sun.[86] Mary Twining commented on a design in a quilt made in John's Island, South Carolina: "It was not a Christian cross, according to residents.... It represented danger, evil, and bad feelings."[87] Many African-American artists are inspired by dreams—dreams that recall memories of forms seen in childhood. Arester Earl used many symbols that can be interpreted as vestiges of African secret society scripts. In her dream quilts (fig. 124) we see what may be a vestigial memory of the Kongo cosmogram, a symbol for Kongo belief in birth, life, death, and rebirth.

Circular designs, like crosses, may have once been a means for remembering the Kongo cosmogram. A pinwheel pattern (fig. 125) evokes the circular nature of the cosmogram, the rebirth of souls into the bodies of grandchildren. A wheel quilt (fig. 126) and a Double Wedding Ring quilt (fig. 127) could have the same function.

Charley Logan (1891–1984; fig. 128) was an amazing preserver of African traditions. An old man from East St. Louis, he embellished walking canes with thread designs and stitched diamonds all over his clothing (fig. 129). Befriended by Ken and Katie Anderson, they watched him over several years stitching script-like designs onto his clothing that also functioned as charms, enclosing money and other potent artifacts.[88]

While contemporary quilters do not speak openly of quilts as protective coverings or as confusing to evil spirits, their aesthetic choices (fig. 130) do imply traditions that once had protective significance and may be a continuation of protective African ideographs. African-American quilts are sometimes asymmetrical and improvisational in their designs and multiple patterns partly because of a traditional technical process and because of earlier, now perhaps lost, desires to confuse the reading of the text-like designs to strangers or evil spirits.

116. Appliqué quilt by Plummer T Pettway, Boykin, Alabama, 1979. 75″ x 67″. Exhibited in "Ten Afro-American Quilters." A remarkably sophisticated quilt if one interprets the various symbols appliquéd and incorporated from selected printed fabrics, which could refer to secret African scripts. The checks are similar to Ejagham Leopard Society cloth; the diamonds are often seen in Central Africa as a representation of the Kongo cosmogram; the large light and dark circles, as in Harriet Powers' quilts, could be derived from a memory of the Kongo sun of life and the midnight sun of the ancestral world. The four round black and white circles, also found appliquéd on Joanna Pettway's quilts, are very similar to the Ejagham sign for physical and spiritual vision (fig. 98). The small hand may be a reference to the African-American charm called a *Mojo* or a "Hand." Collected by Maude Wahlman. (Private collection)

117. Diamond quilt by Alean Pearson, Oxford, Mississippi, 1985. 77″ x 64″. The diamond, like other diamonds in African-American art and culture, may have once referred to the four moments of the Kongo sun. Collected by Maude Wahlman. (Private collection)

118. Diamond Strip quilt by Lucinda Tomer, Macon, Georgia. 80″ x 68″. A classic strip quilt, this pattern also brings to mind the use of light and dark squares and triangles in cloth made by Nigerian women for use by men in the Leopard Society; the light and dark shapes symbolize the spots of the leopard and his power. Similar references to vague memories of a leopard society occur in other African-American folk arts. (Museum of American Folk Art, New York; Gift of William A. Arnett) 1990 .7 .1

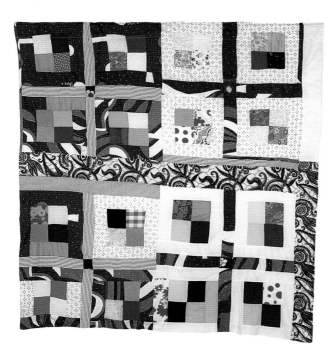

119. Check quilt by Joanna Pettway, Boykin, Alabama, 1979. 77″ x 68″. Exhibited in "Ten Afro-American Quilters" and in "For John Cox' Daughter." This was originally a quilt top given to Mary MacCarthy, one of the founders of the Martin Luther King Freedom Quilting Bee. Joanna Pettway shows her talents as a designer here, creating checks that could easily be accepted in Africa for use in a religious context. Collected by Maude Wahlman. (Private collection)

120. Box Variation quilt by Plummer T Pettway, Boykin, Alabama, 1991. 82″ x 82″. Based on a simple four-part Box pattern and "strings," this quilt becomes remarkably complex when one considers all the other symbols that are evoked from historical precedents: the Box pattern seen on West African armored horses, the woven strips of the Asante with colored blocks, the Ejagham checkered Leopard Society cloth, and the West African red cloth charm. Collected by Maude Wahlman. (Private collection)

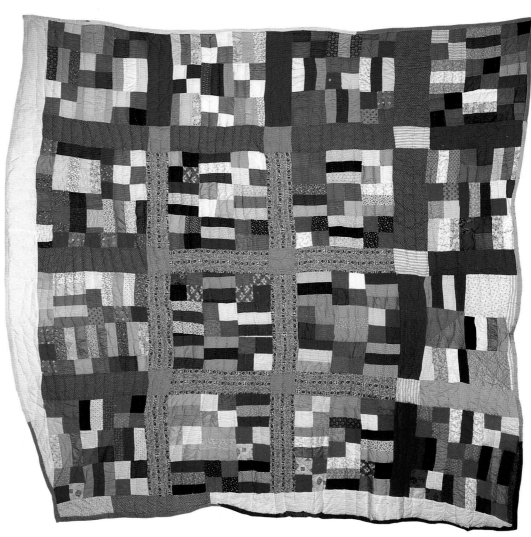

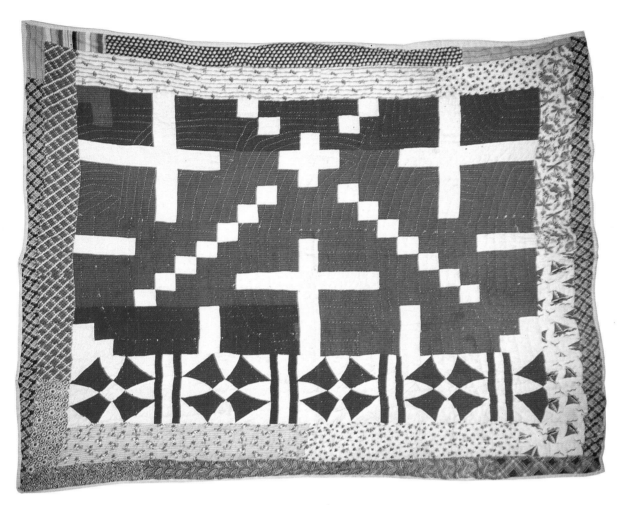

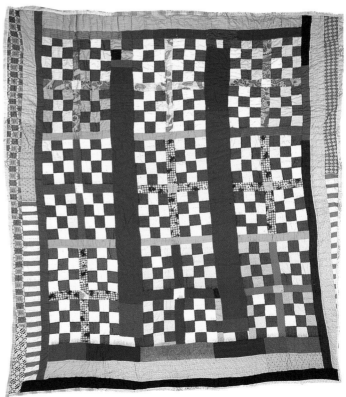

121. Cross quilt, artist unknown, Alabama, c. 1950. 70″ x 81″. This quilt is included because it features a dominant white cross, which in Africa and the southern United States can carry double meanings as a Kongo cross and a Christian cross. New World religions often syncretise African religions and Christianity, thus creating new institutions from a combination of elements. (Robert Cargo Collection)

122. Cross quilt by Sarah Mary Taylor, Yazoo City, Mississippi, 1985. 76″ x 68½″. Although this looks like a simple Nine Patch quilt, we know from a study of African textiles that checks, in Nigeria, can symbolize leopard spots in certain textiles. We also know that for Central African peoples, and for Africans in the New World, the cross can be both a Kongo and a Christian cross. The large red strips remind us of the dominant West African technique of constructing textiles from vertical strips. Collected by Maude Wahlman. (Private collection)

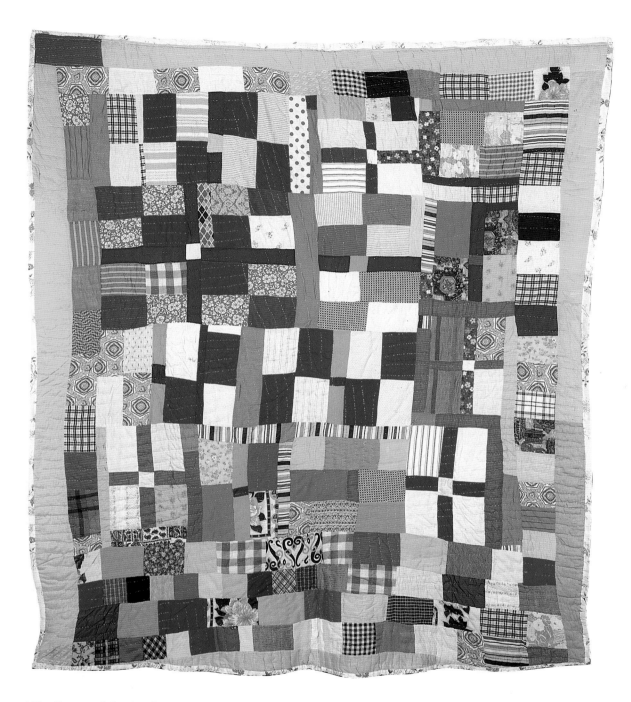

123. Cross quilt by Sarah Mary Taylor, Yazoo City, Mississippi, 1985. 82″ x 74″. This is a more complicated variation on the idea of the cross known to carry several meanings. This quilt also incorporates possible vestiges of the knowledge of Nigerian checked cloth also seen in Cuba and Miami. Collected by Maude Wahlman. (Private collection)

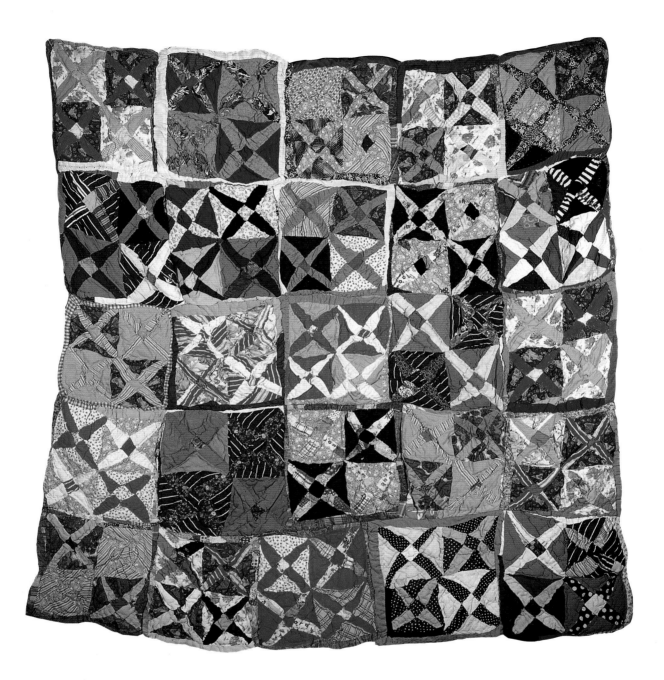

124. Dream quilt by Arester Earl, Atlanta, Georgia, 1981. 92″ x 87″. Exhibited in "Ten Afro-American Quilters." Many African-American artists, including Arester Earl, are inspired by dreams that recall memories of images seen in childhood. They dream of the forms they use in their art. In Arester Earl's "dream quilts" we see a cross that may represent a memory of the Kongo cosmogram, a symbol for the Kongo belief in birth, life, death, and rebirth. Collected by Maude Wahlman. (Private collection)

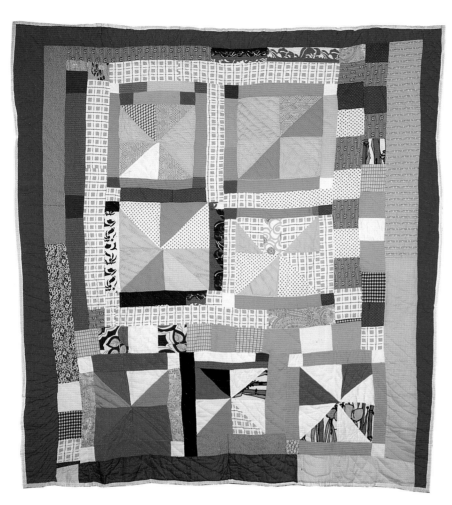

125. Pinwheel quilt by Joanna Pettway, Boykin, Alabama, 1981. 79″ x 73″. Exhibited in "Ten Afro-American Quilters." A pastel version of a pinwheel—a child's toy perhaps, or a potent re-creation of the idea of the Kongo cosmogram, the cycling of souls from birth, to life, to death, and then, if pure, to rebirth again. Collected by Maude Wahlman. (Private collection)

126. Wheel quilt by Marion Entwhistle, Louisiana, c. 1970. 70″ x 80″. Wheels in African-American folk art usually bring to mind the cycling of life predicted by the Kongo cosmogram. Collected by Robert Cargo. (Private collection)

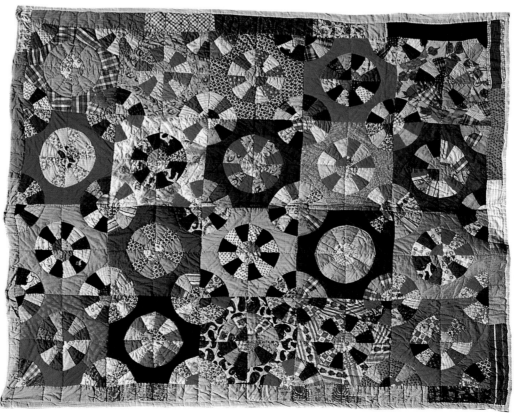

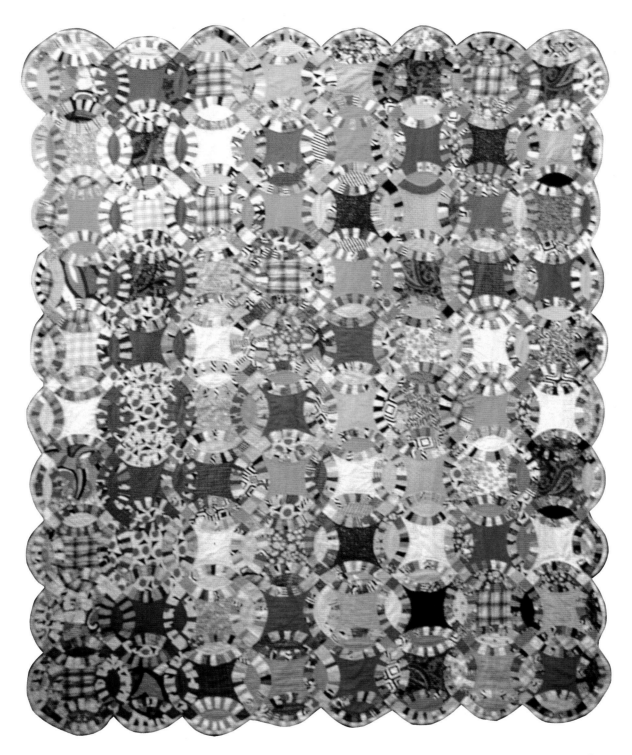

127. Double Wedding Ring quilt by Isadora Whitehead, Oakland, California. Mrs. Whitehead decorated a whole room with Double Wedding Ring designs and writing. She also collected five hundred quilts and spoons to send to refugees in Ethiopia. She traded this quilt to Eli Leon in exchange for his help in acquiring the five hundred quilts.

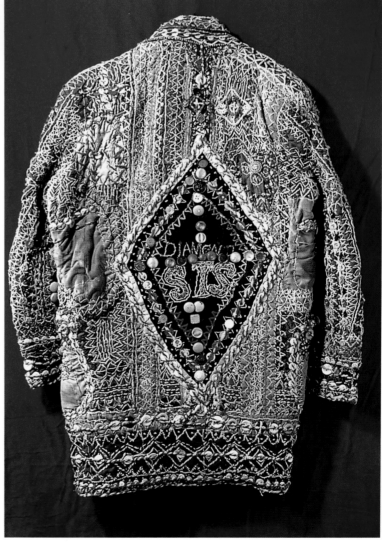

128. Charlie Logan (1891–1984), East St. Louis, Illinois. Katie and Ken Anderson befriended Charlie Logan, an old man who made fantastic canes and clothing very much in the tradition of Mardi Gras costumes. He was fond of using the diamond pattern both inside and outside his clothing. Photograph by Ken Anderson.

129. Diamond Sis coat by Charlie Logan, East St. Louis, Illinois, 1990. The diamond is a common symbol of African-American culture in the southern United States for the four directions or the four stations of life. Here we see it proudly displayed on the back of one of Charlie Logan's fancy coats. He also embroidered diamonds inside his clothing, often encasing coins in the process. Photograph by Maude Wahlman. (Collection of Katie and Ken Anderson)

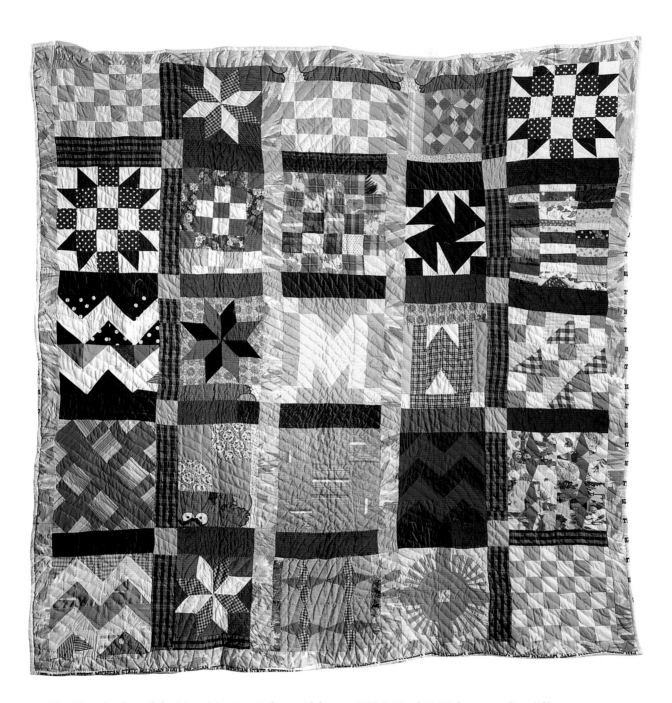

130. Everybody quilt by Mary Maxtion, Boligee, Alabama. 1989. 91½" x 85". With twenty-five different squares carrying eighteen different visual messages, this quilt could possibly be coding of all kinds of cultural information—consciously or unconsciously—a grouping of images that also have historic meaning. (Museum of American Folk Art, New York; Gift of Helen and Robert Cargo) 1991 .19 .2

CHAPTER 4:
Protective Charms

Various African traditions of healing or protective charms have experienced a renaissance in African-American visual arts, including quilt tops. As these protective concepts were retained in the New World, they took different forms and different meanings, partly because ideas from West and Central Africa fused and then creolized with Native American and European ideas, and partly because of new cultural environments.

Charms are an important aspect of African-American religious societies. Charms are made in Africa or the New World by man and woman, priest or priestess, conjureman or conjurewoman, spirit-diviner or folk artist, on commission from clients with political, personal, physical, emotional, or religious problems.[1] Priests and priestesses make charms to suit specific needs, so each charm is different; each is an improvised solution to an individual need. Some are meant to protect, made to ward off evil; others to heal. Charms are accumulated arts, arts made with magical ingredients, either on the inside or the outside. Beads, buttons, coins, claws, feathers, and shells are attached to cloth and costumes to imbue them with protective powers.[2] One can explain some elaborate masks or masked costumes as charms enclosing special bodies in symbolic elements. Kings, for example, are often cloaked in beaded garments to signify power.[3] Charms can thus be large or small; they can stand alone (like dancers) or be attached to something else. They can move or be stationary on an altar.

West African Charms
In West Africa there is a tradition of enclosing writing in charms, because of the knowledge the people consider to be inherent in the writing. These small square packets, often of red leather, cloth, or metal, enclosing script, are worn around the neck and are sewn on hunting, religious, and war costumes, as protection against evil spirits. A child's shirt (fig. 131) may have cloth charms sewn onto it to protect the child. The Tuareg peoples enclose charms in intricate leather and metal designs. The Yoruba peoples put charms on cloth and shirts. Robert Farris Thompson writes that a Yoruba ancestral (*Egungun*) cloth costume (see fig. 19) from Nigeria can be used as a charm against evil.[4] Textiles are a key ingredient in making charms, whether made in Africa or the New World.

Kongo Minkisi
In Central Africa, the Kongo *Minkisi*, or the medicines of God, appear in numerous forms, activated by reciting verbs of action. The goal is to activate the powers that ancestors have to make charms work. *Minkisi* medicines fall into two classes: those materials such as shells, graveyard earth, and clay, which represent spiritual powers; and magical things such as animal claws and tools, which direct action to the client. Thompson reports that important charms could be put upon a cosmogram painted on the ground; and some Kongo priests place charms and ideographic signs on the walls of their shrines in order to neutralize negative forces.[5] Northern Kongo people often asked Pygmy experts to make their good-luck charms for hunters and athletes.[6]

Ceramic vessels with liquid medicines were early types of Kongo charms.[7] Another form occurs in Kongo graves with symbolic objects—references to the watery world of the ancestors. Cloth bags, usually red, could be tied at the neck, with feathers at the top.[8] This cloth type of *Minkisi* is sometimes seen on ceremonial hats (figs. 132, 133) where the charms are surrounded by buttons or animal claws. Beads were often applied to artifacts to make them into protective charms (fig. 134). The ultimate charms were large cloth figures, wrapped with red blankets, "used to transport the smoke-mummified bodies of the most important persons from this world to the next," and often protected with the cosmogram sign to ensure the prosperity of the Kongo nation.[9] Smaller "reliquary mannequins, called *Muzidi* or *Kiimbi,* functioned as vessels for hair, nails, human ashes, and other relics of important persons."[10]

A wooden charm often took a human or animal shape, with a hollow in the center for the magical curing substances. This cavity was sealed with glass, a shell, mica, or a mirror, all references to the watery land of the Kongo ancestors. Nails were sometimes used to activate these wooden charms. We can see a fusion of the cloth form and the wooden form in the African-American *Vodun* doll.

New World Charms
When these charm-making ideas were passed along in the New World, they took different forms and different meanings. African charm-making traditions influenced African–Latin American and African-American charms and textiles.[11]

African-Brazilian charms, for love and war, called *ponto de seguar* (securing points) are small cloth containers designed to stop a spirit or attract a person to its owner. These charms are sealed with tight crisscrossing cords.[12] Protective charms also take the form of wooden hands,

132. Ceremonial hat, Kongo people, Zaire, 9″ x 9½″. This hat is covered with protective cloth *Minkisi*, or the medicines of God, enclosed in cloth charms. The hat would have been worn by a priest or priestess as a symbol of power and authority. Collected by Charles Jones. (Private collection)

131. Child's charm shirt, Monrovia, Liberia, 1980s. 18″ x 7½″. This shirt was made from two strips of handwoven men's weave sewn together and decorated with small charms covered with red cloth. Collected by Charles Jones. (Private collection)

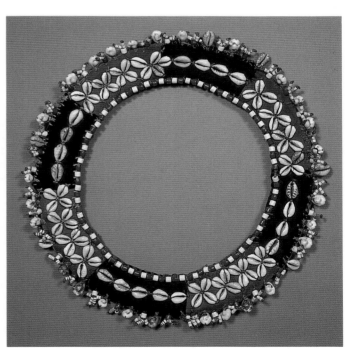

133. Ceremonial hat, Kuba people, Zaire, 17″ x 10″. This hat is covered with protective cloth *Minkisi* as well as animal claws to activate the charms. The hat would have been worn by a priest or priestess. Collected by Charles Jones. (Private collection)

134. Patchwork collar, Kuba peoples, Zaire, W. 12″. This collar may have been worn as a type of charm, for it is embellished with cowrie shells. Collected by Deborah Garner and Jay Bommer. (Private collection)

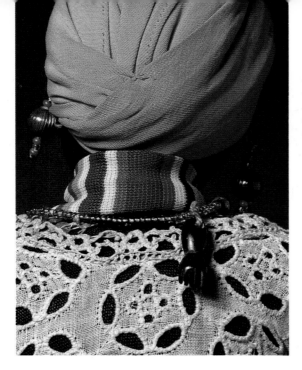

135. Hand charm on *Oshun* doll, Yoruba people, Brazil, South America, 1940. H. ¾″. *Figas* are protective charms in Latin America. Although made in many forms, the most popular form seems to be the hand. *Figas* are often attached to necklaces, and can hang in front or back.

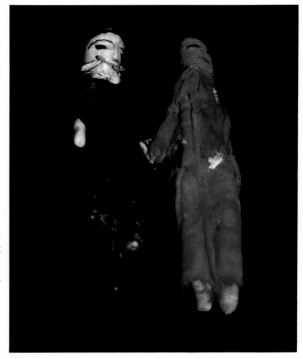

136. Doll charms, Brazil, South America, 20th century. W. 2″. Probably made as charms, these are two of six red and black figures, and each pair is pinned together as if joined in a dance. (National Museum of Natural History, Smithsonian Institution, Washington, D.C.)

137. *Pacquet Congo*, Haiti, c. 1960. H. 6″. Small tightly wound Haitian charms enclose protective medicines in cloth, with arms, beads, ribbons, and sequins. Some have earrings or lace ruffles, and are meant to represent female spirits. In 1953, Maya Deren noted in *Divine Horsemen* that "Pacquets Congo...are bound as magical safeguards...whose efficiency depends on the technique of careful wrapping (the idea being to enclose the soul well, as to keep it from evil)." Collected by Fay Leary. (Private collection)

138. *Vodun* doll, Louisiana. H. 10″. Made from Spanish moss, this doll would have been used to protect against disease or evil spirits (unhappy ghosts), as in Africa. (Collection of William Fagaly)

called *figas*.[13] Some are large, while small ones are often attached to a necklace. An even smaller one (fig. 135) is attached to the necklace of a Yoruba priestess doll (see fig. 21).[14] The Smithsonian Institution has several red-and-black cloth dolls pinned together as if in a dance (fig. 136); presumably they were made to be used as charms.

In Surinam, Melville Herskovits discovered numerous charms, called *Obia*, used to protect, warn, and heal members of secret societies.[15] Other specially prepared necklaces, armbands, and belts were worn for protection against sickness and evil spirits.[16] In African-Cuban culture one finds beaded charms, tied charms, and pots with cosmogram-like signs and magical ingredients. Many African-Cuban examples are now appearing in Miami. I expect many of these ideas will appear in new African-American quilt top patterns. African-American quilts have been described as protective baffles to guard loved ones in the night.[17] Eli Leon discovered a quilt with two pennies sewn into one corner. When quilters were questioned, Wanda Jones said that both her grandmothers sewed pennies in all four corners of their quilts to represent the four corners of the earth.[18] We are just beginning to examine the many ways in which African-American artists use textiles to protect, heal, and encode ideas.

Pacquet Kongo
In Haiti, the Kongo cloth charm is still very much alive in the form of *Pacquet Kongo*, small, tightly wound charms (fig. 137) enclosed in cloth, with arms, beads around the neck, ribbons, and sequins. Some have earrings, or lace ruffles, and are meant to represent female spirits.[19] Maya Deren noted that "Pacquets Congo…are bound as magical safeguards…whose efficiency depends on the technique of careful wrapping (the idea being to enclose the soul well, so as to keep it from evil)…"[20] In Haiti, there are allusions to *Mbaka*, little red figures thought to be messengers from the dead among the Kongo.[21] They look like the small Kongo reliquaries, and there are examples in Haitian paintings. In Haiti and Cuba they are called *Baka*.[22]

Vodun *Dolls*
In the United States, these African and African-Caribbean cloth charm traditions evolve into several new forms. One is the *Vodun* doll, which can be traced back from New Orleans (fig. 138) to the Haitian *Pacquet Kongo* and the *Baka* figures of Cuba and Haiti, to Kongo red mummies, Kongo wooden *Minkisi* with nails, and other Kongo cloth charms. One also sees these spirit figures in contemporary African-American folk paintings.

A calabash *Vodun* doll, made by Clementine Hunter, was found on the Melrose plantation in Louisiana (fig. 139). A 1950 black cloth doll was recently discovered in Alabama with mismatched socks to confuse and thwart malevolent spirits.[23] The African-American folk painters Nellie Mae Rowe and Lizzie Wilkerson recently made

dolls (fig. 140) with red arms and legs, but neither woman would explain why she used red cloth.[24] Often these dolls are made with pins to activate them, just as Kongo wooden charms are activated by nails.

The protective powers of *Vodun* dolls may have been forgotten, but some quilters continue to use the form in new ways. Sarah Mary Taylor and her mother Pearlie Posey appliquéd designs featuring red figures reminiscent of *Vodun* dolls on quilts and pillows. They name their patterns *Men* (fig. 141), *Dolly Dingle Dolls* (fig. 142), *Cowboys* (fig. 143), *Man with Two Dogs* (fig. 144), and *Fashionable Ladies*. Sarah Mary Taylor says,

> When I first started to quilt, I was a child. I was piecing up four patches and nine patches. But here, last year is the first time I just really started to piece fancy quilts. Well, I pieced my first great big man, wide man. Now I was sitting down with a piece of newspaper and I cut him (fig. 195). I told my mother, "I believe this would be pretty on a quilt." Then I got up and got me a square piece of cloth and laid him on it and sewed it down, and it seemed to look pretty good so I went on from there. You see, just like something come to my mind and I say I'm going to do just like that and I piece it. I don't care what time of night it is, I just get up and piece a block of it and after I piece that block, why I don't stop again until I've gone and pieced the top. When I be doing it, be trying to see how pretty I can make it, just how I picture it in my mind.[25]

Sarah Mary Taylor later made a quilt (fig. 145) with one figure, cut from the same template as used for her doll quilts, but now representing herself. She appliquéd cut-out shapes for her address and phone number. Thus, the quilt serves as a poster, advertising her skills as an artist. Lately, she has not been able to quilt as easily, due to arthritis. She has turned her talents and her creative energies to drawings, mostly of people.

Mojo
The African-American term *Mojo* refers to a hex or spell, healing medicine, and the charm or amulet used to lift a spell or protect one from evil forces, as in the folk song "Got My Mojo Working," popularized by blues singer Muddy Waters.[26] A small square red African-American cloth charm is called a "Mojo," or a "Hand" (in the sense that a charm is a helping hand), and it fuses West African and Central African charm concepts.[27] Graphic hands are seen on the houses of West African priests, and as protective shapes in many cultures.[28] In Brazil, carved wooden hands, called *figas*, are sometimes worn as charms, as on a doll dressed as a Brazilian Yoruba priestess (see fig. 135).

Zora Neale Hurston collected this information about a "hand":

139. Calabash doll by Clementine Hunter, Natchitoches, Louisiana. H. 12″. Signed by Clementine Hunter, this doll comes apart to reveal secret compartments that were undoubtedly intended to contain magical, protective ingredients. Collected by William Fagaly.

140. Cloth doll by Nellie Mae Rowe, Vinings, Georgia, 1980s. H. 36″. Nellie Mae Rowe was a prolific painter who used symbols that can be traced back to African and Caribbean religious arts. She also was a quilter and made many dolls, some with red cloth.

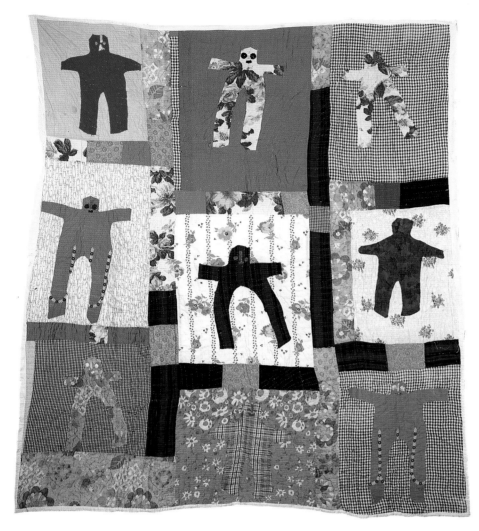

141. Men quilt by Sarah Mary Taylor, Yazoo City, Mississippi, 1979. 80″ x 68″. The red-velvet appliquéd man is similar in particular to the Kongo red mummy, the mythological Caribbean *Baka*, as well as African-American *Vodun* dolls. Collected by Maude Wahlman. (Private collection)

142. Dolly Dingle quilt by Pearlie Posey, Yazoo City, Mississippi, 1981. 80″ x 75″. Exhibited in "For John Cox' Daughter." Also known as Dolly Dimple, this pattern was inspired by a doll that was printed on feed sacks. However, the ways in which Pearlie Posey and Sarah Mary Taylor appliquéd doll shapes, some with red eyes, make one think of *Vodun* dolls. Their other quilt designs also make reference to African-American religious ideas.

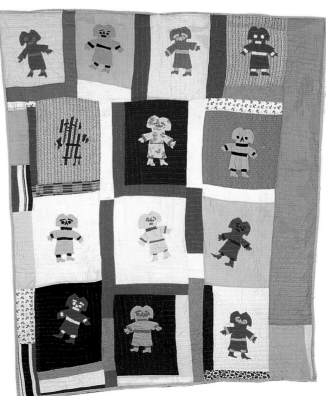

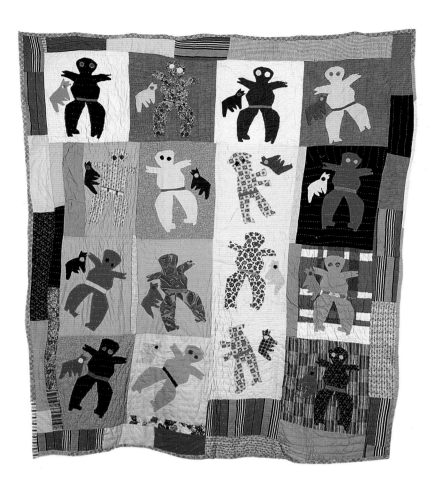

143. Cowboy quilt by Pearlie Posey, Yazoo City, Mississippi, 1981. 73″ x 64″. The cowboys can be interpreted as *Vodun* dolls. Collected by Maude Wahlman. (Private collection)

144. Man with Two Dogs quilt by Sarah Mary Taylor, Yazoo City, Mississippi, 1981. 75″ x 67″. The appliquéd men could be interpreted as *Vodun* dolls. The dogs can be interpreted as Kongo messengers from the ancestors. Collected by Maude Wahlman. (Private collection)

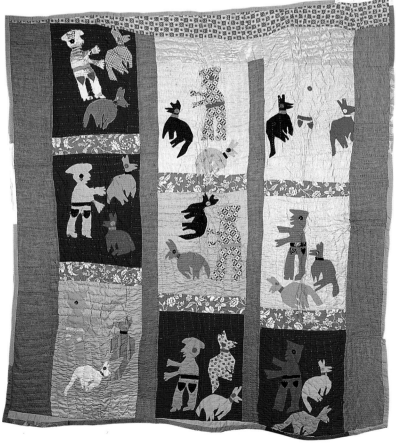

145. Sarah Mary quilt by Sarah Mary Taylor, Yazoo City, Mississippi, 1981. 85″ x 70″. Exhibited in "Ten Afro-American Quilters." Sarah Mary Taylor made this quilt when her aunt, Pecolia Warner, was receiving attention as a master quilter. The appliquéd figure represents Sarah Mary. The appliquéd letters and numbers represent her address and phone number. She did not remember what she originally intended to communicate at the bottom; I suspect it was "Made in America." Collected by Maude Wahlman. (Private collection)

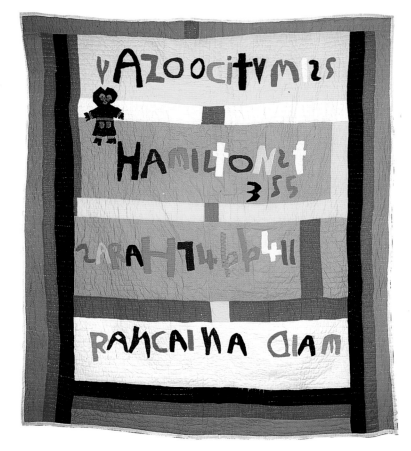

146. Log Cabin quilt by Sarah Mary Taylor, Yazoo City, Mississippi, 1984. 77″ x 69″. One notes the red squares, the same size, shape and color as an African-American charm or *Mojo*. Collected by Maude Wahlman. (Private collection)

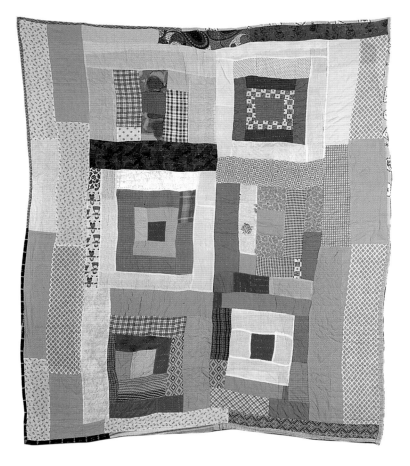

Take a piece of the fig leaf, sycamore bark, John de Conquer root, John de Conquer vine, three paradise seeds. Take a piece of paper and draw a square and let the party write his wishes. Begin, "I want to be successful in all my undertakings." Then cut the paper from around the square and let him tear it up fine and throw it in front of the business place or house or wherever he wants. Put the square in the "hand" and sew it all up in red flannel. Sew with a strong thread and when seams are closed, pass the thread back and forth through the bag 'til all the thread is used up. To pour on "hand": oil of anise, oil of rose geranium, violet perfume, oil of lavender, verbena, bay rum. "Hand must be renewed every six months."[29]

During the Civil War, triangles in a quilt design signified prayer messages or a prayer badge, a way of offering a prayer,[30] or asking for protection. Many African-American quilters prefer patterns, such as Nine Patch or Log Cabin, which incorporate small red squares (figs. 146, 147, 151) that look like a Mojo.[31] Some are decorative; others may be allusions to protective charms. Nora Ezell comments,

My mama used to wear a "nition bag" under her clothes. If someone got a silver dollar, they would keep it in that bag and stay lucky. They were made of red or black cloth. Vodou is just common sense. If you kept a silver dollar in a bag, you wouldn't be broke. It's not luck. I've never made a charm. I've heard of conjurers all my life. The only one I know is the one up above. Hoodoo is really Vodou. I've heard many people say they believe in conjurers. I have strong ESP powers but I don't work to control them. My dreams tell me things that might happen. I don't push it.[32]

An 1895 Album quilt by Josie Covington (see fig. 109) is significant because it incorporates so many protective African concepts. The quilt has been pieced together in long strips that are hard to see because of the protective multiple patterning (as in newspapers on a wall to slow down evil spirits), and the center features an appliquéd hand, which Josie Covington had made by tracing the hand of her son, Sercy, when he was three.[33] There are also many small red squares. This may have been made as a protective quilt for Sercy, who was 86 in 1978.[34]

More recently, Sarah Mary Taylor of Mississippi produced a quilt, which she calls *Mermaid*, with appliquéd female figures on white squares (fig. 148). These figures could be derived from *Vodun* dolls or from the widespread "Mamy Wata" figure in African mythology and religion. In addition, the quilt design features numerous small red squares, the same size, shape, and color as the African-American "Mojo" or "Hand." One red square has an appliquéd blue hand adjacent to it, implying a knowledge of the other term for an African-American charm.[35]

Sarah Mary Taylor also made numerous Hand quilts, using the hand for its aesthetic and symbolic connotations (fig. 149). Ten hands from one of her quilts were reproduced in a poster used to represent the power and creativity of ten black quilters featured in a traveling exhibition. Sarah Mary Taylor's mother, Pearlie Posey, made a protective quilt that she called *Everybody* (fig. 150) and which includes *Vodun* dolls, hands,[36] letters, and red Mojo shapes. Pearlie Posey said,

Another one I liked pretty good. When she (Sarah Mary) was piecing different quilts and had so many blocks left and I had some of these old ones, star and Nine Patch. So I took all of them and made a quilt out of all different kinds of ones she had pieced and the different kinds I had pieced, and I named it *Everybody*.

In Atlanta, Georgia, the late Arester Earl made a series of significant African-American charm-like quilts. One features squares, many of which are red (fig. 151). Another three-dimensional quilt features gathered round puffs of cloth, called yoyos (fig. 152). Her most unusual quilt top was made with pleated and stuffed shells (fig. 153). The three-dimensional shells in many colors, patterns, and materials (mostly silk) are sewn onto a red cloth. This quilt is particularly significant because it illustrates three important Kongo religious principles: that of *Minkisi*, or the medicines of God (charms enclosed in cloth); the form and meaning of the shell, emblem of the sea, the world of Kongo ancestors; and the shape of the cross, or the Kongo cosmogram. That a quilter could have naïvely combined these potent Kongo religious symbols seems unlikely.

Protective Colors
The bold colors and large designs of the African-American textile aesthetic can be traced to memories of the communicative function of textiles in Africa, where they are worn and displayed as an indicator of social status, wealth, occupation, and history. The strong contrasting colors characteristic of African textiles are necessary to ensure a cloth's readability at a distance and in strong sunlight. Similar brilliant colors are found in African-American quilts. African-American quilters speak of "colors hitting each other right." Their creolized quilts are best seen from a distance, as in Africa, where most colors are seen at festivals and ceremonies. In contrast, sedate Euro-American quilts are meant to be admired and inspected in intimate settings.

African-American quilt colors can also indicate protective traditions. In Central Africa, when a person is painted

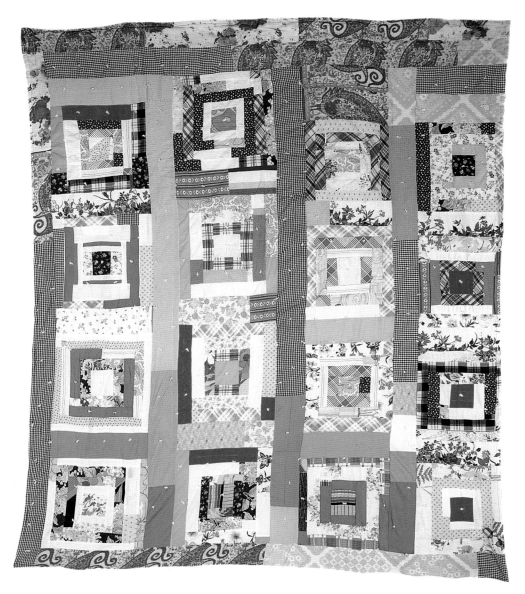

147. Log Cabin quilt by Mozell Benson, Waverly, Alabama, 1984. 87″ x 73″. Again, one notes the red squares, which are the same size, shape, and color as an African-American charm or *Mojo*. Collection by Maude Wahlman. (Private collection)

148. Mermaid quilt by Sarah Mary Taylor, Yazoo City, Mississippi, 1979. 77″ x 72″. The mermaids may refer to: 1) Mamy Wata, a West African and New World image; 2) a version of the Yoruba goddess of love, *Oshun*, or the Haitian goddess, *Erzulie*; or 3) to *Vodun* dolls. This quilt features numerous small red squares, the same size, shape, and color as the African-American charm called a *Mojo*. Collected by Maude Wahlman. (Private collection)

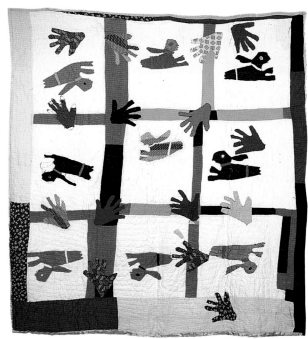

111

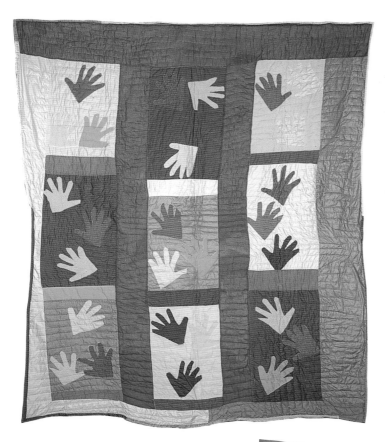

149. Purple Hand quilt by Sarah Mary Taylor, Yazoo City, Mississippi, 1985. 87½″ x 72″. The term "Hand," as in a helping hand, is another word for the African-American *Mojo* charm. This quilt was commissioned from Sarah Mary for use in the film, *The Color Purple*. Collected by Maude Wahlman. (Private collection)

150. Everybody quilt by Pearlie Posey, Yazoo City, Mississippi, 1981. 78″ x 67″. Exhibited in "Ten Afro-American Quilters." This quilt design includes pieced vertical strips, the letter P, as well as appliquéd hearts, hands, a *Vodun* doll, and a dog. While some may call this an Album quilt, Pearlie Posey called it her "Everybody quilt." It functions as a guide to many symbolic designs with African roots, and it could function as a protective quilt in that evil spirits would have to decode all these symbols before doing any harm. Collected by Maude Wahlman. (Private collection)

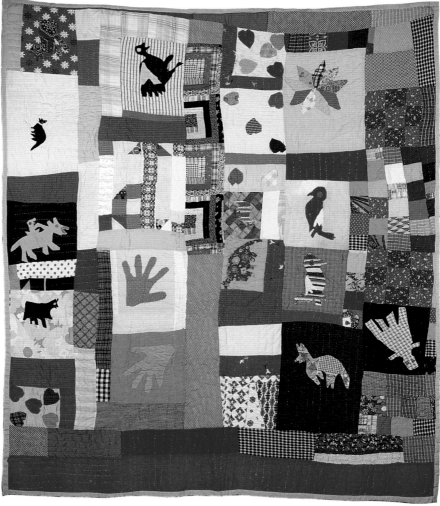

with red, white, and black spots during a Kongo healing ceremony, it signifies that the person has the power to defend himself or herself against "annihilating powers."[37] Red, white, and black are the colors used to fight against all sorts of disturbing influences in the living world. The addition of yellow indicates a contest with forces from the dead.[38] White, as seen in chalk or shells, can represent clairvoyance, mystical vision, and the presence of spirits, especially ancestors.[39] Red, from camwood tree bark, often stands for danger, blood, or power. Black, from charcoal, resins, and soot, represents chaos or evil.[40] Red ocher, an oxidized earth containing iron, is now thought to have been mined in South Africa with stone tools as early as 140,000 years ago for its cosmetic red color.[41]

Among the Yoruba people of Nigeria, white stands for character, the purity of intentions, and the source of knowledge and thought, and is identified with *Obatala*, the creator god.[42] Red is associated with *Shango*, a historic king of the city of Oyo, and later the Yoruba god of thunder. Red can also symbolize *ase*, the Yoruba concept of the power to make things happen and the power to make things multiply, which kings, like *Shango*, possess. *Shango*'s red and white beads symbolize the balance of character and power. Blue symbolizes coolness, composure, calculated thought, control, and generosity.

In Surinam, descendants of runaway Africans, the Djuka, make cloth charms in which blue is used to ward off the spirit of a dead enemy. "A bit of red cloth blinds the wearer to evil sights and makes him serene. A small strand of white cloth provides protection from the bad spirits called *Bakru*...bristles from the anteater give strength. All these charms make the obeiah bracelet a powerful affair."[43] Another magic device was a red necklace of macaw feathers, to bring luck in hunting.[44]

In Haiti, West African and Central African color ideas fused and appear in the form of red and white striped shirts, called *Mayo*, which are worn as protection against evil.[45]

Similar color symbolism has been documented in many African-American communities in the United States:

Nellie Brag, an old black woman of the Warrington, Ohio, area in the first half of the twentieth century was asked why she often went about wearing one red sock with a deliberately mismatched white one. Years later, after trust and friendship had been established between her and her interlocutor, she told the reason why: "To keep spirits away."[46]

At the University of Mississippi, I saw black students wearing tights with one red leg and one black leg. And an Alabama folk doll was made with mismatched socks, to keep evil spirits away.[47]

Zora Neale Hurston documented the following color symbolism in her article, "Voodoo in America": red for victory; pink for love; green to drive off evil spirits; blue for success and protection and for causing death; yellow for money; brown for drawing money and people; lavender to cause harm; and black always for death or evil.[48]

Caribbean blue shutters are used on the oldest house in Savannah, Georgia, "to keep away evil spirits." In South Carolina, Gullah people still paint doors and windows blue to keep away bad spirits.[49] Gladys-Marie Fry notes that for early African-American quilters, blue was believed to protect the maker.[50] Among Sea Island, Georgia, quilters, colors are warm or cold, emphasizing reds, blues, or whites. Red signifies danger, fire, conflict, and passion; blue is a good color used on doors to keep away evil spirits; white is a color that makes one good—a color used at weddings, funerals, and parties. Mary Twining writes:

Red, blue, black, and white are four important colors whose significance is linked to a deeper set of values and beliefs in culture. These have meanings beyond an exciting combination of colors which work well together.... The quilts are often made in striking chromatic contrasts such as red/blue or red/white—color combinations which suggest the binary opposites hot/cool, good/bad, safe/dangerous which are some of the dichotomous predicates that make up the dynamics of human societies.[51]

Most African-American quilters, when discussing their use of bright colors, explain that they look for maximum contrast when piecing scraps together. Sometimes the total design is preplanned, and the colors appear as symmetrical or consistent arrangements. More often scraps are pieced together as they come out of a bag or box, with last-minute decisions as to whether the pieces "hit" or show up well next to each other. Because quilters usually work with salvage materials of many patterns and colors, this piecing technique encourages asymmetrical designs and multiple patterns.

For Pecolia Warner (1901–1983), the colors in her quilts had symbolic meanings beyond their aesthetic function. White, red, black, blue, and yellow had meanings in her life and art. She said,

Red, that's blood. I don't want my house painted red. Red represents blood. But I like to put it in quilts—makes it brighter and show up. Blue is for truth. White is for peace. I gotta think about green. Yellow does stand for something. When a person dies you see the family wear all black. In a quilt that doesn't represent mourning. That makes it show up. They say that gold is for love. Silver is for peace. Brass is for trouble. Brass can turn so many different colors. It can turn black and get back to brass. It can turn two or three different colors. Glass has a meaning to it all right now. Clear like water. Yellow is like gold, it means love.[52]

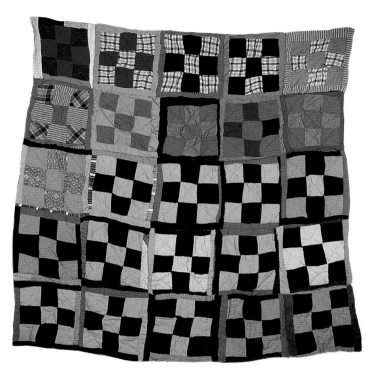

151. Nine Patch quilt by Arester Earl, Atlanta, Georgia, 1978. 85" x 82". Exhibited in "Ten Afro-American Quilters." The American Nine Patch pattern is popular among African-American quilters, perhaps due to its similarity in size and shape to a *Mojo*. Collected by Maude Wahlman. (Private collection)

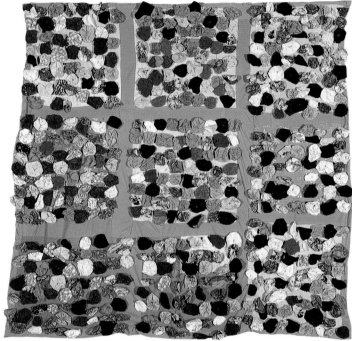

152. Yo-yo quilt by Arester Earl, Atlanta, Georgia, 1981. 60" x 60". The Yo-yo pattern is well known among American quiltmakers. But when Arester Earl uses it, and when one is aware of her other quilts with Kongo symbols, then the yo-yos take on additional meanings, for they can refer to Kongo cloth charms called *Minkisi*. Collected by Maude Wahlman. (Private collection)

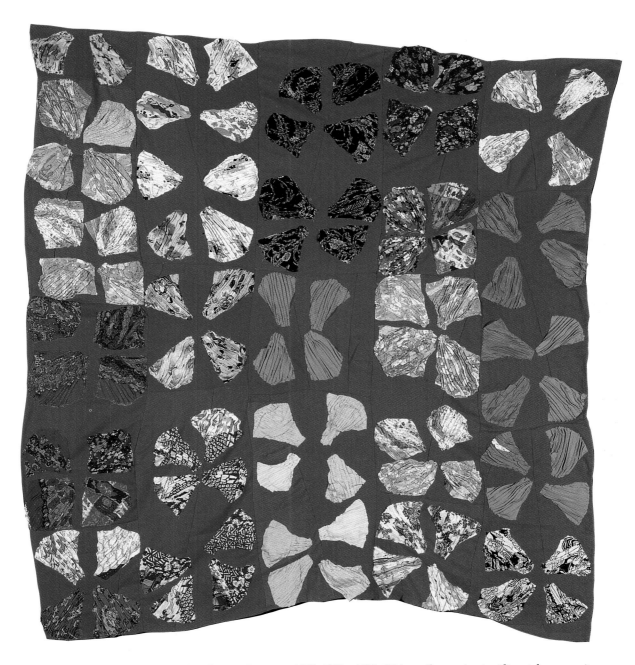

153. Shell quilt by Arester Earl, Atlanta, Georgia, 1979. 75″ x 70″. This quilt top is significant because it illustrates three important Kongo religious principles: 1) that of *Minkisi*, or the medicines of God (charms enclosed in cloth); 2) the form and meaning of a shell, emblem of the sea, world of Kongo ancestors; and 3) the shape of a cross, or the Kongo cosmogram. Collected by April Campbell and Maude Wahlman. (Private collection)

CHAPTER 5:

Conclusion

African-American quilting is a unique American art form, with its own history and style. Yet we must not forget that all arts exist within a cultural complex, as one aspect of the material objects produced by living peoples in concert with other aspects of their lives. These beautiful quilts symbolize more than just an art form; they also stand for a way of life full of laughter, tears, dance, music, hard work, money, birth, youth, school, childbirth, marriage, church, old age, and death. Some quilts were individual creations; many were group efforts. My next book on this subject will deal more specifically with the cultures that produce these textile arts. But I also wanted to introduce here the concept that one can read African-American quilts on many levels—aesthetic, technical, religious; as texts, as charms. Secret societies are well known and documented in Africa; the use of secret writing systems and charms by these societies is more and more evident. There is no reason to think that Africans would not have reconstructed these secret-society functions in the New World. Since textiles are a major aspect of secret-society activities in Africa, we can also expect textiles to carry a major role in the New World. As Fran Dorsey notes,

> When people are not permitted to celebrate their traditional ceremonies, speak their own langauges, or pass on their customs to their children, they do not relinquish those ideas; they just change the code so the oppressors cannot recognize what they are doing."[1]

Thus, while African-American quilt patterns involve aesthetic decisions, many of those aesthetic choices derive from rich cultural traditions. In their choice of techniques, textiles, forms, design names, and colors, African-American quilters perpetuate African techniques and ideas. Strip quilts reflect the strong Mande textile tradition that also manifests itself in African-Caribbean fabrics. Appliquéd quilts bring to mind Yoruba *Egungun* cloths, Yoruba *Shango* bags, Ibibio funerary hangings, and Ejagham *Ekpe* cloths, as well as Fon and Fante banners, flags, and umbrellas. Many quilt patterns may have been chosen because they awakened a memory of ceremonial textiles.

We can infer from the techniques and the aesthetic that certain quilt designs were preferred because they were analogous to significant cloth concepts in Kongo and West African cultures. This rationale makes sense demographically, for it is known that more than one-third of African-Americans came from Kongo and Kongo-influenced cul-

tures. An equally impressive number came from West Africa.

If only one or two African-forms occurred in African-American quilts, it could be coincidental. But the numerous instances of similar forms, and sometimes similar meanings, are evidence of a cultural heritage that is stronger than any one lineage. Like many other African-American folk artists, quilters are inspired by dreams. Quilters' dreams, like those of other folk artists, revive visual imagery from the culture of their childhood. Their dreams are culturally conditioned.

African-American folk artists have often been labeled idiosyncratic because they do not always know, or care to explain, the African traditions that shape their visions, dreams, and arts. African men and women remembered African artistic techniques and traditions when they came to the New World. They mixed and sorted their own traditions, then combined them with Euro-American and Native American ideas to create their unique creolized arts. Their combined ideas were passed down from generation to generation, thus preserving many African art traditions, even when unspoken.

Mozell Benson, born in 1934 in Alabama, comments, "Black families inherited this tradition. We forget where it came from because nobody continues to teach us. I think we hold to that even though we're not aware of it."[2]

Some well-known quilt patterns may have been adapted by African-Americans because they resemble important ideas in African religions. Small squares remind us of *Nsibidi* costumes for the Leopard society, or of script-enclosing charms from West Africa, or a cloth *Nkisi* from Central Africa. Some Anglo-American pattern names such as Flying Geese, Rocky Road to California, and Drunkard's Path indicate movement; while forms such as Bear's Paw imply potential action, as in Kongo charms, where objects are sometimes included because their names are puns for verbs of action. In Kongo religion, it is important to activate a charm to make it work, and words are often part of the process. Certain Anglo patterns may appeal to African-American quilters for numerous historic cultural reasons, visual and verbal.[3]

Most ideas highly valued by a culture are encoded in many forms. Such seems to be the case with African protective religious ideas that have been encoded into visual arts, songs, dance, and black speech in Africa and the New World. All these arts recognize improvisation as a style; and many refer to West African and Central African religious concepts that survive in contemporary African-

American cultures because they have been encoded so many ways. The redundancy indicates high value and ensures survivability. This book has attempted to explain the survival and transformation of African writing and charm traditions in only one form, African-American quilt-making. The evidence is equally rich, powerful, and eloquent for continuities between African writing and charm traditions in African-American architecture, ceramics, painting, sculpture, and environments.

The African-American Art Quilt

In the last ten years I have seen African-American quilt-making evolve in a new direction. Jesse Lane, Wini McQueen, Faith Ringgold, Joyce Scott, and others have drawn on traditional folk designs for inspiration in creating their fine art. They are an educated generation—trained as artists, yet proud of their mothers' folk art, proud of family heirlooms; and they chose to build on family cultural traditions in creating contemporary art.

Jesse Lane deliberately revives colorful Asante narrow-strip traditions in her quilts (fig. 154). Wini McQueen researched African art and now uses royal African images

and versions of African textiles in her quilts (fig. 155). Faith Ringgold consciously incorporates Africanisms in her works. Many of her story quilts are bordered with West African–style tie-dyed cloth pieced together in a Box pattern. She draws on both African-American storytelling traditions and textile traditions in her painted quilts (fig. 156).

Elizabeth Scott is well known for her elaborate appliquéd and embroidered quilts (figs. 157, 158). Her daughter, Joyce Scott, creates many types of textile arts, including altar pieces, clothing, dolls (fig. 159), and quilts (fig. 160). She is most famous for her satirical beadwork.

African-American textile arts provide evidence that American folk arts are not naïve, primitive, or simplistic. African-American arts are unique in America, fusing various international traditions to produce new ones. African-American artists maintaining this creolized aesthetic demonstrate the power and vision of African cultural traditions in contemporary American society, affirming the extraordinary tenacity of African technical, aesthetic, and religious ideas over hundreds of years.

154. Strip quilt by Jesse Lane, Gainesville, Florida. 70″ x 70″. A trained artist, Jesse Lane learned to quilt as a child. Her contemporary quilts grow out of her love for both folk and fine art traditions. Her Strip quilt harks back to the oldest of West African decorative textiles.

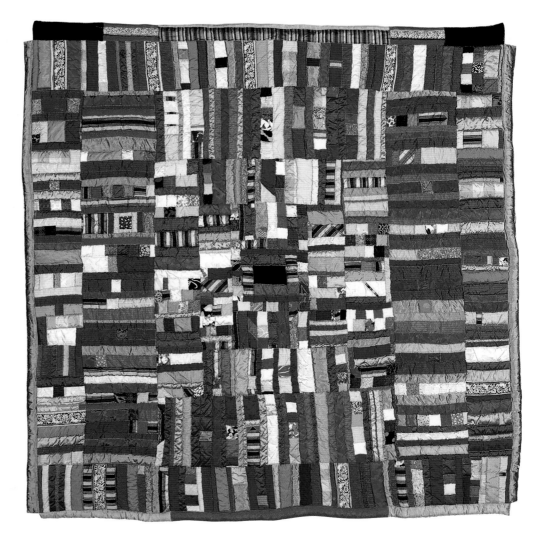

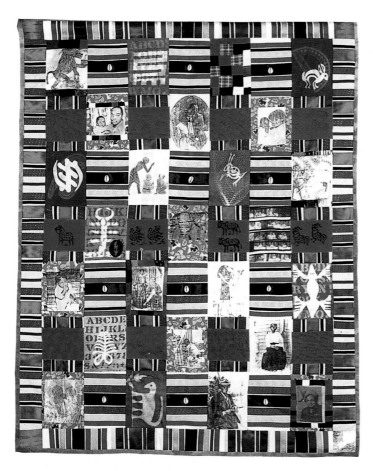

155. *Little Oba's Heritage* quilt by Wini McQueen, Macon, Georgia, 1987. 52" x 39½". This was designed as a crib quilt in 1987 for Ryan Darrell Kelly, the year-old son of Wini McQueen's cousin. A block from McQueen's first quilt, made when she was seven, is incorporated into *Little Oba's Heritage.* Using the narrow strip motif of West Africa, McQueen interspersed family photos with images of Egyptian gods, Adinkra symbols, and even pieced together satin hair ribbons to simulate royal Asante robes. Cowrie shells are added as a symbol of money, with the advice that knowledge is more valuable than money. (Collection of Ryan Kelly, Macon, Georgia)

156. *Tar Beach 2* by Faith Ringgold, 1990. 65" x 65". This is a silkscreen version of an original handpainted quilt inspired by happy childhood memories of summer evenings spent on cool rooftops in New York city. *Tar Beach* is one of five works from Ringgold's *Women on a Bridge Series,* in which she sets women against bridges in New York and San Francisco. Bridges represent masculinity, while the quilt medium represents feminism. The geometric patterns created by spaces between bridge girders are seen as quilts suspended in the air. This quilt reflects Faith Ringgold's belief in magic, for in it, Cassie Louise Lightfoot, the heroine and narrator, flies over buildings and the George Washington Bridge. Flying is an African-American folk-tale theme in which Africans flew to freedom. Copyright © 1990 by The Fabric Workshop, Philadelphia, Pennsylvania.

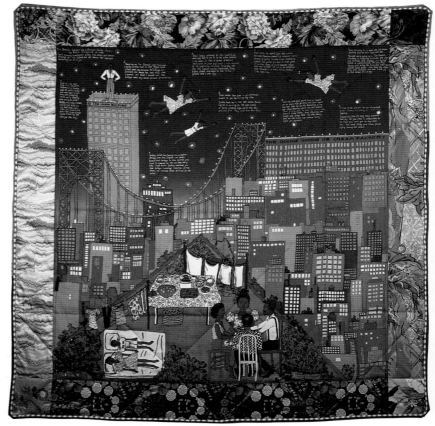

157. *Trouble in Mind* quilt by Elizabeth Scott, Baltimore, Maryland, 1979. Elizabeth Scott comes from a family of quilters, including her father, who lived in South Carolina. She remembers that they traded quilts with the Indians there, often for a load of wood. Her father worked at a blanket factory, so they often blocked out quilt squares with strips made from blankets. Elizabeth Scott describes her quilts as "diaries, as pictographic writing, documenting accumulative experiences." This quilt shows her knowledge of how different materials can be combined with embroidery, and it records in visual form symbols of her thoughts over the one year that it took to create this quilt. Photograph by Maude Wahlman. (Collection of the artist)

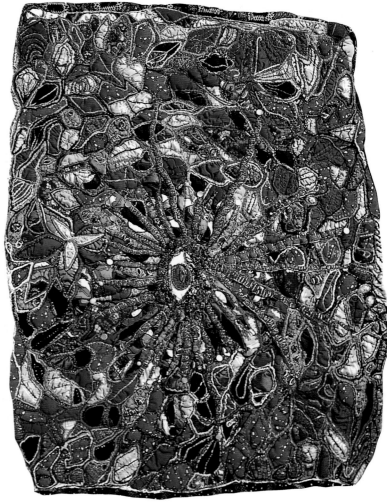

158. *Eyes of the Eighties* quilt by Elizabeth Scott, Baltimore, Maryland, 1990. 36″ x 32″. Inspired by the Masonic Eye, Elizabeth Scott shows how easily African-Americans borrow symbols from numerous traditions and make them their own by the unique ways in which they are combined. (Collection of the artist)

119

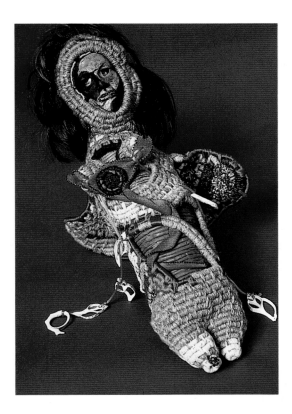

159. Doll by Joyce Scott, Baltimore, Maryland, 1978. Based on the African-American tradition of the protective charm, this doll is also an example of fine art sculpture.

160. Scott/Caldwell Family quilt by Joyce Scott, Baltimore, Maryland. 1989. 78″ x 72″. Joyce Scott is the daughter and granddaughter of quilters. As a trained artist she brings to her work a thorough knowledge of African traditions and African-American folk art heritages. She works with cloth and beads to create "happenings" in cloth and political statements with beads. (Collection of the artist)

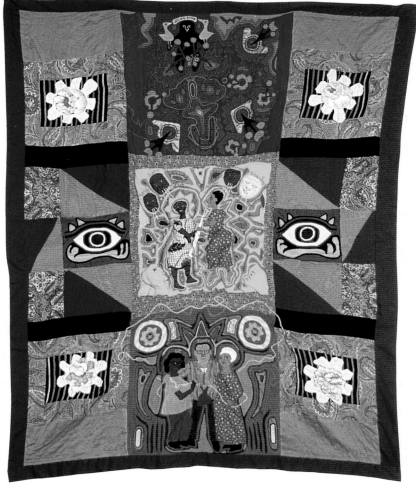

Glossary

Afaka—African-derived writing system of the Djuka people of Surinam, South America.

Anaforuana—African-derived writing system of the African-Cubans.

Baka—Small red figures in African-Caribbean folklore.

Bamana—West African people living in Mali.

Block—a quilt-top design element pieced into a square format. To "block" means to sew small strips on all sides of a pieced square. Different colors are often inserted at the corners.

Bogolanfini—Cloth woven in strips by Bamana men, then dyed by Bamana women with designs possibly derived from an indigenous West African script.

Bottle trees—African-American invention to keep evil spirits away by trapping them inside the pretty colored-glass bottles placed on the bare branches of a dead tree.

Candomble—African-Brazilian religion derived mainly from Yoruba beliefs.

Carneval—African-Caribbean festival that takes place before Lent.

Conjuremen and Conjurewomen—African-American folk priests or priestesses known to be able to heal with medicines and charms.

Cosmogram—Graphic representation of a religious belief system.

Creolized—The combination of elements from various cultural traditions to create something new and unique, as in a creolized language, a creolized art, a creolized cuisine, or a creolized religion.

Djuka—Africans who ran away from coastal plantations in Surinam and settled in the forest, where they recreated an African way of life. See Saramaka.

Egungun—Yoruba ancestral spirits, Nigeria.

Ejagham—Nigerian peoples who invented the *Nsibidi* system of signs.

Elegba—Yoruba god of uncertainty, of the crossroads, of unpredictability.

Fon—Dominant people of The Republic of Benin, formerly known as Dahomey, West Africa.

Funza—Kikongo term for God.

Hand—African-American term for a charm, also called a Mojo.

Hit—to "hit" refers to the juxtaposition of complementary (or clashing) colors for visual impact.

Hoodoo—A variation of *Vodun.*

Igboizing checks—refers to the dominance of the checkered motif among the Igbo and Ibgo-influenced peoples of Nigeria and Cameroons who have adopted the Ekpe (Leopard)-society textile traditions invented by the Ejagham peoples.

Kikongo—Language of the Kongo peoples of central Africa.

Kongo—Dominant people of central Africa; found near the mouth of the Congo River, Zaire.

Kongoizing circles—refers to the dominant circle motif among Kongo and Kongo-influenced peoples in central Africa, the religious meanings associated with that circle, and the prevalence of similar circles in African-American textiles.

Major joncs—Haitian men who lead a *Rara* band through the streets before Lent.

Mamy Wata—West African term for a mermaid-like woman often depicted with snakes.

Mande—A large language group in West Africa.

Mandeizing strips—refers to the dominant influence that itinerant Mande weavers had on many West African textile traditions, and the extension of that influence in America in the strip structure common to many African-American quilts.

Mbaka—Another name for *Baka*, small red figures referred to in African-Caribbean folklore.

Minkisi—Plural term for Kongo charms (see *Nkisi*).

Mojo—African-American term for a charm; derived from a Kikongo word for spark or soul.

Mpeve—Kikongo word for flag.

Multiple patterning—more than one pattern in a textile, a dance, music, or any work of art.

Munkeki—Kikongo word for a type of pot with a stirrup handle; this type shows up again in the New World.

Muzidi—Kikongo word for a mummy.

Nkisi—Singular word for a Kongo charm (see *Minkisi*).

Nsibidi—Ejagham term for their system of graphic signs.

Obia—African-Caribbean term for a charm.

Off-beat, a term borrowed from African-American music, and originally applied by Robert Ferris Thompson to the offsetting of weft designs in West African narrow-strip woven textiles. I have applied this term to the offset design units in African-American quilts, sometimes experienced as asymmetry.

Ogun—Yoruba god of iron.

Oshun—Yoruba goddess of love. Found in Nigeria, Cuba, Brazil, and the United States.

Pacquet Kongo—Haitian cloth charm with feathers, ribbons, sequins, etc.

Ponte de seguar—African-Brazilian term for a tied charm.

Pontos riscados—African-Brazilian term for a graphic system of signs.

Power eyes—African-Caribbean term for spiritual vision.

Prendas—African-Cuban ritual pot.

Rara—African-Haitian musical band that travels and plays before Lent.

Santeria—African-Cuban and African–Puerto Rican religion, based on several African religions, mainly Yoruba.

Saramaka—Africans who ran away from Surinam coastal plantations and set up an African way of life in the interior forest. See Djuka.

Strings—Small, rectangular scraps of cloth, sewn together along their long edges to create subunits for quilt-top patterns called Chimney, Log Cabin, Spider Leg, Spider Web, Twin Sisters, and other quilt designs.

Strip—to "strip" means to piece long narrow strips of cloth between other quilt-top design elements in order to make a quilt top. "Stripped together" refers to a quilt-top design with vertical strips between the bands of pieced designs.

Vai syllabary—A graphic system invented by the Vai people of West Africa in the twentieth century.

Vèvè—Fon term for palm oil; also, Haitian term for graphic signs used in ground paintings and other art.

Vodou—Fon spirit.

Vodun—African-Haitian religion based on numerous African religions and Catholicism.

"Whoop"—a term used by Pecolia Warner to describe the sewing of one piece of cloth to another and the sewing of one color to another. To "whoop that down" means to pull together two contrasting colors. She also spoke of "whooping cotton" with a switch to make home-made batting from raw ginned cotton to fill a quilt.

Yemoja—Yoruba goddess of the sea.

Yoruba—12 million people in Nigeria, West Africa; also a strong cultural influence in the New World, especially in Brazil, Haiti, Cuba, Puerto Rico, Miami, and New York City.

Notes

PREFACE

1. Maude Southwell Wahlman, *Contemporary African Arts* (Chicago: The Field Museum, 1974).

2. Cuesta Benberry, *Always There: The African-American Presence in American Quilts* (Louisville, Kentucky: The Kentucky Quilt Project, 1992).

3. Interviews with quilters took place continually from 1979 through 1992. My goal was to identify the root aesthetics for African-American quiltmaking—those ideas brought over from Africa and passed down from one generation to the next. This aesthetic exists all over the United States, in rural areas and in big cities. It exists alongside other aesthetic traditions that feature pastel colors, small shapes, and predictable symmetrical patterns. Some quilts do both. Other quilters prefer to do one style or the other.

4. Moni Adams writes: "Kuba women use neither simple patterns nor sketches on the cloth; they are working from models in their minds." See *African Arts*, 12:1, 1978, 24–39.

5. Mary Twining, "An Examination of African Retentions in the Folk Culture of the South Carolina and Georgia Sea Islands," Ph.D. dissertation, Indiana University, 1977; John Michael Vlach, *The Afro-American Tradition in the Decorative Arts* (Cleveland, Ohio: The Cleveland Museum of Art, 1978).

6. Eli Leon, *Who'd a Thought It: Improvisation in African-American Quiltmaking* (San Francisco: San Francisco Craft & Folk Art Museum, 1987); *Models in the Mind, African Prototypes in American Patchwork* (Winston-Salem, North Carolina: Winston-Salem State University, 1992).

7. Exhibition grant, The National Endowment for the Arts, for the exhibition *Ten Afro-American Quilters*, 1981–1983; Exhibition grant, The Southern Arts Federation, for the exhibition *Ten Afro-American Quilters*, 1981–1983; Exhibition grant, The National Endowment for the Humanities, for the traveling exhibition *Ten Afro-American Quilters*, 1982–1983; Research grant, National Endowment for the Humanities, for research on Southern Folk Arts, 1981–1985; Utilization of Museum Resources grant, from The National Endowment for the Arts, for the exhibition *African, Afro-Caribbean, and Afro-American Arts*, 1987.

THE ARTISTS

Nora E. Ezell
1. Another grandson, Samual, died in 1967.
2. January 15th.
3. Bob Cargo claims that he suggested the idea to her.

Mary Maxtion
1. Frances Dorsey, *For John Cox' Daughter* (Exhibition catalog; Ann Arbor, Michigan: Jean Paul Slusser Gallery, University of Michigan, 1991).

Lureca Outland
1. They often sew strips between or around the pieced blocks made by the group, and quilt as a group.
2. Frances Dorsey notes that Lureca Outland uses a lively color and placement sense, and at the same time, her quilt patterns reveal a quality of serenity and balance. See Frances Dorsey, *For John Cox' Daughter* (Exhibition catalog; Ann Arbor, Michigan: Jean Paul Slusser Gallery, University of Michigan, 1991).
3. Maude Wahlman, interviews with Lureca Outland, July 4, 1991, and June 19, 1992.

Alean Pearson
1. William Ferris, "Black Art: Making the Picture from Memory," in *Black Art, Ancestral Legacy* (Dallas, Texas: The Dallas Museum of Art, 1989).

Rose Perry Davis and Atlento Perry Warner
1. Jay Hamburg, "Quilts Contain Threads of Past," *Orlando Sentinel*, December 26, 1992, C-1.
2. *Ibid.*
3. Personal communication, Orlando, Florida, January 24, 1993.
4. Hamburg, "Quilts," 1992, C-12.
5. Personal communication, 1993.
6. Personal communication, 1993.

Leola Pettway
1. Interviews with Leola Pettway on July 3, 1991, and June 14, 1992.
2. The first manager of the Freedom Quilting Bee.

Elizabeth Scott
1. Eva Ungar Grudin, *Stitching Memories: African-American Story Quilts* (Williamstown, Massachusetts: Williams College Museum of Art, 1990), 38-39.
2. *Ibid.*, 11, 38-39.
3. *Ibid.*, 11, 34.

Joyce Scott
1. Eva Ungar Grudin, *Stitching Memories: African-American Story Quilts* (Williamstown, Massachusetts: Williams College Museum of Art, 1990), 69.
2. Karen Searle, "Joyce Scott, Migrant Worker for the Arts," in *Ornament*, Summer 1992, Vol. 15, No. 4, 49.
3. Organized by the Southeastern Center for Contemporary Art, Winston-Salem, North Carolina. Joyce Scott's beadwork is featured in full-page color plates (101–107) in the 1990 book, *Next Generation: Southern Black Aesthetic*.
4. Karen Searle, 46.
5. *Ibid.*, 75.
6. Lowery Sims, "On Notions of the Decade: African-Americans and the Art World," in *Next Generation: Southern*

Black Aesthetic (Chapel Hill, North Carolina: University of North Carolina Press, 1990), 11.

Yvonne Wells

1. Robert Cargo, *Adam's Rib: Twelve Contemporary Women Folk Artists of the South* (Tuscaloosa, Alabama: Robert Cargo Folk Art Gallery, 1987).

2. Best of Show Award, Kentuck Festival, Tuscaloosa, Alabama, 1985; quilts shown at the Birmingham Museum of Art, the Montgomery Museum of Fine Arts, and the Terada Gallery, Tokyo, Japan.

3. Frances Dorsey, *For John Cox' Daughter* (Exhibition catalog; Ann Arbor, Michigan: The Jean Paul Slusser Gallery, University of Michigan, 1991), 18.

4. Interview by Eva Ungar Grudin with Yvonne Wells, February 1989.

5. Eva Ungar Grudin, *Stitching Memories: African-American Story Quilts* (Williamstown, Massachusetts: Williams College Museum of Art, 1990), 42-43.

INTRODUCTION

1. See Maude Wahlman, *Ten Afro-American Quilters* (Exhibition catalog; University, Mississippi: The Center for the Study of Southern Culture, 1983).

2. Karl-Ferdinand Schaedler, *Weaving in Africa* (Munich, Germany: Panterra, 1987), 447, 448.

3. See Melville Herskovits, *Myth of the Negro Past* (Boston, Massachusetts: Beacon Press, 1941); *Cultural Anthropology* (New York: Alfred A. Knopf, 1955); Harold Courtlander, *The Drum and the Hoe: The Life and Lore of Haitian People* (Berkeley, California: University of California Press, 1960); John Szwed and Roger Abraham, *An Annotated Bibliography of Afro-American Folk Culture* (Philadelphia, Pennsylvania: The American Folklore Society Bibliographic and Special Series, 1979); and Peter H. Wood, *The Black Majority* (New York: Alfred A. Knopf, 1974).

4. See Robert Farris Thompson, "African Influences on the Art of the United States" in *Black Studies in the University: A Symposium* (A. Robinson, et al, ed.) (New Haven, Connecticut: Yale University Press, 1969); John Michael Vlach, *The Afro-American Tradition in the Decorative Arts* (Cleveland, Ohio: The Cleveland Museum of Art, 1978); Maude Wahlman, "Afro-American Quilt Aesthetics," in *Something to Keep You Warm* (Patti Carr Black, ed.) (Jackson, Mississippi: The Mississippi Department of Archives and History, 1981), 6-8; *Ten Afro-American Quilters* (Exhibition catalog; University, Mississippi: The Center for the Study of Southern Culture, 1983); "Aesthetic Principles in Afro-American Quilts" (John Scully, coauthor) in *Afro-American Folk Arts and Crafts* (William Ferris, ed.) (Boston, Massachusetts: G.K. Hall, 1983), 78-97; "Continuities Between African Textiles and Afro-American Quilts" in *Traditions in Cloth* (Los Angeles, California: California African-American Museum, 1985), 8-15; "African Symbolism in Afro-American Quilts," *African Arts* (Vol. XX, No. 1, 1986); "African-American Quilts: Tracing the Aesthetic Principles," *The Clarion* (Vol. 14, No. 2, 1989), 44-54; "Religious Symbolism in African-American Quilts," *The Clarion* (Vol. 14, No. 3, 1989), 36-43; Eli Leon, *Who'd a Thought It: Improvisation in African-American*

Quiltmaking (San Francisco, California: San Francisco Craft & Folk Art Museum, 1987); *Models in the Mind: African Prototypes in American Patchwork* (Winston-Salem, North Carolina: Winston-Salem State University, 1992); Eva Ungar Grudin, *Stitching Memories: African-American Story Quilts* (Williamstown, Massachusetts: Williams College Museum of Art, 1990); and Cuesta Benberry, *Always There: The African-American Presence in American Quilts* (Louisville, Kentucky: The Kentucky Quilt Project, 1992).

5. See Philip Curtin, *The Atlantic Slave Trade* (Madison, Wisconsin: The University of Wisconsin Press, 1969), 224-225; and Peter Wood, *The Black Majority* (New York: Alfred A. Knopf, 1974), 34-41.

6. Maude Wahlman, "Quilts" (with Ella King Torrey) in *Craft International* (New York, 1982), 37.

7. See an illustration of a carved-ivory Egyptian figure of a king in Averil Colby, *Quilting* (New York: Charles Scribner's Sons, 1971), 5.

8. See the following illustrations: a nineteenth-century Bagirmi horseman with padded armor, in Schaedler, *Weaving in Africa*, 332; Djerma armored horsemen, Niger, in Leiris and Delange, *African Art*, 160; two Fulani cavalrymen in quilted armor, Cameroons, in Picton and Mack, *African Textiles*, 182–183; nineteenth-century cotton and wool armor for a war horse, Sudan, in *Weaving in Africa*, 1987, 331; Hausa riders and horses taking part in an Independence Day celebration, Niger, on a Smithsonian National Museum of African Art postcard (1971); and a Fulani man's quilted jacket, Cameroons, 1932, in Picton and Mack, *African Textiles*, 181.

9. Schnuppe von Gwinner, *The History of the Patchwork Quilt*, translated from German by Dr. Edward Force (West Chester, Pennsylvania: Schiffer Publishing Ltd., 1988), 19-20.

10. *Ibid.*, 22-23.

11. Eli Leon has been accumulating evidence for patchwork patterns that may have been kept in the mind when Africans came to the New World and then were subsequently taught to generations of African-American children. Personal communication, October 1992.

CHAPTER 1: SOME AESTHETIC TRADITIONS

1. For excellent examples of West African men (Djerma, Fon, Peul, Korhogo) weaving on narrow portable looms, see Karl-Ferdinand Schaedler, translated from the German by Leonid Prince Lieven and Judy Howell, *Weaving in Africa* (Munich, Germany: Panterra, 1987).

2. *Ibid.*, 448.

3. See the photo of a Liberian robe made from seven-inch-wide alternate strips of cut broadloom cotton dyed indigo blue and narrow woven strips of a white cotton with an indigo design, in Schaedler, *Weaving in Africa*, 142.

4. John Mack and John Picton, in *African Textiles* (London: The British Museum, 1980), 119, report that cotton was introduced to the Asante in the seventeenth century, and the unraveling of imported silk cloths in order to get colored thread started shortly thereafter. See an early cotton cloth with colors in Venice Lamb, *West African Weaving* (London: Duckworth, Gerald & Co, Ltd., 1975), 184.

5. Although rayon was invented in the 1890s, it was not used extensively until it was made into supplies for World War II.

After the war, industrial countries needed new markets in order to keep up production. Thus, 1947 would have been the ideal time for Britain to begin trading rayon cloth and thread to Ghana.

6. What may be the oldest example of tie-dye, made before 1656, is illustrated in Schaedler, *Weaving in Africa*, 147. It is a male garment made from cotton strips that were sewn together before dyeing.

7. See Robert Farris Thompson, *African Art in Motion* (Washington, D.C.: The National Gallery of Art, 1974), cover photo.

8. See an 1886 *Jibbeh* patched with brown and blue cloth and worn by followers of the Mahdi, in Mack and Picton, *African Textiles*, 172; and a blue, brown, and white patchwork *Jibbeh* worn by an officer of the Mahdi, in Schaedler, *Weaving in Africa*, 406.

9. See a patchwork and appliquéd 1910 Asafo flag made by the Fante people, West Africa, courtesy Doran Ross, *Asafo Flags*, postcard, African-American Institute.

10. See a color photo of an *Egungun* cloth costume made with patchwork triangles in Henry Drewal and John Pemberton III, *Yoruba: Nine Centuries of African Art and Thought* (New York: The Center for African Art, 1989), 177; and a Yoruba man's dance apron at the American Museum of Natural History, in Eli Leon, *Models in the Mind: African Prototypes in American Patchwork* (Winston-Salem, North Carolina: Winston-Salem State University), 1992; fig. 36; 23.

11. A Cameroonian example is on display at the American Museum of Natural History, New York.

12. An excellent example of a Kuba barkcloth patchwork skirt is illustrated in Roy Sieber, *African Textiles and Decorative Arts* (New York: The Museum of Modern Art, 1972), 156.

13. See Robert Farris Thompson, *Paintings from a Single Heart, Preliminary Remarks on Bark Cloth Designs of the Mbute Women of Haute-Zaire* (München, Germany: Fred and Jens Jahn, 1983).

14. See Pierre Verger, *Notes sur le Culte des Orisha et Vodoun à Bahia, la Baie de Tous les Saints au Brésil, et l'Ancienne Côte des Esclaves*. Mémoire No. 51 (Dakar: Institut Français d'Afrique Noire, 1957).

15. Collected in 1940 by Frances and Melville Herskovits for their daughter, Jean Herskovits. Other things collected were lost at sea when the ship was bombed by the Germans. The Herskovits family had been warned by Yoruba priestesses not to go home by sea, so they flew and Jean took the doll with her on the plane.

16. M. Ferdinand Denis, *La Guyane: ou histoire, moeurs, usages et costumes des habitants de cette partie de l'Amerique* (Paris: Nepveu, 1823), 130, fig. 136.

17. Sally Price writes that the Saramacan term *Aseésènte* now refers to both men's capes and the construction technique of sewing strips together. *Co-Wives and Calabashes* (Ann Arbor, Michigan: University of Michigan Press, 1984), 144.

18. Sally and Richard Price, *Afro-American Arts of the Suriname Rain Forest* (University of California, Los Angeles: Museum of Cultural History, 1980), 82-84.

19. See Ute Stebich, *Haitian Art* (Brooklyn, New York: The Brooklyn Museum, 1978), 113.

20. Richard L. Morrill and Fred Donaldson, "Geographic Perspectives on the History of Black America," in *Black American: Geographic Perspectives*. (New York: Doubleday, 1976), 12.

21. Stuart Schwartz first showed me a photograph of this painting.

22. Eudora Welty, *One Time, One Place* (New York: Random House, 1971), 106.

23. For classic examples of strip quilts see Eli Leon, *Who'd a Thought It, Improvisation in African-American Quiltmaking* (San Francisco: San Francisco Craft & Folk Art Museum, 1987), 38, 57, 60, 65, 66.

24. Interview with Nora Ezell, June 1992.

25. Robert Farris Thompson uses the terms "attack coloration," an even outpouring of high-decibel, often clashing hues, or "technicolor staccato." See the introduction by Thompson in Eli Leon, *Who'd a Thought It*, 13.

26. Maude Southwell Wahlman, *The Art of Afro-American Quiltmaking: Origins, Development, and Significance*. Ph.D. dissertation (New Haven, Connecticut: Yale University, The History of Art Department, 1980).

27. Sally Price, *Co-Wives*, 55.

28. Maude Southwell Wahlman, *The Art of Afro-American Quiltmaking*, x, 220-222.

29. Robert Thompson also notes that jazzmen sometimes use the phrase, "hit it," when starting to play music. He traces these expressions back to a Kikongo verb, *sika. Ku sika* means "to hit." See introduction by Thompson in Eli Leon, *Who'd a Thought It*, 18.

30. Interviews with Plummer T Pettway, August 1979.

31. Interview with Nora Ezell, June 1992.

32. A classic example of the preference for bright contrasting color is noted by Eli Leon in *Who'd a Thought It*, 36–37. When visiting women were shown a traditional Double Wedding Ring quilt, they were quiet and respectful; when they were shown Emma Hall's red, white, and blue Double Wedding Ring quilt, "these five stately women, a moment before so sweet and serene, started to hoot and stomp."

33. Bronze figure of a bowman, Upper Niger, Nigeria, fifteenth century A.D. From Michael Leiris and Jacqueline Delange, *African Art* (London: Thames and Hudson, Ltd., 1968), fig. 354; 310. The casting depicts a garment made of strips of handwoven men's weave, with asymmetrical arrangements of the design blocks. This may be an early representation of an *Egungun* costume known for its strips that fly out as the dancer moves.

34. Thompson, *African Art in Motion*, 11.

35. Sieber, *African Textiles and Decorative Arts*, 190.

36. For an excellent photograph of an Igbarra woman weaving on a wide stationary loom, see Mack and Picton, *African Textiles*, 19.

37. Judith Chase, "Afro-American Heritage from Ante-Bellum Black Craftsmen," in Afro-American Folk Arts and Crafts. *Southern Folklore Quarterly* (William Ferris, ed., 1978), 156.

38. See Thompson in Leon, *Who'd a Thought It*, 14.

39. *Ibid.*, 16.

40. See two Kuba raffia cloths from the 1920s in Leon, *Who'd a Thought It*, 27.

41. Thompson in Leon, *Who'd a Thought It*, 21.

42. See Leon, *Who'd a Thought It*, for numerous quotes from quilters who prefer to trust their own aesthetic instincts rather

than measure, 28-30.

43. *Ibid.*, 37.

44. *Ibid.*, 37-40.

45. See a 1900 photo of King Akuffo of Akropong, Ghana, in Schaedler, *Weaving in Africa*, plate 369; 251; and a 1970 photo of an Asante king wearing a rare *Asasia Adweneasa* cloth, in Venice Lamb, *West African Weaving*, 102.

46. See Sieber, *African Textiles and Decorative Arts*, 192.

47. See Herbert Cole and Doran Ross, *The Arts of Ghana* (Los Angeles: The University of California, 1977), 24 and color plate IV.

48. Thompson, *Paintings from a Single Heart*, 221.

49. *Ibid.*, 296-97.

50. Sally and Richard Price, *Afro-American Arts of the Suriname Rain Forest*, 77.

51. Interview with Plummer T Pettway, 1981.

CHAPTER 2: APPLIQUÉ TRADITIONS

1. See photographs of an elaborate appliquéd umbrella in Melville J. Herskovits, *Dahomey, An Ancient West African Kingdom* (New York: J.J. Augustin, 1938), plates 33, 52.

2. Personal communication, Rosalyn Jeffries, 1980, and Marie-Jeanne Adams, 1983; see Pierre Verger and Clement da Cruz, "Musée Historique de Oudah," *Études Dahoméanes* (n.s. No. 13, 1969), 18-19.

3. Jill Salmons, "Funerary Shrine Cloths of the Annang Ibibio, Southeastern Nigeria," *Textile History* (Vol. 11, 1980), 132.

4. *Mpeeve*, the Kikongo word for flag, refers both to the fluttering of cloth in the wind and to the presence of unseen spirits. See Robert Farris Thompson, "The Flash of the Spirit: Haiti's Africanizing Vodun Art," in Ute Stebich, *Haitian Art* (Brooklyn, New York: The Brooklyn Museum, 1978), 34.

5. Robert Farris Thompson (with Pierre Cornet), *Four Moments of the Sun* (Washington, D.C.: The National Gallery of Art, 1981), 191.

6. While not mentioning these two appliquéd textiles, Cuesta Benberry does note that Creoles of color in New Orleans were influenced by Haitians fleeing the Haitian Revolution in the eighteenth century; that they spoke French, and that they practiced the Catholic religion. Cuesta Benberry, *Always There: The African-American Presence in American Quilts* (Louisville, Kentucky: The Kentucky Quilt Project, 1992), 49.

7. A photograph of the Convent of the Ursuline Nuns, in New Orleans, Louisiana, with the construction dates 1745–1750, appears in Elsa Honig Fine, *The Afro-American Artist* (New York: Holt, Rinehart and Winston, Inc., 1973), 21. The elegant ironwork was done by African-Americans.

8. Florence Peto, *Historic Quilts* (New York: American Historical Company, 1939), 56-57.

9. Marie-Jeanne Adams, "The Harriet Powers Pictorial Quilts," *Black Art* (Vol. 3, no. 4, 1980), 12-28.

10. *Ibid.*

11. Gladys-Marie Fry, "Harriet Powers: Portrait of a Black Quilter," in *Missing Pieces: Georgia Folk Art 1770–1976* (Anna Wadsworth, ed.; Atlanta: Georgia Council for the Arts and Humanities, 1976), 16-23.

12. Lucne Finch, "A Sermon in Patchwork," *The Outlook*, 108, 1914, 493-495; and Eleanor C. Gibbs, "The Bible Quilt," *Atlantic Monthly* (July 1922), 65-66.

13. Members of the research team include Andrew Ferguson, Gladys-Marie Fry, William Gilcher, Wyatt MacGaffey, Judith McWillie, Phinizy Spalding, Sterling Stuckey, Michael Thurmond, Mary Arnold Twining, Maude Southwell Wahlman, James Washington, Jr., Pam Wilson, Peter Wood, and others.

14. Cuesta Benberry, *Always There*, 44, 89.

15. Eudora Welty, *One Time, One Place* (New York: Random House, 1971), 96.

16. Cuesta Benberry, *Always There*, 46, 90.

17. Interview with Nora Ezell, June 1992.

18. Several pieces left from sewing Mrs. Lincoln's gowns were donated to Wilberforce University, Wilberforce, Ohio. See Monroe A. Majors, *Noted Negro Women: Their Triumphs and Activities* (Chicago: Donohue and Henneberry, 1893), 260.

19. Pat Ferrero, Elaine Hedges, and Julie Silber, *Hearts and Hands: The Influence of Women and Quilts on American Society* (San Francisco: The Quilt Digest Press, 1987), 76.

20. See the quilts of Lillian Beattie, Chattanooga, Tennessee, for example, in Eva Ungar Grudin, *Stitching Memories: African American Story Quilts* (Williamstown, Massachusetts: Williams College Museum of Art, 1990), 79, 81.

21. Interview with Pearlie Posey, August 1979.

22. *Ibid.*

23. Interview with Pearlie Posey, March 1980.

CHAPTER 3: TRACING RELIGIOUS SYMBOLS

1. Robert Farris Thompson, *Flash of the Spirit: African and Afro-American Art and Philosophy* (New York: Random House, 1983), 297.

2. George Kubler, *The Shape of Time* (New Haven, Connecticut: Yale University Press, 1976), 50-51.

3. Thompson, *Flash of the Spirit*, 221.

4. *Ibid.*, 222.

5. See illustrations of two war shirts from Togo, painted with Koranic texts and magical symbols meant to protect the wearer, in Karl-Ferdinand Schaedler, *Weaving in Africa* (Munich, Germany: Panterra, 1987), plates 28 and 29; 144. Another example of a shirt with both painted texts and texts enclosed in leather charms is in John Mack and John Picton, *African Textiles* (London: The British Museum, 1980), 164.

6. See a 1900 photo of the Asante ex-king, Prempeh I, dressed in *Adinkra*, in Schaedler, *Weaving in Africa*, plate 402; 270.

7. See *African Arts* (1980), No. 2, 61.

8. Maude Wahlman, *Contemporary African Arts* (Chicago: The Field Museum of Natural History, 1974), 16-17.

9. David Dalby, *Africa and the Written Word* (Lagos: Centre Cultural Française; and Paris: Fête de la Lettre, 1986).

10. Melville Herskovits, *Dahomey, An Ancient West African Kingdom* (New York: J.J. Augustin, 1938), 101-104.

11. *Ibid.*, 342.

12. *Ibid.*, plate 35b; 54; see also A. Lee Herisse, *L'Ancien Royaume du Dahomey* (Paris, 1911), plate XX.

13. *Ibid.*, 342.

14. *Ibid.*

15. *Ibid.*, 234.

16. *Ibid.*, Vol. 1, 159.

17. See discussion and illustration in Henry Drewal and John Pemberton III, *Yoruba: Nine Centuries of African Art and Thought* (New York: The Center for African Art, 1989), 21.

18. Robin Poyner, *Thunder over Miami: Ritual Objects of Nigerian and Afro-Cuban Religion* (Exhibition Catalog; Gainesville, Florida: The Center for African Studies, The University of Florida, 1982), 7.

19. Drewal and Pemberton, *Yoruba* (1989), 14-16.

20. *Ibid.*, etc., 33; see fig. 34.

21. Gary Edwards and John Mason, *Black Gods—Orisa Studies in the New World* (Brooklyn, New York: The Yoruba Theological Archministry, 1985), 66.

22. See P. Amaury Talbot, *In the Shadow of the Bush* (London: William Heinemann, 1912), Appendix G, 447-461.

23. *Ibid.*, 43.

24. *Ibid.*, 246.

25. See Ellen Elsas and Robin Poyner, *Nigerian Sculpture: Bridges to Power* (Birmingham, Alabama: Birmingham Museum of Art, 1984), 52.

26. Robert Farris Thompson, *African Art in Motion* (Washington, D.C.; The National Gallery of Art, 1974), 18.

27. Kenneth Campbell, "Nsibidi Update," *Arts Africaines* (1985), 45.

28. Thompson, *Flash of the Spirit*, 248-252.

29. Gerhard Kubik, "African Graphic Systems," *Muntu* (1986), 87.

30. Examples include a quilt by Lucinda Toomer and a 1900–1925 Album quilt by Emma Perkins Wilbourn (illustrated in Benberry, *Always There*, 98).

31. See Thompson, 1983; John Jansen and Wyatt MacGaffey, *An Anthology of Kongo Religion* (Lawrence, Kansas: The University of Kansas Press, 1974); Fu-Kiau Bunseki, *Nza Kongo* (Kinshasa, Zaire, 1969), 34.

32. Robert Farris Thompson (with Pierre Cornet), *Four Moments of the Sun* (Washington, D.C.: The National Gallery of Art, 1981), 63-71.

33. Robert Farris Thompson, *Paintings from a Single Heart, Preliminary Remarks on Bark Cloth Designs of the Mbute Women of Haute-Zaire* (München, Germany: Fred and Jens Jahn, 1983), 5; see also Thompson, *Flash of the Spirit*, plate 52; 84.

34. *Ibid.*, 8; see plate 52; 84.

35. Examples abound. See Eli Leon, *Who'd a Thought It, Improvisation in African-American Quiltmaking* (San Francisco: San Francisco Craft & Folk Art Museum, 1987), 27.

36. Thompson, *Flash of the Spirit*, plate 68; 116.

37. Sally Price, *Co-Wives and Calabashes* (Ann Arbor, Michigan: University of Michigan Press, 1984), figs. 40, 43, 44.

38. Collected by Jeannette Hillman Henney before 1968. See Felicitas D. Goodman, Jeannette Hillman Henney, Esther Pressel, *Trance, Healing and Hallucination* (New York: John Wiley & Sons, 1974), 109-111; and Jeannette Hillman Henney, *Spirit Possession, Belief and Trance Behavior in a Religious Group in St. Vincent, British West Indies* (Ann Arbor, Michigan: University Microfilms, 1968), 204.

39. Thompson, *Flash of the Spirit*, 262-266; plates 159, 161.

40. See *Recall of the Dead* by Rigaud Benoit, Haiti, 1973. Milwaukee Art Museum, Milwaukee, Wisconsin; Gift of Richard and Erna Flagg. "Shortly after death, souls travel to an island under the water, where they stay until they are cold and lonely." See Ute Stebich, *Haitian Art* (Brooklyn, New York: The Brooklyn Museum, 1978), 87.

41. *Ibid.*, 191.

42. Melville Herskovits, *Life in a Haitian Valley* (Garden City, New York: Anchor Books, 1971), 254-255.

43. Carole Devillers, "Of Spirits and Saints: Haiti's Vodoo Pilgimages." *National Geographic*, 167, No. 3 (March 1985), 400.

44. Thompson, *Four Moments of the Sun*, 191.

45. Dolores Yonkers, in John Nunley and Judith Bettelheim, *Caribbean Festival Arts* (St. Louis, Missouri: St. Louis Art Museum, 1988), 151.

46. *Ibid.*, 148.

47. See Moses Dickson, *Manual of the International Order of Twelve Knights and Daughters of Tabor, containing general laws, regulations, ceremonies and drill* (St. Louis, Missouri: A.R. Fleming Printing Co., 1903).

48. Gladys-Marie Fry, *Stitched from the Soul: Slave Quilts from the Ante-Bellum South* (New York: Museum of American Folk Art and Dutton Studio Books, 1990), 52, 65.

49. Eva Ungar Grudin, *Stitching Memories: African-American Story Quilts* (Williamstown, Massachusetts: Williams College Museum of Art, 1990), 32.

50. *Ibid.*

51. Ruth Bass, "Mojo" and "The Little Man," in *Mother Wit and the Laughing Barrel* (Allan Dundes, ed.; New York: Prentice Hall, Inc., 1973), 393.

52. Trudier Harris, personal communication, 1984.

53. Roger Abrahams told me that the practice of enclosing magical holy words to increase their power is found widely in early literate cultures. The Bible is used as an amulet and as a divining tool; if you are looking for a sign of what to do, open the Bible and read the first verse you encounter.

54. Rose Perry Davis, personal communication, January 1993.

55. John Vlach, *The Afro-American Tradition in the Decorative Arts* (Cleveland, Ohio: The Cleveland Museum of Art, 1978), 74, 139.

56. See artist's statement for Macquette for "Quilting Time," at The Detroit Institute of Arts, 1984.

57. See Horace Pippin, *The Domino Players*, 1943, at The Phillips Collection, Washington, D.C.; and *Quaker Mother and Child*, 1940s, illustrated in Elsa Honig Fine, *The Afro-American Artist* (New York: Holt, Rinehart and Winston, Inc., 1973), 117.

58. Jacob Lawrence's painting, *Vaudeville*, 1951, shows multiple patched quilt designs in the background; illustrated in Fine, 161.

59. John Biggers paintings, *Shotguns* and *Starry Crown*, in Robert Rozelle, Alvia Wardlaw and Maureen A. McKenna (editors), *Black Art: Ancestral Legacy, The African Impulse in African-American Art* (Dallas, Texas: Dallas Museum of Art, 1989), 200.

60. Judith McWillie, "Another Face of the Diamond: Black Traditional Art from the Deep South," *The Clarion* (Vol. 12, no. 4), 42-53.

61. See Judith Alexander, *Nellie Mae Rowe* (Exhibition catalog; Atlanta, Georgia: The Southern Arts Federation, 1983), back cover.

62. Mitchell Kahan, *Heavenly Visions: The Art of Minnie Evans* (Raleigh, North Carolina: North Carolina Museum of Art, 1986), figs. 2, 15, 21.

63. Elizabeth Reynolds, *Southern Comfort* (Atlanta, Georgia: Atlanta Historical Society, 1978), 6-7.

64. Dominic Parisi, "Conversations with Black Women Who Live and Quilt in Eastern Kentucky," Master's Thesis, Afro-

American Studies (Yale University, 1979).

65. Talbot, *In the Shadow of the Bush*, 447-461.

66. Elizabeth Reynolds, *Southern Comfort*, 34-35.

67. Jules Prown, personal communication, 1980.

68. Talbot, *In the Shadow of the Bush*, 456.

69. Grudin, 49.

70. Fry, *Stitched from the Soul*, fig. 76; 53.

71. *Ibid.*, fig. 59; 44.

72. For the last two years I have been involved with a group of people from the Visual Press at the University of Maryland and the Smithsonian Institution in research for two films on the life of Harriet Powers. The first film is a documentary interpretation of the events that might have occurred around the making of the two quilts by Powers. The group has gradually come to the conclusion that Harriet Powers was possibly associated with a Masonic group.

73. Herskovits, *Dahomey*, 342.

74. Charles Joyner, *Down by the Riverside: A South Carolina Slave Community* (Chicago: University of Illinois Press, 1984), 5, 135, 148.

75. I was pleased to see that Cuesta Benberry has also recently noted the possible Masonic influence on symbols used by African-Americans. She writes: "Blacks frequently turned to their fraternal organizations to obtain what small sickness and accident stipends and death benefits they could. Other benefits were ceremonial rites of honor at funerals and the opportunity for social interaction. Nearly all of the organizations had secret symbols that identified them, were known to members, and may have appeared on their quilts. See Cuesta Benberry, *Always There: The African-American Presence in American Quilts* (Louisville, Kentucky: The Kentucky Quilt Project, 1992), 45.

76. Are the shooting stars symbols for *simbi* (Kongo spirits reborn, as in Haiti)? Is Moses holding up a snake really Damballah conjuring for rain? Jacob's ladder is often a reference to the underground railroad. The pig named Bets who ran five hundred miles is said to be another reference; a third may be the Jacob's coffin in the Boston quilt (sky sign to follow at night?). The eclipse may be a message to people to go to the praise house when the sun goes dim. Are Kongo gestures to stop (one hand on hip; one hand up) warning signs? Is the red sun a reference to the eclipse that occurred during the crucifixion? Are the number of animals a number of miles? Was the quilt sent to the fair as a message of hope to other conjurewomen? Was it a code for freedom? Were quilt squares left around as messages to other conjurewomen? Can the quilt designs be read as codes for stations on the underground railroad?

77. Scott Rodolitz, personal communication, January 1993.

78. Alvin J. Schmidt, *Fraternal Organizations* (Westport, Connecticut: Greenwood Press, 1980).

79. Interview with Pecolia Warner, March 1980.

80. Thompson, *Flash of the Spirit*, 248.

81. See a classic example of small squares used in flexible checked patterns in Leon, *Who'd a Thought It*, 52, 74.

82. See #111, #119, #374, #375, #494, #652, in Brigitte Menzel, *Textilien aus Westafrika II* (Berlin, Germany: Museum für Volkerkunde, 1972).

83. Examples include a quilt by Lucinda Toomer and a 1900–1925 Album quilt by Emma Perkins Wilbourn (illustrated in Benberry, *Always There*, 98).

84. See Leon, *Who'd a Thought It*, 27.

85. Gail Andrews and Janet Strain McDonald, *Black Belt to Hill Country: Alabama Quilts from the Robert and Helen Cargo Collection* (Birmingham, Alabama: Birmingham Museum of Art, 1982), 27.

86. Thompson, *Four Moments of the Sun*, 153.

87. Mary Twining, "An Examination of African Retentions in the Folk Culture of the South Carolina and Georgia Sea Islands" (Indiana University Ph.D. dissertation, 1977), 188.

88. I am thankful to Janet Berlo for introducing me to Ken and Katie Anderson, and I am in debt to them for letting me photograph the Charlie Logan arts. Nothing is known of his life other than that he received a Social Security check from the United States government because of a disability.

CHAPTER 4: PROTECTIVE CHARMS

1. Recent examples can be found by fine artists such as Joyce Scott of Baltimore, Maryland.

2. For a marvelous illustration of a Yoruba *Ibeji* (twin) figure (made to protect a male twin child) with a beaded jacket done in the Box pattern, see *Sotheby's Auction Catalog* for April 21, 1990, lot 330.

3. See Robert Farris Thompson, "Yoruba Beaded Crowns," *African Arts* Vol. 3, no. 3, 1970, 8-17, 74-80.

4. Robert Farris Thompson, "Introduction," in John Nunley and Judith Bettelheim, *Caribbean Festival Arts* (St. Louis, Missouri: St. Louis Art Museum, 1988), 26.

5. Robert Farris Thompson (with Pierre Cornet), *Four Moments of the Sun* (Washington, D.C.: The National Gallery of Art, 1981), 151.

6. Robert Farris Thompson, introduction to Eli Leon, *Who'd a Thought It, Improvisation in African-American Quiltmaking* (San Francisco: San Francisco Craft & Folk Art Museum, 1987), 20-21.

7. John Jansen and Wyatt MacGaffey, *An Anthology of Kongo Religion* (Lawrence, Kansas: The University of Kansas Press, 1974), 37.

8. See Robert Farris Thompson, *Flash of the Spirit: African and Afro-American Art and Philosophy* (New York: Random House, 1983), plate 72.

9. Thompson, *Four Moments*, 63-71.

10. *Ibid.*, 31.

11. See Maude Southwell Wahlman, "African Symbolism in Afro-American Quilts," *African Arts*, Vol. XX, no. 1, 1986; "Religious Symbolism in African-American Quilts," *The Clarion*, Vol. 14, no. 3 (Summer 1989), 36-43; "Afro-American Quiltmaking" and "Pecolia Warner, Afro-American Quilt-maker" in *The Encyclopedia of Southern Culture* (University, Mississippi: Center for the Study of Southern Culture, 1990).

12. Thompson, *Flash of the Spirit*, 127.

13. "The Figa was a 'little object in the form of a closed fist, with the thumb between the index and the middle finger used superstitiously to ward off evil spells, disease, etc." From Gilberto Freyre, *The Masters and the Slaves: A Study of the Development of Brazilian Civilization* (translated from Portuguese by Samuel Putnam), (2nd ed., revised, New York: Alfred A. Knopf, 1966), 143. The thumb extending between the index and the middle finger is named a figa because it suggests a fig in terms of its size.

14. The doll and the Herskovits family survived because they

had been warned by Yoruba priestesses to return to the United States by plane. Other personal belongings and artifacts were sent on a ship that was sunk by the Germans at the beginning of World War II.

15. Melville Herkovits, *Rebel Destiny: Among the Bush Negroes of Dutch Guiana* (New York: McGraw-Hill Book Co., Inc., 1934), 307-326.

16. Sally and Richard Price, *Afro-American Arts of the Suriname Rain Forest* (University of California, Los Angeles: Museum of Cultural History, 1980), 86.

17. Thompson repeated this idea in reference to African-American quilts in 1987 in his introduction to Leon, *Who'd a Thought It*, 21.

18. Eli Leon documented this information while talking to Wanda Jones and others; phone conversation by the author with Eli Leon, July 5, 1992.

19. Thompson, *Flash of the Spirit*, 31-36.

20. Maya Deren, *Divine Horsemen: The Living Gods of Haiti* (New York: Thames and Hudson, 1953), 275.

21. Melville Herskovits, *Life in a Haitian Valley* (Garden City, New York: Anchor Books, 1971), 239-244.

22. Selden Rodman, *The Miracle of Haitian Art* (New York: Doubleday & Co., 1965), 76.

23. Eugene Metcalf and Michael Hall, *The Ties that Bind: Folk Art in Contemporary American Culture* (Cincinnati, Ohio: The Contemporary Arts Center, 1986), and Thompson, *Flash of the Spirit*, 221.

24. Jean Ellen Jones, personal communication, 1984.

25. Interview with Sarah Mary Taylor, March 1980.

26. Folk song written by Willie Dixon for Muddy Waters, with whose name the song is usually associated. Other bluesmen have recorded the song, however, among them B.B. King for ABC Records, Inc., in 1977. Personal communication, Sue Hart and Phillips Stevens, Jr.

27. The term *mojo* comes from the Kikongo word *Mooyo*, referring to the soul, spiritual spark, or force in Kongo charms. The "y" lightly changes to a "j." Personal communication, Robert Farris Thompson, 1984.

28. Nunley and Bettelheim, *Caribbean Festival Arts*, 123.

29. Zora Neale Hurston, "Hoodoo in America," *Journal of American Folklore*, 1931, Vol. 44, 414.

30. Gladys-Marie Fry, *Stitched from the Soul: Slave Quilts from the Anti-Bellum South* (New York; Museum of American Folk Art and Dutton Studio Books, 1990), 65.

31. See a nineteenth-century Four Patch quilt with red squares by Jennie Nevile Stroud in Gladys-Marie Fry, *Stitched from the Soul*, fig. 62; 46.

32. Interview with Nora Ezell, June 1992.

33. See John Michael Vlach, *The Afro-American Tradition in the Decorative Arts* (Cleveland, Ohio: The Cleveland Museum of Art, 1978), illustration, 139.

34. Richard Hulan, personal communication, 1989.

35. Carolyn Mazloomi, from Louisiana, says the hands in her quilts represent all the caring relatives that helped keep the family together. See Cuesta Benberry, *Always There; The African-American Presence in American Quilts* (Louisville, Kentucky: The Kentucky Quilt Project, 1992), 65.

36. Cuesta Benberry notes a small hand embroidered on an 1890 quilt made by Mima Thompson Perkins. She also notes an unusual square (left, center row) made from pieced rectangles

(strings) arranged in a Log Cabin type design. Benberry mentions that this "square was not inserted willy-nilly on the quilt but had special significance to the family." We are left wondering what the "special significance" was or is. Since some shapes resemble red *mojo* charms, one can postulate a protective function. However, the square could be special because it was made by a family member. See Benberry, *Always There*, 53, 93.

37. Victor Turner, *The Forest of Symbols* (Ithaca, New York: Cornell University Press, 1967), 74.

38. Fu-Kiau Bunseki, *Nza Kongo* (Zaire: Kinshasa, 1969).

39. John M. Jansen, *Expressions of Belief: Masterpieces of African, Oceanic, and Indonesian Art from the Museum vor Volkerkunde, Rotterdam* (Edited by Suzanne Greub; New York: Rizzoli, 1988), 42.

40. *Ibid.*

41. Lyall Watson, *Lightenbird* (New York: Simon & Schuster, 1982), 206.

42. Robert Farris Thompson, Lectures, Yale University, 1977–1980.

43. Morton C. Kahn refers to "Obeiahs, or talismans, for protection" in *Djuka: The Bush Negroes of Dutch Guiana* (New York: Viking Press, 1931), 22, 149.

44. Kahn, *Djuka*, 150.

45. Ute Stebich, *Haitian Art* (Brooklyn, New York: The Brooklyn Museum, 1978), 113.

46. Thompson, *Flash of the Spirit*, 221.

47. Eugene Metcalf and Michael Hall, *The Ties that Bind: Folk Art in Contemporary American Culture* (Cincinnati, Ohio: The Contemporary Arts Center, 1986); Thompson, *Flash of the Spirit*, 221.

48. Zora Neale Hurston, "Hoodoo in America," *Journal of American Folklore*, Vol. 44, 1931, 414.

49. See Charles Joyner, *Down by the Riverside: A South Carolina Slave Community* (Chicago: University of Illinois Press, 1984), 153; and Joseph Opala, *The Gullah* (Freetown, Sierra Leone: USIS, 1986), 12.

50. Fry, *Stitched from the Soul*, 65.

51. Mary Twining, "An Examination of African Retentions in the Folk Culture of the South Carolina and Georgia Sea Islands," (Ph.D. Dissertation, Indiana University, 1977), 189.

52. Maude Southwell Wahlman, *The Art of Afro-American Quiltmaking: Origins, Development, and Significance.* Ph.D. dissertation (New Haven, Connecticut: Yale University, The History of Art Department, 1980), Vol. 2.

CHAPTER 5: CONCLUSION

1. Frances Dorsey, *For John Cox' Daughter* (Exhibition catalog; Ann Arbor, Michigan: The Jean Paul Slusser Gallery, University of Michigan School of Art, 1991), 6.

2. *Ten Afro-American Quilters* (Exhibition catalog; University, Mississippi: The Center for the Study of Southern Culture, 1983), 6-7. Mozell Benson is a remarkable woman who has demonstrated quiltmaking for the Smithsonian Institution, the University of Michigan, and numerous other institutions. In 1985, the State Department sent her to Africa to demonstrate quiltmaking in conjunction with my traveling exhibition, *Ten African-American Quilters*. While in Nigeria, she collected numerous fabrics that she has incorporated in her recent quilts.

Mozell Benson is also one of several quilters who were commissioned to make quilts for the film, *The Color Purple*.

3. The underground railroad also influenced quilt patterns. Jacob's Ladder, also called Stepping Stones and Wagon Tracks, became known as the Underground Railroad pattern in the northeast United States. See Eva Ungar Grudin, *Stitching Memories: African-American Story Quilts* (Williamstown, Massachussetts: Williams College Museum of Art, 1990), 49.

Bibliography

Adams, Marie-Jeanne. "The Harriet Powers Pictorial Quilts," *Black Art*, Vol. 3, no. 4, 1980.

Adele, Lynne. *Black History/Black Vision*. Austin, Texas: University of Texas Press, 1989.

Alexander, Judith. *Nellie Mae Rowe* (Exhibition catalog). Atlanta, Georgia: The Southern Arts Federation, 1983.

Andrews, Gail and Janet Strain McDonald. *Black Belt to Hill Country: Alabama Quilts from the Robert and Helen Cargo Collection*. Birmingham, Alabama: Birmingham Museum of Art, 1982.

Bass, Ruth. "Mojo" and "The Little Man," in *Mother Wit and the Laughing Barrel* (Alan Dundes, ed.). New York: Prentice Hall, Inc., 1973.

Benberry, Cuesta. *Always There: The African-American Presence in American Quilts*. Louisville, Kentucky: The Kentucky Quilt Project, 1992.

"Afro-American Women and Their Quilts." *Uncoverings*, 1980.

Bohannan, Paul. "Rethinking Culture: A Project for Current Anthropologists," in *Current Anthropology*, Vol. 14, no. 4, 1973.

Brenner, Carla. "African Improvisations: Textiles from the Indianapolis Museum of Art." *The Walters Monthly Bulletin*, March 1991.

Brett-Smith, Sarah. "Speech Made Visible: The Irregular as a System of Meaning," *Empirical Studies of the Arts*, Vol. 2, no. 2, 1984.

Brown, Karen McCarthy. *The Vèvè of Haitian Vodou: A Structural Analysis of Visual Imagery*. Ann Arbor, Michigan: University Microfilms, 1975.

Bunseki-Lumanisa, Fu-Kiau Kia. *N'Kongo Ye Nza Yakun'zungidila: Nza Kongo*. Kinshasa, Zaire: Office National de le Recherche et de Developpement, 1969.

Cabrera, Lydia. *El monte: notas sobre las religiones, la magia, las supersticiones y el folklore de los negros criollos y del peublo de Cuba*. Havana, Cuba: Ediciones C,R, 1954.

Anaforuana. Madrid, Spain: Editions R, 1975.

Campbell, Edward D.C., Jr., and Kym S. Rice (editors). *Before Freedom Came: African American Life in the Antebellum South*. Charlottesville, Virginia. The Museum of the Confederacy and the University Press of Virginia, 1991.

Campbell, Kenneth. "Nsibidi Update," *Arts Africaine* (1985).

Cargo, Robert. *Adam's Rib: Twelve Contemporary Women Folk Artists of the South*. Tuscaloosa, Alabama: Robert Cargo Folk Art Gallery, 1987.

Chase, Judith. "Afro-American Heritage from Ante-Bellum Black Craftsmen," in Afro-American Folk Arts and Crafts, *Southern Folklore Quarterly*, 42 (William Ferris, ed.), 1978.

Colby, Averil. *Patchwork*. New York: Charles Scribner's Sons, 1982.

Cole, Herbert and Doran Ross. *The Arts of Ghana*. Los Angeles, California: The University of California, 1978.

Courlander, Harold. *The Drum and the Hoe: The Life and Lore of Haitian People*. Berkeley, California: University of California Press, 1960.

Cover, Ruth. "Ten Afro-American Quilters: An Exhibit." *The Flying Needle*, February 1985.

Curtin, Philip. *The Atlantic Slave Trade*. Madison, Wisconsin: The University of Wisconsin Press, 1969.

Delatiner, Barbara. "What Quilting Means to Black Women," *The New York Times*, January 26, 1992.

Denis, M. Ferdinand. *La Guyane: ou histoire, moeurs, usages et costumes des habitants de cette partie de l'Amérique*, Paris, France: Nepveu, 1823.

Deren, Maya. *Divine Horsemen: The Living Gods of Haiti*. New York: Thames and Hudson, 1953.

Devillers, Carole. "Of Spirits and Saints: Haiti's Vodoo Pilgrimages." *National Geographic*, Vol. 167, no. 3, March 1985.

Dewhurst, C. Kurt, Betty MacDowell, and Marsha MacDowell. *Religious Folk Art in America*. New York: E.P. Dutton, 1983.

Artists in Aprons: Folk Art by American Women. New York: E.P. Dutton, 1979.

Dorsey, Frances. *For John Cox' Daughter* (Exhibition catalog). Ann Arbor, Michigan: The Jean Paul Slusser Gallery, University of Michigan School of Art, 1991.

Drewal, Henry. "More Powerful than Each Other: An Egabado Classification of Egungun." *African Arts*, Vol. 11, no. 3, 1978.

Drewal, Henry and John Pemberton III. *Yoruba: Nine Centuries of African Art and Thought*. New York: The Center for African Art, 1989.

Edwards, Gary and John Mason. *Black Gods—Orisa Studies in the New World*. Brooklyn, New York: The Yoruba Theological Archministry, 1985.

Ferrero, Pat, Elaine Hedges, and Julie Silber. *Hearts and Hands: The Influence of Women and Quilts on American Society*. San Francisco, California: The Quilt Digest Press, 1987.

Ferris, William (ed.). *Afro-American Folk Arts and Crafts*. Boston: G.K. Hall, 1983. *Local Color* (Brenda McCallum, ed.). New York: McGraw-Hill Book Company, Inc., 1982.

Finch, Lucine. "A Sermon in Patchwork," *Outlook*, Vol. 108, October 28, 1914.

Fine, Elsa Honig. *The Afro-American Artist*. New York: Holt, Rinehart and Winston, Inc., 1973.

Fisher, Angela. *Africa Adorned*. New York: Harry N. Abrams, Inc., 1984.

Fox, Sandi. "The Log Cabin: An American Quilt on the Western Frontier." *The Quilt Digest*. San Francisco, California: Kiracofe and Kile, 1983.

Twentieth Century American Quilts. Tokyo, Japan: The Seibu Museum of Art, 1983.

Wrapped in Glory, Figurative Quilts and Bedcovers, 1700–1900. New York: Thames and Hudson, and the Los Angeles County Museum of Art, 1990.

Fry, Gladys-Marie. "Harriet Powers: Portrait of a Black Quilter," in *Missing Pieces: Georgia Folk Art 1770–1976* (Anna Wadsworth, ed.). Atlanta, Georgia: Georgia Council for the Arts and Humanities, 1976.

Broken Star: Post Civil War Quilts made by Black Women. Dallas, Texas: Museum of African-American Life and Culture, 1986.

Stitched from the Soul: Slave Quilts from the Ante-Bellum South. New York: Museum of American Folk Art and Dutton Studio Books, 1990.

Gilcher, William. *Anything for Wisement: A Film on Southern Cultural History.* College Park, Maryland: The Visual Press, University of Maryland at College Park, 1992.

Goodman, Felicitas D., Jeannette Henney, Esther Pressel. *Trance, Healing and Hallucination.* New York: John Wiley & Sons, 1974.

Gross, Joyce. *A Patch in Time, A Catalog of Antique, Traditional, and Contemporary Quilts.* Mill Valley, California: Joyce Gross, 1973.

Grudin, Eva Ungar. *Stitching Memories: African-American Story Quilts.* Williamstown, Massachusetts: Williams College Museum of Art, 1990.

Hartigan, Lynda. *Made with Passion: The Bert Hemphill Collection.* Washington, D.C.: Smithsonian Institution Press, 1990.

Henney, Jeannette Hillman. *Spirit Possession, Belief and Trance Behavior in a Religious Group in St. Vincent, British West Indies.* Ann Arbor, Michigan: University Microfilms, 1968.

Herskovits, Melville. *Rebel Destiny, Among the Bush Negroes of Dutch Guiana.* New York: McGraw-Hill Book Company, Inc., 1934.

Life in a Haitian Valley. Garden City, New York: Anchor Books, 1937, 1971.

Dahomey, An Ancient West African Kingdom. New York: J.J. Augustin, 1938.

Myth of the Negro Past. Boston, Massachusetts: Beacon Press, 1941.

Cultural Anthropology. New York: Knopf, 1955.

Holloway, Joseph E. *Africanisms in American Culture.* Bloomington, Indiana: Indiana University Press, 1990.

Holmes, Peter. "Alice Bolling and the Quilt Fence." New Haven, Connecticut: Yale University, 1977.

Horton, Laurel and Lynn Robertson Myers. *Social Fabric: South Carolina's Traditional Quilts.* Columbus, South Carolina: McKissick Museum, The University of South Carolina, 1985.

Horton, Roberta. *Calico and Beyond: The Use of Patterned Fabric and Quilts.* Martinez, California: C & T Publishing, 1986.

Hurston, Zora Neale. "Hoodoo in America," *Journal of American Folklore,* 1931, Vol. 44.

Hyatt, Henry. *Hoodoo–Conjuration–Witchcraft–Rootwork.* Hannibal, Missouri: Western Publications, 1974, Vol. 4.

International Order of Twelve Knights and Daughters of Tabor. *Manual of the International Order of Twelve Knights and Daughters of Tabor, Containing General Laws, Regulations, Ceremonies, Drill, and Taborian Lexicon.* St. Louis, Missouri: A.R. Fleming Printing Co., 1903.

Jansen, John and Wyatt MacGaffey. *An Anthology of Kongo Religion.* Lawrence, Kansas: The University of Kansas Press, 1974.

Kahan, Mitchel. *Heavenly Visions: The Art of Minnie Evans.* Raleigh, North Carolina: North Carolina Museum of Art, 1986.

Kahn, Morton C. *Djuka: The Bush Negroes of Dutch Guiana.* New York: Viking Press, 1931.

Kerr, Robert. "African Style Quilts Hit Bright Riffs in Tradition of Black Art." *The Commercial Appeal,* March 13, 1991.

Kubler, George. *The Shape of Time.* New Haven, Connecticut: Yale University Press, 1976.

Lamb, Venice. *West African Weaving.* London, England: Duckworth, Gerald & Co., Ltd., 1975.

Le Herisse, A. *L'Ancien Royaume du Dahomey.* Paris, 1911.

Leon, Eli. *Who'd a Thought It: Improvisation in African-American Quiltmaking.* San Francisco, California: San Francisco Craft & Folk Art Museum, 1987.

Models in the Mind: African Prototypes in American Patchwork. Winston-Salem, North Carolina: Winston-Salem State University, 1992.

Lewis, Maggie. "Afro-American Quilts: Patching Together African Aesthetics, Colonial Craft." *Christian Science Monitor,* Section B, December 1, 1982.

Lippard, Lucy. "Up, Down, and Across: A New Frame for New Quilts." *The Artist & The Quilt* (Charlotte Robinson, ed.). New York: Alfred A. Knopf, 1983.

Livingston, Jane and John Beardsley. *Black Folk Art in America 1930–1980.* Washington, D.C.: Corcoran Gallery of Art, 1982.

MacGaffey, Wyatt. *Religion and Society in Central Africa: The Bakongo of Lower Zaire.* Chicago, Illinois: The University of Chicago Press, 1986.

Mack, John and John Picton. *African Textiles.* London, England: The British Museum, 1980.

Majors, Monroe A. *Noted Negro Women: Their Triumphs and Activities.* Chicago, Illinois: Donohue and Henneberry, 1893.

McWillie, Judith. "Another Face of the Diamond: Black Traditional Art from the Deep South," in *The Clarion,* Vol. 12, no. 4 (1987).

Another Face of the Diamond: Pathways Through the Black Atlantic South (Exhibition catalog). New York: Intar Latin American Gallery, 1989.

"The Migrations of Meaning," in *Visions Art Quarterly,* 10, Fall 1989.

McMorris, Penny. "Afro-American Quilts," Quilting II. Bowling Green, Ohio: WBGU-TV, Bowling Green University Press, 1982.

Metcalf, Eugene and Michael Hall. *The Ties that Bind: Folk Art in Contemporary American Culture.* Cincinnati, Ohio: The Contemporary Arts Center, 1986.

Morris, Bob. "Family Finds Makings of Memories in Closet." Orlando, Florida: *Orlando Sentinel,* 1990.

Nasisse, Andy. "Aspects of Visionary Art," in *Baking in the Sun: Visionary Images from the South.* Lafayette, Louisiana: University Art Museum, 1986.

Newman, Joyce Joines. *North Carolina Country Quilts: Regional Variations.* Chapel Hill, North Carolina: The Ackland Art Museum, University of North Carolina, 1978.

Nunley, John and Judith Bettelheim. *Caribbean Festival Arts.* St. Louis, Missouri: St. Louis Art Museum, 1988.

Opala, Joseph. *The Gullah.* Freetown, Sierra Leone: USIS, 1986.

Orloff, Alexander. *Carneval: Myth and Cult.* Austria: Perlinger, 1981.

Orlofsky, Patsy and Myron Orlofsky. *Quilts in America.* New York: McGraw-Hill Book Company, Inc., 1974.

Parisi, Dominic. "Conversations with Black Women who Live and Quilt in Eastern Kentucky." Master's thesis, Afro-American Studies, Yale University, 1979.

Peterkin, Julia. *Black April.* New York: Grosset & Dunlap, 1927.

Peto, Florence. *Historic Quilts.* New York: American Historical Company, 1939.

Poyner, Robin. *Thunder over Miami: Ritual Objects of Nigerian and Afro-Cuban Religion* (Exhibition catalog). Gainesville, Florida: The Center for African Studies, The University of Florida, 1982.

Price, Sally and Richard. *Afro-American Arts of the Suriname Rain Forest.* University of California, Los Angeles: Museum of Cultural History, 1980.

Price, Sally. Co-Wives and Calabashes, Ann Arbor, Michigan: University of Michigan Press, 1984.

Ramsey, Bets and Merikay Waldrogel. *The Quilts of Tennessee.* Nashville, Tennessee: Rutledge Hill, 1986.

Reynolds, Elizabeth. *Southern Comfort.* Atlanta, Georgia: Atlanta Historical Society, 1978.

Rodman, Selden. *The Miracle of Haitian Art.* New York: Doubleday & Co., 1973.

Rogers, Patricia Dane. "A Bible of Black History." *Washington Post*, March 19, 1992.

Rosenak, Charles and Jan. *Encyclopaedia of Twentieth Century American Folk Art.* New York: Abbeville Press, 1990.

Rozelle, Robert, Alvia Wardlaw and Maureen A. McKenna (editors). *Black Art: Ancestral Legacy: The African Impulse in African-American Art.* Dallas, Texas: Dallas Museum of Art, 1989.

Safford, Carleton L. and Robert Bishop. *America's Quilts and Coverlets.* New York: E.P. Dutton, 1972.

Salmons, Jill. "Funerary Shrine Cloths of the Annang Ibibio, Southeastern Nigeria." *Textile History*, Vol. 11, 1980.

Schaedler, Karl-Ferdinand (translated from the German by Leonid Prince Lieven and Judy Howell). *Weaving in Africa.* Munich, Germany: Panterra, 1987.

Sieber, Roy. *African Textiles and Decorative Arts.* New York: The Museum of Modern Art, 1972.

Siegmann, William and Cynthia Schmidt. *Rock of the Ancestors.* Liberia: Cuttington University College, 1977.

Sims, Lowery S. and Adrian Piper, *Next Generation: Southern Black Aesthetic.* Chapel Hill, North Carolina: University of North Carolina Press, 1990.

Spence, Menerva. *Nsibidi Scripts.* New Haven, Connecticut: Yale University M.F.A. thesis, 1980.

Stebich, Ute. *Haitian Art.* Brooklyn, New York: The Brooklyn Museum, 1978.

Stevens, Phillips. "Satanism: Where are the Folklorists?" *New York Folklore*, Vol. 15, nos. 1-2, 1989.

Stuckey, Sterling. *Slave Culture: Nationalist Theory and the Foundations of Black America.* New York: Oxford University Press, 1987.

Szwed, John and Roger Abraham. *Afro-American Folk Culture: An Annotated Bibliography of Materials from North, Central and South America and the West Indies.* Philadelphia, Pennsylvania: Institute for the Study of Human Issues, Inc., 1978.

Talbot, P.A. *In the Shadow of the Bush.* London, England: William Heinemann, 1912.

Thompson, Robert Farris. "African Influences on the Art of the United States" in *Black Studies in The University: A Symposium* (A. Robinson, et al., ed.). New Haven, Connecticut: Yale University Press, 1969.

"The Sign of the Divine King: An Essay on Yoruba Bead Embroidered Crowns with Veil and Bird Decorations." *African Arts*, Vol. 3, no. 3, 1970.

African Art in Motion. Washington, D.C.: The National Gallery of Art, 1974.

"The Flash of the Spirit: Haiti's Africanising Vodun Art," in *Haitian Art*, by Ute Stebich. Brooklyn, New York: The Brooklyn Museum, 1978.

Flash of the Spirit: African and Afro-American Art and Philosophy. New York: Random House, 1983.

Four Moments of the Sun: Koingo Art in Two Worlds (with Pierre Cornet). Washington, D.C.: The National Gallery of Art, 1981.

Paintings from a Single Heart, Preliminary Remarks on Bark Cloth Designs of the Mbute Women of Haute-Zaire. München, Germany: Fred and Jens Jahn, 1983.

"Introduction," in John Nunley and Judith Bettelheim, *Caribbean Festival Arts.* St. Louis, Missouri: St. Louis Art Museum, 1988.

"The Voice in the Wheel: Ring Shouts, Wheel-Tire and Hubcap Art," in Judith McWillie, *Another Face of the Diamond: Pathways Through the Black Atlantic South.* New York: Intar Latin American Gallery, 1989.

"The Song that Named the Land," in *Black Art: Ancestral Legacy, The African Impulse in African-American Art.* Dallas, Texas: Dallas Museum of Art, 1989.

Torian, Sarah. "Ante-Bellum and War Memories of Mrs. Telfair Hodgson." *Georgia Historical Society* 27 (1943).

Turner, Victor. *The Forest of Symbols.* Ithaca, New York: Cornell University Press, 1967.

Twining, Mary. "An Examination of African Retentions in the Folk Culture of the South Carolina and Georgia Sea Islands." Ph.D. dissertation, Indiana University, 1976.

Van Sertima, Ivan. *They Came Before Columbus.* New York: Random House, 1977.

Verger, Pierre. *Notes sur le Culte des Orisha et Vodoun à Bahia, la Baie de Tous les Saints au Brésil, et l'Ancienne Côte des Esclaves.* Memoire No. 51. Dakar, Senegal: Institut Français d'Afrique Noire, 1957.

Verger, Pierre and Clement da Cruz. "Musée Historique de Oudah," *Études Dahoméanes*, n. s. No. 13, 1969.

Vlach, John Michael. *The Afro-American Tradition in the Decorative Arts.* Cleveland, Ohio: The Cleveland Museum of Art, 1978.

von Gwinner, Schnuppe. *The History of the Patchwork Quilt* (translated from the German by Dr. Edward Force). West Chester, Pennsylvania: Schiffer Publishing Ltd., 1988.

Wahlman, Maude Southwell. *Contemporary African Arts.*

Chicago, Illinois: The Field Museum, 1974.

Contemporary African Fabrics (Exhibition catalog). Chicago, Illinois: The Museum of Contemporary Art, 1975.

(with John Scully) *Black Quilters* (Exhibition catalog). New Haven, Connecticut: Yale Art and Architecture Gallery, 1980.

The Art of Afro-American Quiltmaking: Origins, Development, and Significance. Ph.D. dissertation, Yale University, the History of Art Department, 1980.

"Afro-American Quilt Aesthetics," in *Something to Keep You Warm* (Patti Carr Black, ed). Jackson, Mississippi: The Mississippi Department of Archives and History, 1981.

"Southern Quiltmaking" in *The Mid-South Folklife Festival Catalogue.* Memphis, Tennessee: The Center for Southern Folklore, 1982.

"Quilts" (with Ella King Torrey) in *Craft International.* New York: Fall Issue, 1982.

"Afro-American Quilts" (with Ella King Torrey) in *Art Papers.* Atlanta, Georgia: Fall Issue, 1982.

Ten Afro-American Quilters (Exhibition catalog). University, Mississippi: The Center for the Study of Southern Culture, 1983.

"Aesthetic Principles in Afro-American Quilts" (John Scully, co-author) in *Afro-American Folk Arts and Crafts* (William Ferris, editor). Boston: G.K. Hall, 1983.

"Gifts of the Spirit: Religious Symbols in Afro-American Folk Arts" in *Gifts of the Spirit* (Exhibition catalog). Asheville, North Carolina: Southern Highland Handicraft Guild, 1984.

"Continuities Between African Textiles and Afro-American Quilts" in *Traditions in Cloth.* Los Angeles, California: California African-American Museum, 1985.

"Religious Symbols in the Art of James Ford Thomas" in *James "Son" Thomas.* Las Cruces, New Mexico: New Mexico State University Art Gallery, 1985.

"Symbolic Dimensions in Afro-American Folk Arts" in *A Report.* San Francisco, California: San Francisco Craft & Folk Art Museum, 1985.

"The Art of Elijah Pierce" in *Elijah Pierce* (Exhibition catalog). Columbus, Ohio: Keny and Johnson Gallery, 1985.

"African Symbolism in Afro-American Quilts," *African Arts,* Vol. XX, no. 1, 1986.

"Religious Symbols in Afro-American Folk Arts" in *New York Folklore* (Phillips Stevens, ed.). Buffalo, New York: New York Folklore Society, Vol. XII, nos. 1-2, 1986.

"Symbolic Dimensions in the Art of David Butler" in *Shared Visions/Separate Realities: David Butler/John Geldersma* (Exhibition catalog). Orlando, Florida: Valencia Community College, 1986.

Baking in the Sun: Visionary Images from the South (Andy Nasisse, co-author). Lafayette, Louisiana: University of Southeastern Louisiana Art Museum.

"African-American Quilts: Tracing the Aesthetic Principles." *The Clarion,* Vol. 14, no. 2 (Spring 1989).

"Religious Symbolism in African-American Quilts," *The Clarion,* Vol. 14, no. 3 (Summer 1989).

"Afro-American Quiltmaking" and "Pecolia Warner, African-American Quiltmaker" in *The Encyclopaedia of Southern Culture.* University, Mississippi: Center for the Study of Southern Culture, 1990.

"African-American Quilts: Current Status," in *Folk Art Finder,* Vol. 12, no. 1, 1991.

Welty, Eudora. *One Time, One Place.* New York: Random House, 1971.

Wilson, Charles Reagan and William Ferris (co-editors). *Encyclopaedia of Southern Culture.* Chapel Hill, North Carolina: University of North Carolina Press, 1989.

Wilson, James L. *Clementine Hunter, American Folk Artist.* New York: Pelican, 1988.

Wood, Peter H. *Black Majority.* New York: Alfred A. Knopf, 1974.

Yonkers, Dolores. "Haitian Arts" in John Nunley and Judith Bettelheim, *Caribbean Festival Arts.* St. Louis, Missouri: St. Louis Art Museum, 1988.

"Haitian Vodou Flags," *A Report.* San Francisco, California: San Francisco Craft & Folk Art Museum, 1983.